EGYPTIAN
DRAWINGS

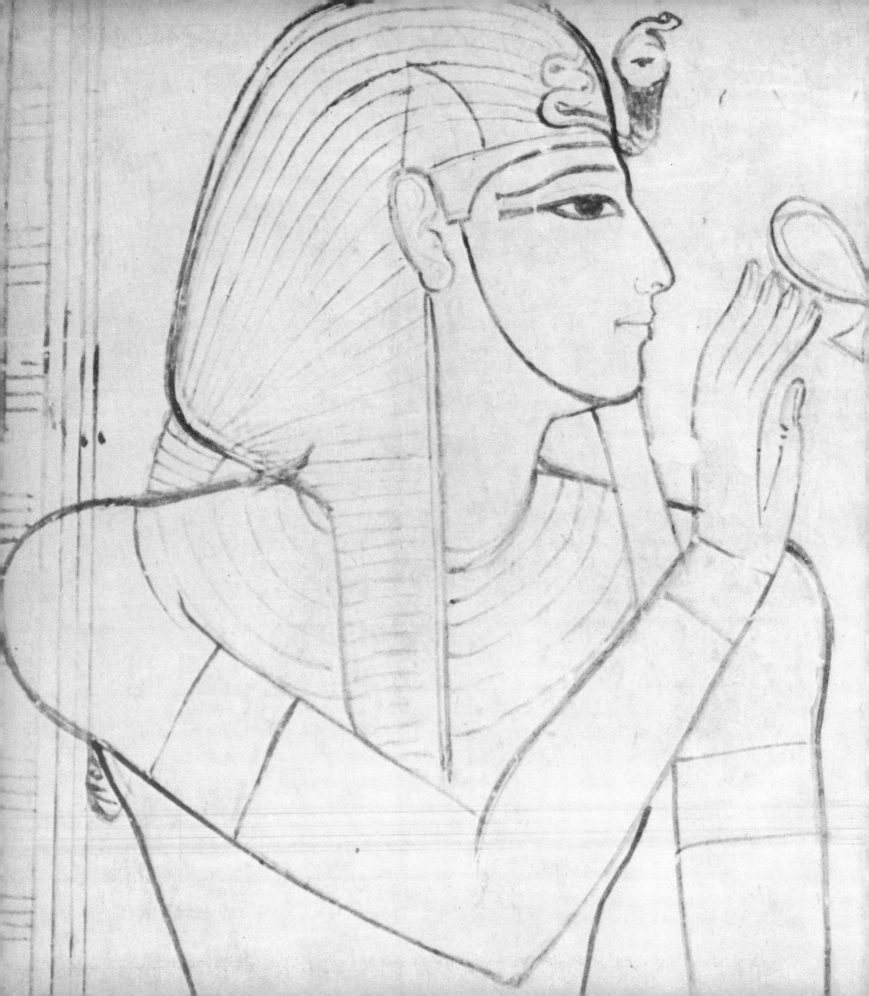

William H. Peck

EGYPTIAN DRAWINGS

Photographs by John G. Ross

E. P. DUTTON
New York

Half-title page: The hand of the god Thoth, patron of scribes and god of writing, from tomb 55, Valley of the Queens, Thebes, time of Ramesses III. *Photo John G. Ross.*
Title-pages: Maʿat (right), the personification of Justice and Truth, offers the symbol of life, the *ankh*, to Pharaoh Seti I: a preparatory drawing for a relief carving in the tomb of Seti I, Valley of the Kings, Thebes. Cf. *plates 39–40. Photo Hirmer Verlag, München.*

For information contact: E. P. Dutton, 2 Park Avenue, New York, N.Y. 10016
Library of Congress Catalog Card Number 78-52246

ISBN: 0-525-09691-4
10 9 8 7 6 5 4 3 2 1
First Edition

Contents

This book is dedicated to the memory of Edward L. B. Terrace, American Egyptologist and outstanding scholar, who originally conceived the idea for a work on Egyptian drawings but died before he could put his plan into effect.

THE SELECTION OF DRAWINGS presented by William Peck in the following pages is a good representative sampling of what has survived from ancient Egypt, but can be no more than an infinitesimal proportion of what was produced during its long history. For the Egyptian consciousness of art was essentially two-dimensional, determined by a universe which was understood as rectilinear and traversed by two co-ordinates – the general flow of the Nile from south to north, and the daily path of the sun from east to west. The contiguous planes of this environment are clearly defined and remain separate for most of Egyptian history, except for aberrations during the New Kingdom (*c.* 1554/51–1080 BC) when native ideas were interpenetrated by foreign influences, or were modified by a more intimate knowledge of the larger world outside the Nile Valley. But the cubic nature of the Egyptian feeling for space is seen in pharaonic temple architecture which is a model of the universe at its creation and uncompromisingly orthogonal.

The development of drawing on a two-dimensional surface in Egypt marched in close step with the progress of hieroglyphic writing, to which we shall return in a moment, but its character was determined by a vision which is shared by children and all people who are not conscious of a centripetal position in the world. The Egyptian universe was god-orientated, created by a demiurge who was omnipresent and continuously engaged in the cyclic re-creation of life, every day, every year and in every reign of his incarnation, the pharaoh. The perspectival vision that the Promethean Greek eventually evolved, and his Humanist followers of the

European Renaissance further developed, saw the world from a certain standpoint and at a certain moment of time as a personal revelation. This would have seemed to the ancient Egyptian as mere illusion, a distortion of reality. Indeed, the highest development of the perspectival vision, the Baroque feeling for space, has suffered a decline in modern Europe where the progress of scientific thought has removed Man from a central to his former peripheral position in the universe, and all but traditional art has returned to a non-perspectival view of reality.

Instead of a personal vision of the world of space seen at an instant of time, the Egyptian represented not what he saw transiently, but what he expected to be there eternally. This vision was not peculiar to the artist, but part of that immutable canon of creation that had been established as an institution of the Egyptian state. What was important was not the expression of an individual view of reality, but the conforming to a sanctified creative mode; and Egyptian art was adjudged successful when this had been achieved by the highest technical skill of which the artist was capable.

By a non-perspectival view of reality the Egyptian artist strived to place himself in harmony with a universe which he knew to exist. Creativity lay in the orthographical projection of natural forms in their dominant recognizable aspect, generally in profile, as in the representation of animals and birds; but also in a superimposed frontal view or plan where such adjuncts were required for complete understanding. Thus a palace might be drawn in its combined plan and elevation as a rectangular compound with a façade rising from its base-line. In the case of the human form which required to be shown in a variety of identifiable actions, a synthesis of these two aspects was represented, the head in profile, the shoulders shown frontally, the hips and legs in side view, and so on. But once devised, with natural proportions and the correct orthographical rendering of each separate part, such creations

took on a life of their own with their own inherent logic, particularly in dynamic gestures, such as the folded-over shoulder to show the forward movements of both arms, popular in the Old and Middle Kingdoms (*c.* 2635–1650 B C), and the later development of the complete side-view (cf. *plates 63, 66*), a pose that early makes its appearance in the representation of the static statues of men.

Such conceptual images of reality are as selective, therefore, in their creation as the distortions of perspective, but were sufficient for complete recognition of what they were and in what action they were engaged. For the purpose of creative art in Egypt was to make a statement, as the demiurge had created the world by making an utterance. It is seldom that a work of art in ancient Egypt is not completed by a written label setting the scene, defining the action and naming the protagonists; even a slight sketch may be accompanied by an inscription (e.g. *plates 29, 36*). Nuance, recession, abstraction are not expressed in Egyptian drawing which on the contrary was concerned with clarity of exposition of the forms of nature as they were perceived in the understanding. Egyptian drawing, in fact, is intimately associated with hieroglyphic writing, both developing together in the formative Predynastic and Early Dynastic periods (*c.* 3200–2800 B C), of which, alas, only the merest vestiges survive. During this time of gestation, a series of symbols was evolved in which the natural form of an object was unambiguously rendered in accordance with aspective principles; so that, for instance, the characteristics of over twenty different bird-signs could be identified and distinguished one from the other. Once the repertoire of different glyphs had been learnt, the scribe had become *ipso facto* an artist, since to a great extent Egyptian drawings are the ideograms of hieroglyphs writ large, and the composition of a picture was often only the assemblage of a number of ideographs. Both drawing and writing were considered part of the same creative discipline, since both could be animated by

magic. For a period it was thought that hieroglyphs of men and animals carved in the proximity of the deceased could come alive and work him ill, and were therefore mutilated to render them innocuous. Similarly some of the Theban tombs bear witness to spiteful injuries done to pictures of the deceased in order to harm him.

But while the scribe could on occasion practise the art of drawing, it is doubtful, having regard to the extreme specialization of the craftsman in Egypt, whether the outline draughtsman could act as scribe. The drawings on the pillars in the tombs of Amenophis II and Seti I (*plate 40*) or those on the walls of the tomb of Ramose (*plates 5, 6*), still awaiting the chisel of the sculptor or the brush of the painter, reveal that the draughtsman working on a large-scale composition could draw an outline around his conception with a verve and assurance that are seldom exhibited in the tentative notations on the ostraka. It is in fact highly probable that the artist who drew the tomb pictures and temple reliefs, whether for carving or painting, and those who illuminated papyri were narrow specialists in their own fields, each with a similar vision and technique, but one accustomed to the use of the entire arm, and the other trained in the use of the hand only to achieve their finished results. Both would have acquired their skill by constant practice of a number of icons that form most of the repertoire of official Egyptian art and which modified their style only very slowly during the long course of Egyptian history.

It is thus to a certain extent that the work of Egyptian draughtsmen eludes us and is often only visible in the contours of paintings and reliefs in which the final form has usually been achieved as the result of a collaboration with painters, sculptors, goldsmiths and scribes. The many ostraka of New Kingdom date, which contribute such a preponderance of sketches to our knowledge of Egyptian drawing, and necessarily form the bulk of the illustrations in this book,

paradoxically tend to refract our view of the subject. For in the writer's opinion, many of these are the work of scribes rather than draughtsmen, though perhaps the distinction is more semantic than real. A few appear to be studies for larger compositions (e.g. *colour plates I, IX,* and *plates 4, 8, 44, 86, 131*); and others may be pupils' exercises (e.g. *plates 30, 33, 37, 46, 51*); yet others may be votive offerings (e.g. *plates 12, 49, 50, 53*). But a number are apparently illustrations to parables or folk-tales that are now lost to us and are not illustrated on the monuments (e.g. *plates 71, 73–8, 90*). Included in this group of subjects which are found only in such ephemeral sketches and notes are the erotica and scurrilities (e.g. *plates 21, 36, 65, 83–5*) which do not form part of the repertoire of the monumental artists, and give a glimpse of another face of Egypt beneath the veil of Isis.

Probably from our modern standpoint the most successful of such sketches are the studies of animals drawn with a gusto and immediacy that suggest that the animal kingdom was not regarded as acting under the same social restraints as the subjects of Pharaoh. Nevertheless it should be observed that in all his doodles, sketches, projects and studies the Egyptian preserved the same aspective view of reality, the same perceptual vision throughout his long history, until in fact the introduction of Christian beliefs destroyed the basis of his old pagan culture.

CYRIL ALDRED

Chronological table

All dates are BC. Only those monarchs mentioned in the text or captions are listed here. Absolute dates before 3000 BC are very approximate; dates for the Dynastic period are based on Von Beckerath 1971.

PREDYNASTIC PERIOD

Amratian (Naqada I)	c. 3800–3400
Gerzean (Naqada II)	c. 3400–3000

EARLY DYNASTIC PERIOD

Dynasty I	c. 3000–2780
Den	c. 2900
Enezib	c. 2800
Dynasty II	c. 2780–2635

OLD KINGDOM

Dynasty III	c. 2635–2570
Zoser	c. 2620–2600
Dynasty IV	c. 2570–2450
Dynasty V	c. 2450–2290
Dynasty VI	c. 2290–2155

FIRST INTERMEDIATE PERIOD

Dynasties VII–X	c. 2155–2040

MIDDLE KINGDOM

Dynasty XI	c. 2134–1991
Dynasty XII	c. 1991–1785
Dynasty XIII	c. 1785–1650

SECOND INTERMEDIATE PERIOD

Dynasties XIV–XVII	c. 1715–1554/51

NEW KINGDOM

Dynasty XVIII	c. 1554/51–1305	
Hatshepsut	c. 1490–1470/68	
Tuthmosis II	c. 1490–1439/36	
Amenophis II	c. 1439–1413	
Amenophis III	c. 1403–1365	
Akhenaten	c. 1365–1349/47	
Tutankhamun	c. 1347/46–1337/36	
Horemheb	c. 1332–1305	
Dynasty XIX	c. 1305–1196	⎫
Seti I	c. 1303–1290	
Ramesses II	c. 1290–1224	
Dynasty XX	c. 1196–1080	⎬ Ramesside period
Ramesses III	c. 1193–1162	
Ramesses IV	c. 1162–1156	
Ramesses IX	c. 1137–1119	⎭

THIRD INTERMEDIATE PERIOD

Dynasties XXI–XXIV	c. 1080–712

LATE PERIOD

Dynasty XXV	c. 745–655
Dynasty XXVI	c. 664–525
Psamtik I	c. 664–610
Dynasties XXVII–XXXI	c. 525–332

PTOLEMAIC PERIOD c. 332–30

ROMAN PERIOD c. 30 BC–AD 324

DRAWING CAN BE DEFINED as any pictorial expression which involves making a mark on a surface. Such marks may be made with a variety of materials – paint, ink, pencil or even a sharpened point which leaves an incised line. Whatever the medium the effect is essentially the same and the result a linear abstraction. Three-dimensional masses are reduced to a series of lines, perhaps describing a figure in relation to an environment and against a ground. In the tradition of Western art, drawing can serve either as an independent mode of artistic expression or as a preparation for a work in another medium. The finished drawing, complete in itself, requires little explanation. In the second category there are three basic types: sketches which suggest the germination of an idea; studies which help to explain the evolution of a pictorial concept; and carefully finished works which have often been prepared for translation into painting or sculpture. (In non-Western art, where drawing and painting are more closely allied, there is not always such a clear differentiation between the development of the idea and the finished work.) For an appreciation of any drawing, it is necessary to determine as nearly as possible which category it belongs to. Is the observer dealing with what was meant to be a finished product, a casual sketch, a student exercise or a step in the progress towards a finished work in another medium?

In nearly all drawing there is the suggestion that one is close to the moment of artistic creation. Therein lies the fascination of the form. The brush-stroke is free, unencumbered by the details and refinements of painting. The feeling of spontaneity is sometimes so great that one almost senses what the artist experienced as he

The historical background

put line to surface, shaping the subject. It is this opportunity to identify with the artist at the moment of inspiration that has made drawings so popular in modern times. That one can achieve this kind of rapport with artists who practised three thousand years ago seems remarkable and is largely thanks to the chance preservation of a body of works from ancient Egypt.

Any mention of the art of ancient Egypt suggests to the modern mind images of such magnitude that they seem to exclude the intimate and the personal. Egyptian civilization conjures up pyramids, temples or tombs. The best-known Egyptian artifacts and art objects seem to admit of little informality and the tendency is therefore to imagine that there must be little evidence for the inner workings of the Egyptian artist's mind. Yet a greater familiarity with the culture of ancient Egypt allows the enquirer to penetrate beyond the more formal aspects of its art and to become aware of countless indications, particularly among drawings, of a deep understanding of nature and a joy in beauty.

Drawing did not exist as an independent art form in ancient Egypt in the way we know it today, serving mainly as an adjunct to painting, sculpture and architecture. It is perhaps for this reason that Egyptologists and laymen alike have considered it less important than the other arts. But Egyptian drawing should not be underestimated. It sired the arts that it later served. Sketches on rock walls and pot surfaces existed long before the unification of Egypt under the pharaohs (*c.* 3000 BC) and the first real flowering of painting, sculpture and architecture. The strong tradition of draughtsmanship continued throughout the period of pharaonic rule. Egyptian two-dimensional art was always essentially linear in conception. Unfinished paintings and relief carvings show that basic layouts were invariably done as line drawings. Even three-dimensional sculptures were begun as sketches on three sides of a block. And detailed and accurate plans of tombs and parts of temple complexes indicate that no master-builder would undertake a complicated architectural project without first drawing up a proper visual guide for his workmen. Drawing was

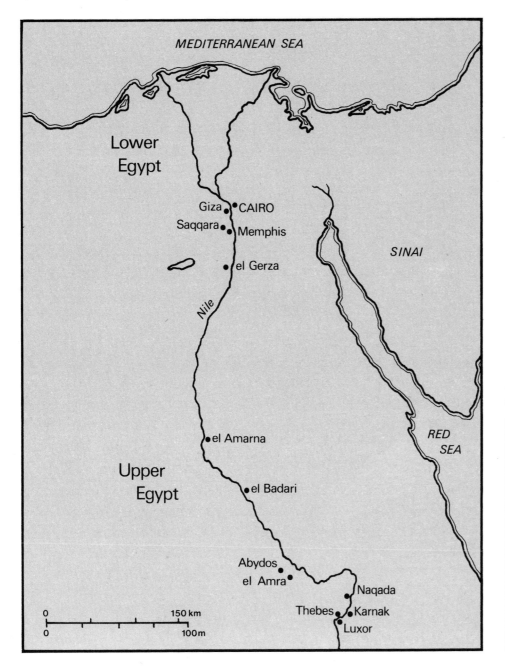

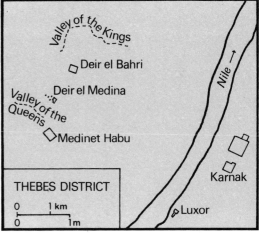

Sketch maps of Egypt and the Theban district, showing principal sites mentioned in the text.

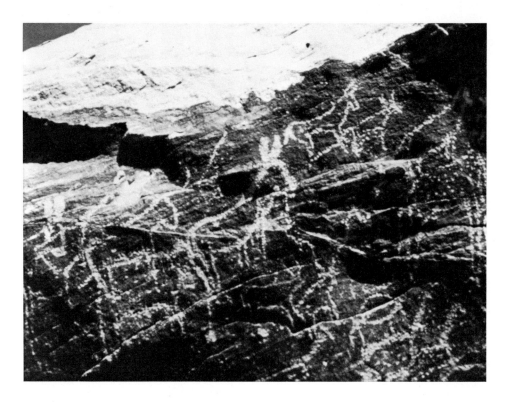

A late Palaeolithic rock engraving at Wadi es Sebua, Valley of the Lions, in Nubia, showing various animals, especially wild ass but also gazelle.

therefore both a handmaiden to the major arts and the basis upon which each one was founded.

The evidence for Egyptian drawing is gathered from a number of different sources. Drawings which were self-sufficient in their own right as works of art include papyrus illustrations and designs on prepared boards, pots, bowls and objects of faience. Sketches on walls for unfinished tomb paintings or reliefs are an equally important source of information. But it is the notes and doodles, trials and sketches preserved chiefly on limestone flakes, also on fragments of broken pottery (both known as 'ostraka'), that provide the principal evidence for Egyptian drawing. Ostraka were the cheapest and most accessible surfaces upon which the draughtsmen could practise their art – papyrus would have been easier to use but was too precious to be wasted on trial pieces. Once sketches had been made, perhaps forming the basis for wall-paintings or carvings, the ostraka were discarded, their usefulness at an end. In this way, and thanks to their durability, they have

been preserved in almost as good a state as when they left the hands of the artists who made them.

Most of the ostraka known to us are of the New Kingdom (*c.* 1554/51–1080 BC) and were found in and around the necropolis on the west bank of the Nile at Thebes, that is, mainly in the Valley of the Kings, the Valley of the Queens, at Deir el Bahri and Deir el Medina. Deir el Medina was once occupied by a village established during the course of Dynasty XVIII (*c.* 1554/51–1305 BC) to accommodate workmen engaged in the decoration of royal tombs in the Theban necropolis. Excavations by M. B. Bruyère in 1929–30 uncovered a large number of painted ostraka executed by the workmen in the village. By their association with ostraka bearing palaeographically dateable hieratic scripts they could be assigned to a period falling between the reigns of Seti I (*c.* 1303–1290 BC; Dynasty XIX) and Ramesses IV (*c.* 1162–1156 BC; Dynasty XX). It must be assumed that similar preparatory material existed in earlier times, although little of it has survived. In effect any history of Egyptian drawing must depend heavily on the New Kingdom evidence and inferences must be drawn from it as to the practices in other periods.

The origins of drawing in ancient Egypt extend well back into prehistory. Hunters at the end of the Palaeolithic period, some 15,000 years ago, scratched and carved designs on rock walls along the edge of the Nile Valley and in the deserts of Upper Egypt and Lower Nubia, like Stone Age men in other parts of the world. Included among the representations are images of giraffe, elephant, ostrich, antelope, gazelle, ibex, lizard, snake and crocodile. Crude as they are in design, these rock drawings still possess enough sophistication for the different animal types to be clearly distinguished. The hunter with his bow, and possibly his traps as well, is included in lively tableaux which probably had as their purpose the assurance of a good hunt through magical means.

Towards the end of the fifth millennium BC the peoples of the Nile valley began to settle in villages, practise agriculture and

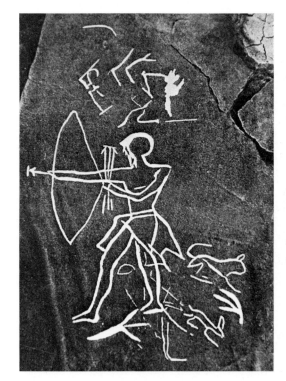

A rock engraving of an archer and animals, near Dakhla Oasis in Upper Egypt. The lion with tail over its rump tends to date this carving to the late Predynastic or early Dynastic period. The archer wears a simple kilt and draws on his bow, holding spare arrows in his left hand.

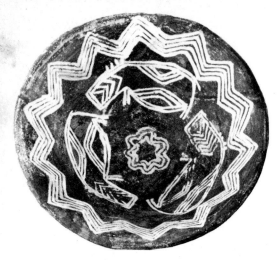

Three stylized hippopotami are arranged in a circle on a red-burnished bowl, surrounded by zigzag lines suggesting water. This so-called 'white-line' decoration, where the design is incised and then filled with white pigment, is typical of the Predynastic Amratian or Naqada I culture of the early fourth millennium B C.

Another piece of Amratian pottery, a jar from a grave at Naqada itself, is decorated with horned animals within borders above and below of triangular shapes, perhaps meant to represent hills or mountains. The animals are difficult to identify, but may be gazelles or mountain goats, some possibly even giraffes to judge by the knobbed horns.

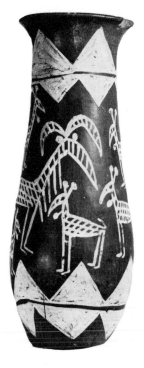

introduce new classes of objects such as pots, sickles and bead ornaments. But it is not until the very beginning of the fourth millennium that we have preserved, for the most part on pottery, any type of art which can be classified as drawing. This developed into the designs in white line, often cross-hatched, on red-burnished pottery of the Predynastic 'Amratian' or 'Naqada I' culture (named after sites where the culture was first found). The decoration of this ware often took the form of geometric designs suggesting basketry, interspersed with recognizable attempts to render animal and plant motifs, particularly Nile Valley fauna, including fish, hippopotamus, crocodile and scorpion. These sketches of natural life are the first real beginnings of a tradition of visual observation which would continue and develop until the coming of Christianity.

Around the middle of the fourth millennium B C the Amratian/Naqada I was superseded by a more developed culture known as 'Gerzean' or 'Naqada II'. Significant changes appear in the design of many types of artifact including pottery. A more diverse range of subject-matter in ceramic decoration emerges and the use of the human figure becomes prevalent. Men (or gods) are characterized by wide shoulders and slim hips, women (or goddesses) by wide hips and large heads. It has been suggested that the upraised arms of many of the female figures portray a ritual dance. One of the most important design elements is the Nile boat, delineated with care and detail, including oars, cabins or shrines, passengers and ensigns. These have been interpreted as ritual vessels and the male and female figures within the cabins as images of deities on a ceremonial voyage, although we still lack definite proof. What can be determined with certainty is that the craft of boat building had progressed in this later Predynastic period to the point where large river vessels were being constructed. Propelled by many oarsmen, the boats seem to have been distinguished by various ensigns which may have had a cult significance. The growing importance of the Nile as a waterway and path of communication for the developing country is

expressed in a graphic manner. The river-valley landscape is suggested by rows of triangles symbolizing mountain ranges and areas of wavy lines indicate water. Plant forms become more elaborate and decorative, and animals and birds abound.

The artist of this period had a much greater repertoire than his counterpart of Naqada I. It was with a fluid line that he caught the shape of a boat, the character of a horned animal or the grace of a long-necked bird. After the beginning of the Dynastic era (*c.* 3000 BC) pottery decoration never quite maintains the same standard (except perhaps in the New Kingdom), but the tradition of calligraphic line and careful observation of nature carried on in other art forms. With these elaborate figural designs of the late Predynastic period we begin to approach the point at which drawing and painting diverge. Line drawing is no longer sufficient for all purposes. Bodies of animals and humans are filled in with paint, foreshadowing the polychrome decorations of later periods.

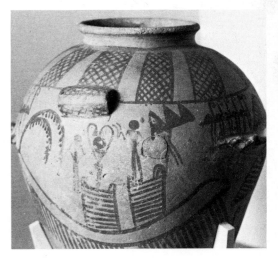

A pot from el Amra of the Gerzean (Naqada II) culture, mid-fourth millennium BC, decorated with a Nile boat carrying an ensign, cabins or shrines and human figures or gods.

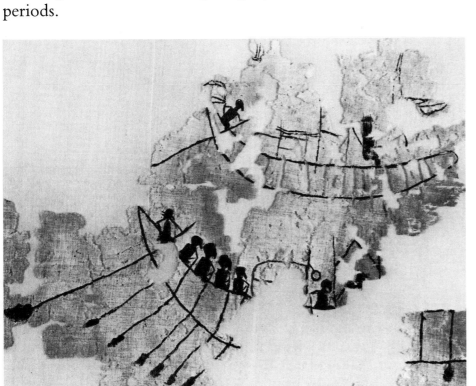

More Nile boats are depicted on this rare late Predynastic fragment of textile from Gebelein in Upper Egypt. Oars and oarsmen, generally omitted from similar scenes on pots, are clearly delineated here, together with cabins or shrines. It is possible that this drawing illustrates a ritual voyage to a cult centre, if the figure in the upper boat is correctly identified as the deceased.

The beginning of the Dynastic era, when the country was first unified and a kind of pictographic writing emerged, may be taken as the point when line drawing came into being in a form much as we understand it today. What is extraordinary about this period of transition is the sudden appearance of principles which were to remain basic to Egyptian art for the next three thousand years. In translating solid forms into two dimensions the artist attempted to identify the typical and enduring aspects rather than the ephemeral, to see an object in terms of what was known rather than what was observed. Only within these limitations could he use insights based on his own experience. Rules and guidelines developed for the laying out of figures and scenes remained constant until late in pharaonic history. These restrictions upon the freedom of the artist will be discussed more fully below, when we come to study the artist's vision and training; here we may merely observe that, although drawing evolved considerably in the millennia following Dynasty I, it was nearly always within the framework of the ideas and canons first worked out soon after 3000 BC. The exceptions to the rule that can be demonstrated from among the preserved drawings are therefore all the more interesting.

In the Early Dynastic period (Dynasties I–II, *c.* 3000–2635 BC) many drawings were scratched or incised on objects of stone, bone, ivory, wood or shell. Stone vessels were decorated in this manner as well as bone or ivory ornaments. Working with a sharp point on a hard material allowed only a limited variation in the quality of the line produced. Often the drawings were linked with writing in some way. It is thought that Egyptian writing began with simple signs or 'hieroglyphs' (from the Greek for 'sacred carving') which could be understood as representing objects. When it became necessary to recall to mind that which could not be completely communicated in pictures, hieroglyphs which stood for sounds were developed. By the Early Dynastic period hieroglyphic characters inscribed on the surfaces of stone bowls had assumed a form which was to be little altered over the

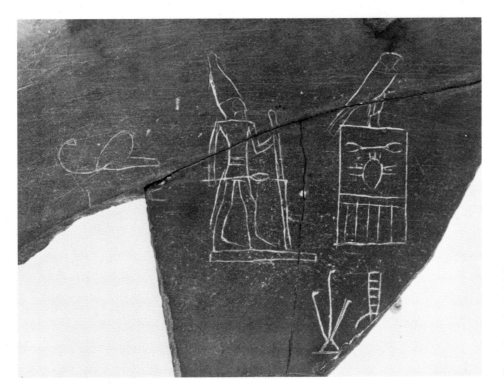

This fragment of a schist bowl bears an incised inscription giving the name of Enezib (c. 2800 B C), one of the last kings of Dynasty I, in its Horus form. The figure beside the name represents the king wearing the White Crown of Upper Egypt, holding a mace in his right hand and a staff in his left. The rectangle below the king's feet may indicate that this depicts a statue rather than the monarch himself.

centuries. Written signs and pictorial images came to be essential complements of one another. On an ivory label of King Den from Abydos (*c.* 2900 B C) the monarch is shown as a mighty ruler defeating the enemy. This important event in his reign is identified by the inscriptions as 'Year of the first time of smiting the East'. This great king of Dynasty I, at the outset of Egyptian art, is shown in a pose which becomes the standard for representations of the victorious monarch. The tableau of king and conquered and the text which identifies the event are interdependent. One without the other would not tell the complete story or make the subject clear.

28

For the Old Kingdom (Dynasties III–VI, *c.* 2635–2155 B C) we are less fortunate in the material that has come down to us. Probably there were preparatory studies made for tomb and temple decoration, but these are for the most part lost. It is necessary to infer from the finished works how the art of drawing

progressed. The wealth of visual material preserved in the tombs shows clearly that the artist was able to depict almost any activity demanded of him. The deceased and spouse are regularly represented in formal and informal situations; the wealth of offerings brought to the funerary meal gives us a virtual catalogue of the foodstuffs of the time; while the great variety of activities shown on the estate and farm tell us much about everyday life. Undoubtedly such complex decorations would first have been worked out as drawings.

The same lack of evidence limits our understanding of the drawings of the Middle Kingdom (Dynasties XI–XIII, *c.* 2134–1650 BC). Here again we must assume that wall-paintings and relief carvings began as sketches – although it is a fairly certain assumption. We also have the additional evidence of the painted decorations in Middle Kingdom coffins to aid us. The funerary tradition of the time allowed for the burial of the mummified body in a box-shaped coffin, the interior walls of which were decorated with depictions of offerings in addition to the standardized texts. These paintings often show a high degree of ability on the part of the artist who executed them and, in cases where the paint has become transparent with time, the skill of the draughtsman is clearly evidenced.

The New Kingdom (Dynasties XVIII–XX, *c.* 1554/51–1080 BC) is the best documented period in the history of Egypt for a study of drawing. In part because of increased building programmes which demanded the training of corps of artists, and in part because many more drawings of this time on papyrus have endured, there are a disproportionate number of New Kingdom drawings left to us. The Ramesside period (*c.* 1305–1080 BC) in particular has furnished a wealth of material, so that most of the examples in this work are of that date. Much of the discussion that follows, therefore, is based upon the New Kingdom evidence, and mention of earlier periods is often a projection backwards from this data.

The artist's vision

THE ARTIST WAS TRAINED in the service of the Egyptian state and religion to produce a type of art which was essentially timeless. For the mural decorations in tombs and temples it was necessary that the artist create a synthesis of experience which transcended the momentary. The human figure was drawn and painted, not as it would have been seen at a glance, but so that its image incorporated all the important aspects which made up its essence.

In her epilogue to the recent English translation of Heinrich Schäfer's *Principles of Egyptian Art* (Oxford 1974), Emma Brunner-Traut has admirably elucidated the problem encountered by those trained in modern concepts of art in their attempt to understand that of ancient Egypt. To make the explanation of Egyptian perceptions clear, she has coined the word 'aspective', a term which she holds can be applied to other manifestations of Egyptian culture as well as art. Schäfer throughout his lifetime struggled with the formulation of a term which would describe how the Egyptians saw. For lack of a better word or phrase he tried to use *geradvorstellig* ('based on frontal images') and *geradvorstellung* ('basis in frontal images'), which he believed described the vision of the Egyptian artist. Since it is generally agreed that Egyptian art is lacking in perspective, the word 'aspective' would perhaps be even more applicable, in the sense that the art is 'without perspective'. The Egyptian artist rendered each object part for part as it was and not as it seemed to be, giving the important or characteristic side precedence and showing only as many other parts as were necessary to define the object. This combination of images is naturally confusing to a modern observer: the gaming board seen in plan with the pieces above and in profile seems a naive image; yet it is in fact a

complete description of the object in its necessary views. Often it was the individual artist who dictated the choice of parts; but gradually, by usage and convention, a standard set of patterns grew up which became the accepted norm for representation.

Aspective art as defined by Brunner-Traut aims at a true representation of the object as it is and remains, whereas the world seen through a perspective view is that of passing appearance. The Egyptian artist worked on the basis of what was known rather than what he observed, because his personal viewpoint was subjugated to the existing order. 'Aspective' implies that each image is seen from a restricted viewpoint and is set out without relation to any other. It is restricted in time as well. The object is characterized without reference to 'before' or 'after'. This way of seeing is exemplified in Egyptian art by the use of clearly set out parts, distinct boundaries, dependence on line and the separation of the work of art from the real world. Egyptian painting was not concerned with the illusion of space because spatial effects would have added nothing to what it was intended to present. The individual view of parts is extended in the same mode of seeing figures to depictions of groups; here, for instance, the rule of demonstrating importance through size (e.g. the king larger than the queen, the queen larger than the nobles) is a function of the mode of seeing. In the aspective view the most important element, the king, is given greatest prominence, others, less important in descending order, are treated only in so far as they are necessary to define the action.

The aspective view of the world is one in which space and time are strictly under control, which is not to say that they do not exist, but that they are defined only as far as is necessary for the particular representation. There is no background or foreground. On tomb walls that suggest a progression of locales from the Nile through the desert to the foothills, the notion to be conveyed is not 'the landscape' in modern terms, with the river in the foreground, plain in the middle and hills in the distance, but rather it is the idea of 'the land', comprised of these elements, that

28–9, 43–4

is meant. The observer's viewpoint is not taken into consideration. The known elements are arranged in a way that conveys not the visual momentary impression but a description of reality at no fixed time. Certainly temporal events are depicted, particularly in the New Kingdom, but the individual representations which go to make up a description of a historical event, such as Hatshepsut's expedition to Punt, are still images 45–6 which describe no time. Space is also suggested only when it is necessary for the expression of an essential quality of the image.

The typical view of the world as it is expressed in Egyptian art is one which accords with the Egyptian view of the universe. The Egyptian believed himself to be a part of the universe, of an order set down by the gods. For him to arrive at the kind of personal view which was necessary for a perspective drawing or painting he would have had to break with this established order. It was really only in the handling of details that the artist could rely on his own view of natural phenomena. All else was dictated for him. It is only through the medium of drawing that we are able to gain some appreciation of the individual differences of artistic perception. The finished product which most of the drawings served would have had far less individual character. It is certainly true that quality varies from one Egyptian work of art to another, but this is not so much a function of individual vision as of the particular skill of the artist in rendering the design in the 'correct' way. When Egyptian art is dismissed for not changing over three thousand years the reason for its existence is completely misunderstood. The artist was not intended to be an innovator. His role was to translate the Egyptian view of the world into graphic forms, following the canonical rules and working with an aspective vision.

At the start of the artist's training it was necessary that he master the manner of delineating the standard motifs, which included the human figure and its parts as well as animals, plants and other subjects. He was also obliged to study the canon of proportion,

THE CANON OF PROPORTION

IV, 2, 32

the standardization of the parts which make up the harmonious whole. There exist a number of squared-off designs which provide us with information about the system of proportion used by the artist and how it was applied. Working from a module based on the forearm length measured from the elbow to the thumb tip (the small cubit), which was divided into 6 palms (handbreadths), each of which consisted of 4 digits, the human figure was drawn within a squared-off grid. The grid-squares each measured one unit known as the fist, which was equal to $1\frac{1}{3}$ palms or 1 palm plus the width of the thumb. The standard height of a standing figure was set at 18 squares from the baseline to the hairline at the brow. The part of the head above the hairline was not measured as carefully, because it could be variable according to type of wig, crown or other headdress. The seated figure, by this standard, was considered to measure 14 squares high (because 4 squares had been lost now that the upper leg was in a horizontal rather than upright position). The small cubit – the forearm length from elbow to thumb tip – was $4\frac{1}{2}$ squares (6 palms) or one quarter of the standing height. Within these standards the human figure could be designed with a series of close relationships which ensured an internal coherence throughout. Several drawings exist showing how a master artist corrected errors of proportion perpetrated by a student. In a number of examples there is

30, 31

31

included, as a reference, a drawing of a closed fist, which illustrates the full handbreadth, or an extended hand, which shows the correct size for other units such as the distance from hairline to shoulder. The grid-squares served both as the standard of measure and as the working guide by which the drawing could be transferred to a larger scale. Examples of preparatory drawings

IV, 2

with the squares, as well as tomb walls so prepared, indicate that a design was worked out in miniature and enlarged square-for-square to full size.

Eric Iversen, in his monumental study, *Canon and Proportions in Egyptian Art* (revised edition Warminster 1975), has examined the history, the basis and the development of the canonical system.

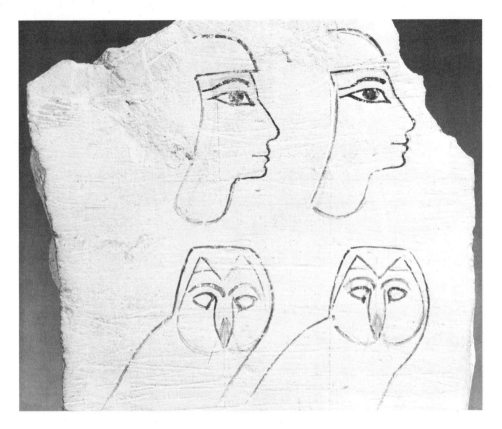

Trial drawings of two human heads in profile and two frontal owl faces are shown on an ostrakon from Deir el Bahri, Thebes. The sketches, drawn to vertical guidelines, provide a good example of a student's first attempts to copy the work of his master and thereby learn the correct mode of representation for standard subjects. The two heads on the right are the better proportioned, perhaps indicating that the master draughtsman drew them to demonstrate errors in an apprentice's work on the left. But all four drawings are in fact similar enough to be by one student artist who learnt by his mistakes and improved from one pair of sketches to the next.

He defines it as 'an anthropometric description of the human body, based on the standardization of its natural proportions expressed in the Egyptian measure of length'. This system, he maintains, grew out of a pre-established set of units based on the average size of body parts. Once the artist had learned the correct method by which the figure was delineated, his task was made immeasurably easier; it was simply a matter of following the rule or 'canon' set down for him. According to Iversen, 'The canonical tradition was carried on in unbroken continuity from the Ist to the XXVIth Dynasty with no change in its basic principles.' He excepts recurrent periods of cultural stagnation when artistic activity declined and the period of Akhenaten (1365–1349/47 BC), which he states needs a special study.

26–7, 30

Despite the absence of grid-lines to prove his case, Iversen demonstrates convincingly that the canonical system existed in a

developed form from as early as the beginning of the Dynastic period. He shows this by applying his understanding of the rule to one of the earliest two-dimensional representations of a fully developed nature, a palette of Dynasty I (*c.* 3000 BC) with the southern king Narmer conquering the north.

Evidence for the canon is scant in the Old and Middle Kingdoms. But two burial chambers at Saqqara suggest that methods known from later times were already in use. An *XI, 120* unfinished wall-painting of birds and bird-catchers in the tomb of Neferherptah (Dynasty V, *c.* 2450–2290 BC) shows clearly that the work was 'blocked-out' in red and corrections made in black paint. This is a sculptor's drawing which would have disappeared under the chisel. There is no proportional grid for the catchers but the sense of such a guide underlies the drawing. It is possible that the grid was put in a form which was easily removed, perhaps by the use of dry pigment in powder form, but this cannot be proved. Similarly, in the burial chamber of Mereruka (*opposite*) among the representations of food offerings for the deceased can be made out the lines of a large-scale grid which seems to have been employed not so much for the proportion of the offerings as for the placement of the individual units. In a register which depicts dead animals, a horizontal guideline can be made out which was clearly the indication for the height of the forms. Vertical lines occur at the two ends of each animal marking the length allowed for each. In addition, a number of traces of preparatory layout can be seen throughout the chamber. In some cases the finished drawing deviates only slightly from the preliminary indication, in others whole objects which appear in the first stage have been omitted and left undrawn in the second. It is simple enough to observe that a careful system of organization was followed which must have been based on preliminary material now lost to us. Guidelines for figures do exist but not the grid-squares common later on.

The canon of proportion and system of grid-squares is best known from the New Kingdom, and has already been described.

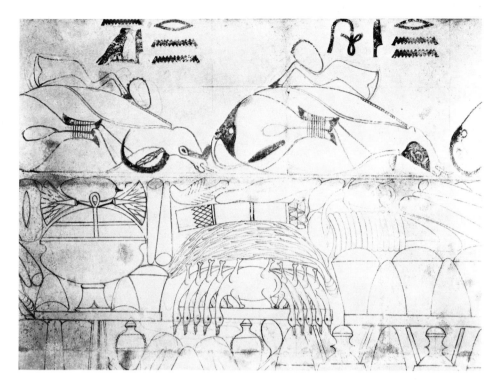

In the burial chamber under the mastaba tomb of the official Mereruka at Saqqara (Dynasty VI, c. 2290–2155 BC), depictions of offerings are preserved in the preparatory drawing stage. Traces of horizontal and vertical lines used to divide the walls and place the elements are still visible. The first arrangement of some of the objects has been altered in the final drawing – occasionally complete groups have been omitted, suggesting that the original layout was considered too cluttered and needed to be simplified.

Iversen demonstrates that the rules continued unaltered until the Late Period. At the beginning of Dynasty XXVI (*c.* 664 BC), he is able to prove that a reform came about which changed the structure of the grids, so that the figure was no longer drawn as 18 squares high from the baseline to the hairline, but was instead measured as 21 squares high from the baseline to a new measuring point at the root of the nose and the corner of the eye. This apparently coincides with a metrological reform in which the 'reformed cubit' was substituted for the small cubit. The reformed cubit was measured as a forearm's length from the elbow to the tip of the middle finger (rather than the thumb tip). The grid-square in the revised system is taken to represent one-sixth of the reformed cubit or one great palm. It is Iversen's contention, for which he provides convincing evidence, that the revised system of grid-squares in Dynasty XXVI had the purpose of bringing the old standard of proportion into accordance with the new metrological reform.

A wooden palette-and-pencase belonging to the scribe Amen-mes, of Dynasty XIX, c. 1305–1196 BC. The six depressions were for carrying cakes of black and red pigment and other colours – normally there would only have been two depressions, one for writing in black, the other for rubrics in red. The angled slot in the middle held the artist's pens or brushes, as here. The presence of six instead of the more-usual two ink-pans suggests that Amen-mes worked at the illumination of papyrus manuscripts. The reverse of the pencase has a head in profile.

The materials and uses
of Egyptian drawing

THE MATERIALS of the Egyptian draughtsman were simple in the extreme and were, for the most part, the result of a selection from what was naturally available. For the production of a drawing in a liquid medium there are three basic ingredients, pigment suspended in a vehicle, an instrument to convey the colour to a surface and a prepared support on which to make the design. Generally the black pigment was simply carbon, derived most easily from soot, although there are instances of other substances being used. In addition red, normally a red ochre, was sometimes needed by scribes or for laying out drawings. A fixative, probably a plant gum, was added to make the paint or ink more permanent. The ink or colour seems to have been made by grinding the pigment into water with the addition of the fixative and the whole allowed to dry. It was then used in cakes or in the recesses of the scribal palette. The method of application of the colour was a simple matter of dipping the brush into water and rubbing it on the dry ink.

The equipment of the scribe, and by extension that of the artist, is represented in relief and hieroglyphs as simply a brush, a water container and a palette. The brush consisted of a section of rush (*Juncus Maritimus*), not reed, according to Alfred Lucas,[*] which was cut to a chisel point before it was chewed or beaten to separate the fibres into a brush form. As a result, the point of the scribal instrument was capable of a wide or a narrow line, or of a variation between thick and thin in one single line. This characteristic tool played a decisive part in the appearance of the

* Lucas 1962, p. 365. The information given here on writing materials is derived mainly from Lucas.

finished drawing. A pointed brush would have given a totally different effect. The combination pencase-palette was a rectangular object usually made of wood but sometimes of other materials. It had two depressions for cakes of red and black ink and a slot for holding the pens or brushes. More elaborate examples have more than two colour 'pans', but these were for colouring rather than drawing.

The support or drawing surface used by the Egyptian artist could be made of a variety of materials. The most important of these to a study of drawing, as we have seen, are papyrus sheets and ostraka (limestone flakes and pottery fragments). In addition, drawings were also made on bone, ivory, unbaked clay, leather, metal, wood panels prepared with a gesso coating, cloth and stone other than limestone.

The Egyptian drawings that have come down to us served a number of different purposes, which may be categorized as follows:

THE USES OF DRAWING

Trial sketches on ostraka or papyri which were clearly intended to be studies for works (or elements of works) in other media.

IV, 4, 8, 44, 86, 131

Student works, mostly on ostraka, which were intended to be instructional in nature and not trials for finished works in other media.

30, 33, 37, 46, 51

Sketches for the artist's own amusement, or at least for a limited audience, of humorous or genre subjects, drawn mostly on ostraka and papyri.

21, 36, 65, 74–85

Preliminary drawings on tomb walls and stone fragments, intended to have been an integral part of paintings or sculptures which were for some reason left unfinished.

XI, 2, 5, 6, 12, 27 39, 40, 57–9, 120

Finished drawings on papyri, prepared boards, pots, bowls and tiles, either unglazed or glazed (faience).

V, XIV, XV, 32, 91, 124, 129

Copies from formal and finished works of art. (This category is a difficult one to assign drawings to because it is often not easy to determine the difference between studies for another work and

45–6

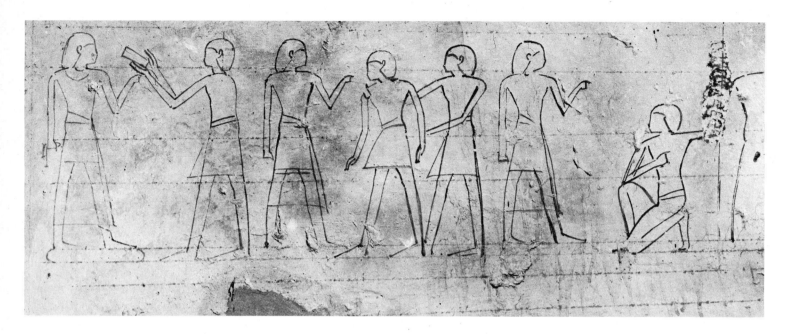

This is a preliminary drawing for an unfinished wall-painting from the tomb of Nebseny at Thebes (Dynasty XVIII, c. 1554/51–1305 BC). It depicts various rites before three statues, presumably of the deceased, who is shown (far left) holding a folded cloth in his right hand; he would later have been given a staff for his left hand. The horizontal guidelines for the composition are clearly visible and the figures have been completely blocked out as far as their general outlines. The first, third and sixth figures from the left are the statues, the other representations are of people making offerings, presentations and objurations. Little detail has been included at this stage because it would have been added later in colour. In several instances it can be seen that corrections have been made to the shape of parts such as arms or legs. This was a normal procedure since the design was worked out on the wall, within the guidelines.

copies after an established piece. There is, however, at least one indisputable example where an artist can be shown to have recorded his observation from an existing monument, and that is the drawing on an ostrakon now in the Egyptian Museum, Berlin, bearing an image of the Queen of Punt copied from a relief at Deir el Bahri.)

The majority of these categories are self-explanatory. Trial sketches and finished drawings, for instance, though at opposite ends of the spectrum, are nevertheless quite clearly meant to be drawings and nothing else. Preliminary drawings, on the other hand, have a complex interrelationship with the media they were intended to serve, that is, painting and sculpture. Similarly the art of the draughtsman, drawing, and the art of the scribe, writing, are so closely bound up that their interconnection requires some elucidation.

DRAWING AND PAINTING

It is often difficult to separate the art of drawing from those of wall-painting or papyrus illumination. All Egyptian two-dimensional expression began with a layout in line, in some cases

more evident than others. In a wall-painting of the New Kingdom it is possible to discern three basic stages of development. If the work is unfinished, or if the colour has become more transparent than was intended, the initial drawing (e.g. *opposite*) may be seen. This may be a rather crude indication of the relative placement of the parts of the design. The next step was the addition of colour, first in broad areas and then in greater detail. The painting was completed usually by the addition of a linear outline which gave the final definition to the coloured areas. This required a high degree of skill on the part of the draughtsman-artist, for these finishing lines could be very thin.

In preparing illustrations for texts on papyrus much the same order of work was followed with the exception that the initial drawing served also as the final outline, with colour added. In less complex papyrus illuminations the line drawing acted as the complete illustration, without the addition of colour. As a consequence, much of the work of the Egyptian artist on papyrus can be considered to be drawing, or at any rate 'coloured' drawing, since it comes closer to being a linear production than one which is actually painted. In the case of both wall-painting and papyrus illustration, therefore, the artist had to be an adept draughtsman before he became accomplished at any other aspect of his art. The skill of the colourist was secondary.

Throughout the history of ancient Egypt the written language remained, in the words of Sir Alan Gardiner, 'a picture-writing eked out by phonetic elements'. Since the writing of the language depended on an ability to draw the pictures which stood for ideas or sounds, the distinction between art and language is difficult to make, and in many cases, impossible. Egyptian writing began in the late Predynastic period as an attempt to convey information with pictorial signs. In its most rudimentary form this probably consisted of lists which recorded possessions – the notion of 'three cows' could be conveyed with three pictures of the animal, or with one animal qualified by three marks of some kind. It was

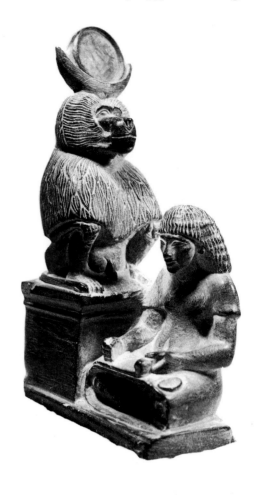

DRAWING AND WRITING

This small sculpture from Tell el Amarna, of the reign of Akhenaten (c. 1365–1349/47 BC), is evocative of the art of writing and, by extension, of the art of drawing. A scribe squats cross-legged before the baboon of Thoth, the patron of scribes and god of writing. The scribe sits as a student before a teacher, a papyrus scroll half unrolled on his right knee, a palette on his left. His right hand is poised as if holding a pen or brush. Many such images exist, testifying to the dedication of those who practised this most honoured of Egyptian professions.

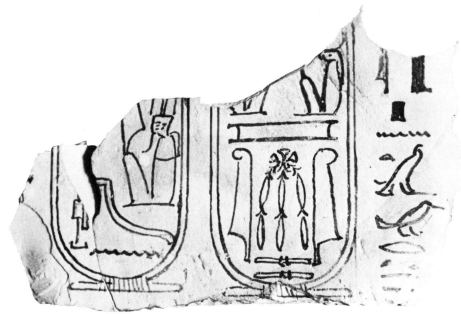

A fragmentary ostrakon bears the two names of Ramesses IV (c. 1162–1156 BC) and a short text which identifies a scribe named Pentaurt. Like many other such fragments, it was found in the Valley of the Kings, where it was probably used in the preparation of tomb inscriptions.

only when a person wished to record information that could not be depicted literally that the language began to develop. Even before the unification of the country under one rule (*c.* 3000 BC) the principle of like sounds had begun to be employed. That is, if an object or idea could not be drawn easily, a word with the same or a similar sound might provide the picture which would be used as a substitute. This use of the so-called *rebus* principle made picture-writing practical. As writing developed and its grammatical structure was more clearly conveyed, the shapes of the individual signs which had been codified early in the third millennium changed only slightly.

In almost every case where a graphic representation is used with the written language, the two forms are interdependent. The language is an extension and an explanation of the art and the art of the language. For example, if the figure of a man is

p. 21

represented with a text giving his name and titles, the figure usually functions as a qualification or a 'determinative' for the written words. In its most fully developed stage, the written language made use of only two basic types of signs, *ideograms*, conveying meaning, and *phonograms*, representing sounds.

The artist-scribe had to be familiar with almost every animate or inanimate object around him. At any time he might be required to represent the great range of human types and deities; animals and birds, as well as their parts; reptiles and insects; trees, plants, earth and water; architectural projects; ships, shrines and furniture; garments, implements or weapons. The formal design of each character had to be mastered by practice and repetition, based on an observation of standard models. Thanks to this method of teaching a number of carefully drawn individual hieroglyphic characters have been preserved. In many cases, the sculptor or painter who was to produce the finished work of art would have been illiterate and this required the preparation of squared-off models of individual characters and groups. The division between the scribe who prepared the text for a wall decoration and the executant is not always clear. In many instances the first laying out of an inscription in red was probably done by a person who could read and write. The corrected version in black where the characters were more carefully incorporated into the total design of a wall may also have been done by a literate person, but the actual execution was left to craftsmen who did not necessarily understand what they carved or painted. This is suggested, particularly in the last centuries of Egyptian history, by the number of so-called 'artists' models', often showing one character or stages in the development of one character.

Some signs were obviously considered more difficult to render than others. There exist from many periods study examples of the *M* owl and the *Hr* face. The chief problem with both of these signs was that they depicted their subjects from a frontal viewpoint rather than the more normal profile. It seems that the scribe trained to visualize all living things as having a profile face had to have extra instruction in the full-face technique. Other standard characters required study, but it is generally those which were not so often used which needed practice and have therefore been preserved. (See *colour plates III* and *X*.)

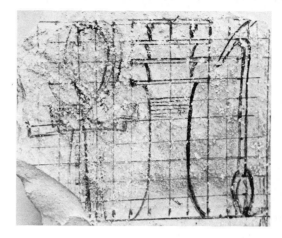

This limestone flake from Deir el Bahri (time of Hatshepsut, c. 1490–1470/68 BC) was used by a draughtsman for a rough lay-out of three hieroglyphic characters often juxtaposed as decorative elements. These ankh, djed *and* was *signs were endlessly repeated, for they symbolize 'life', 'stability' and 'power', desirable attributes for both kings and gods. The squared-off grid served as a guide to the correct proportion of the three elements and also made it easier to transfer the drawing to a wall in preparation for carving in relief.*

This relief from the temple of Hatshepsut at Deir el Bahri (time of Hatshepsut, (c. 1490–1470/68 BC) is a finished example of the same three characters which were seen in the preceding drawing. It is unlikely that the drawing was actually the guide for this particular carving – the proportions of the signs are not the same – but the relief carver would undoubtedly have relied upon a very similar preliminary sketch to help him.

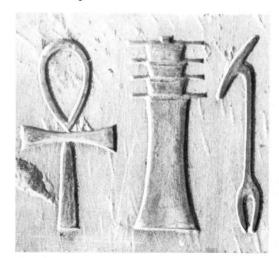

For religious or political inscriptions and texts each character was designed with a great deal of care, and could be a miniature work of art in its own right. The individual parts of each sign were often carved or painted with attention to the most minute details. Hieroglyphs in painted texts in tombs range from carefully executed polychrome characters to simply drawn monochrome ones. The most formal use of the pictorial language was reserved generally for temple inscriptions. *Hieroglyphic* means 'sacred carving', the name given to this most developed form of the script by the Greeks. At first, it was used for all purposes, but the care it demanded in setting down even a simple text spurred the development of a cursive form which could be written more quickly. For much of Egyptian history from the later Old Kingdom onwards, the cursive form was *hieratic* ('priestly writing'); in the last centuries of pharaonic history, however, *demotic* ('popular writing') was introduced, an even more abbreviated adaptation of the hieroglyphic characters. It might be said that *hieratic* and *demotic* stand in the same relation to the formal signs as modern cursive handwriting does to the characters in a printed book.

Ancient Egyptian writing was an art form with its own particular limitations, those of the language, as well as those of the context in which it was used. But it was an art form nonetheless. The name and titles of a king can make up a beautiful design. Figures in a wall-painting can be skilfully integrated with a descriptive text or even passages of conversation. A kneeling figure of a man can be surrounded by the text of the prayer which he has uttered and caused to be recorded as a pious act. When a nobleman is shown fishing and hunting on the painted walls of his tomb, it adds much to our perception of the scene to find that the text describes him as 'taking recreation, seeing pleasant things in the place of eternity'. In a painting of the funeral procession to the tomb, the relationship of two of the participants is made more meaningful when we are aware that the text tells us that one man is telling another to 'mind the pace, get back in step'.

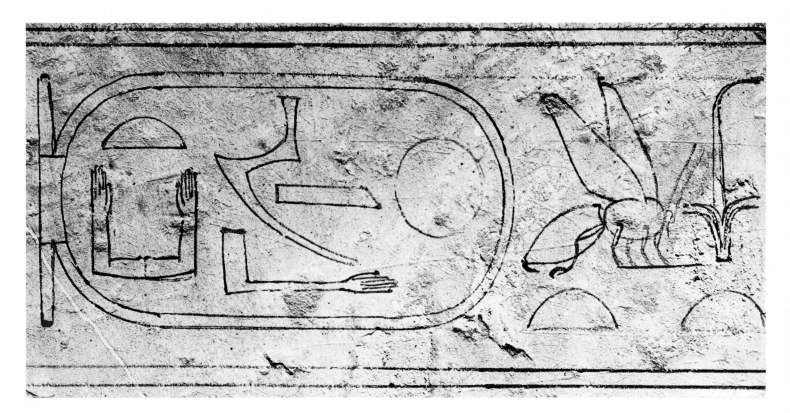

The interaction of text and illustration goes far beyond the simple level of written lists and pictures of offerings. Hieroglyphic characters were used extensively for amuletic purposes which approach pure decoration. Every useful object could be embellished with the name of a king, the owner, or signs evocative of power and protection. The special character of a written form which was also pictorial lent itself to the decoration of furniture, jewelry, implements and clothing. From a rich tomb such as that of Tutankhamun, there is hardly an object which does not bear the name of the king and his wife. Standard decorative devices in jewelry design were usually in the form of a limited number of signs which were in effect abbreviations for words such as 'life', 'health', 'completeness', 'prosperity' and 'power'. However decorative such devices may seem to the modern mind, they always had as their basis a seeming need repeatedly to evoke important powers and qualities.

This ink inscription in the tomb of Senenmut at Deir el Bahri gives the prenomen of Hatshepsut (c. 1490–1470/68 BC): 'The King of Upper and Lower Egypt, Maʿat-ka-Re', continuing (but not shown in the photograph), 'son of the Sun, Hatshepsut'. The drawing of the individual hieroglyphic characters suggests that the inscription was to have been carved or at least painted. The figures within the cartouche spell out the prenomen; the sedge and the bee are heraldic symbols for the 'two lands'.

DRAWING AND SCULPTURE

The Egyptian artist who worked in stone had always to be a trained and practised draughtsman, for every work carved in relief or in the round was first conceived as a line drawing.

For wall decoration, there were two basic kinds of carving employed, raised and sunk relief. In the first, the figures were left standing above the surrounding wall surface, and as a result, large areas of stone had to be carved back, a technique which was both laborious and time consuming. In the second, only the figures were carved below the surface and the inner parts modelled. In both systems, the original design was executed as a line drawing. There are any number of incomplete relief carvings which attest to this practice. Many tomb owners died before their chambers were ready for them, leaving decorations often of high quality, but in an unfinished state. It has been said that hardly a tomb in the

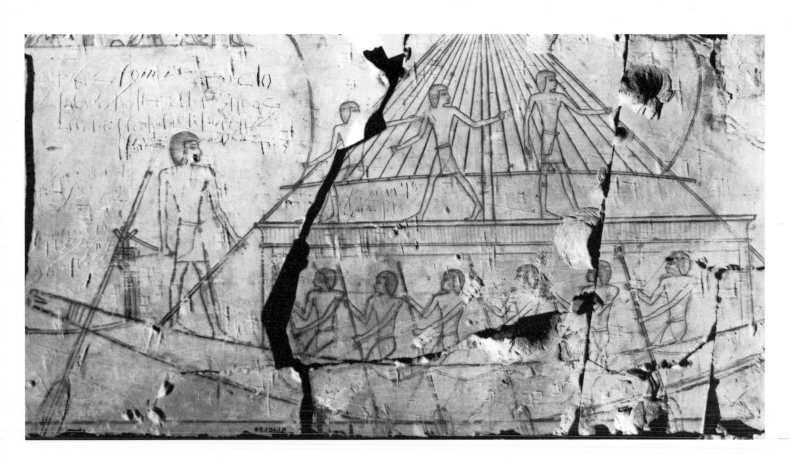

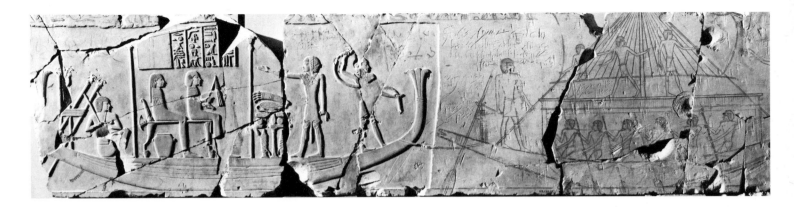

Theban necropolis was completed. As a result, examples of unfinished tomb walls may be found which reflect all the intermediate stages from the first drawing to the complete relief. In some cases, even the rough placement sketch which has been corrected by a second, more precise, hand gives us the information that the transfer of the complete design on to the wall and the rendering of the individual figures may have been done by two different artists.

Each of the two types of relief required a different working method. In the production of raised relief less-skilled workers might be entrusted with the laborious task of cutting away the background, leaving the figural areas to be detailed by a master craftsman. This technique is attested to in a wide range of material from unfinished tomb walls to incomplete relief stelae. In the production of sunken relief, it is possible that one sculptor did the whole job, since any cutting in the figural areas would ultimately influence the final result.

A relief from the tomb of Nespekashuti (reign of Psamtik I, *c.* 664–610 BC, Dynasty XXVI), and now preserved in the Brooklyn Museum (*above*), provides a good example of the raised-relief technique. Here similar subjects can be seen and studied in the two important stages of preparatory drawing and completed carving. The elements and details of the composition are carefully indicated in line and a rope which connects two boats exists in both drawing and relief. The cutting of the

This unfinished relief in the tomb of Nespeka-shuti at Deir el Bahri (reign of Psamtik I, c. 664–610 BC) depicts the 'return from Abydos', part of a pious voyage the deceased expected to make to the holy place of the god of the dead, Osiris. On the left, in carved relief, the man and his wife are shown wrapped as mummies, seated under a canopy, with priest and offering-table before them and steersman behind. The stately vessel on which they are conveyed is pulled by the oared boat on the right, still only at the drawing stage (see the detail, opposite). The whole fragment demonstrates very clearly how the shapes were cut back from a preliminary drawn outline to produce the raised relief.

background has been stopped between the two vessels, suggesting that the working method was to concentrate on one area of the composition at a time. In other examples, the preparatory reduction of the background was carried out over large sections of a wall, leaving only the figural parts for the hand of the finishing sculptor. An unfinished stela in the East Berlin collections shows the figures of two kings treated in exactly this way. They have been left in one, flat plane, with none of the modelling which would have given them form. A slightly raised intermediate plane has also been left for the carving of the sun rays.

Another example of the process of carving raised relief is found in the tomb of the vizier Ramose (Dynasty XVIII, *c.* 1554/51–1305 BC) in the Theban necropolis. On it walls every stage is preserved, from the initial line drawing in red, which was corrected in black, through the blocking out of large areas of relief with the figures left standing, but not carved in detail, to the finished carving. Both the initial drawings and the relief carvings from this tomb rank among the masterpieces of Egyptian art.

To supplement our knowledge of the processes of relief gained from unfinished tomb walls, we may turn to the practice pieces from the sculptor's studio. Just as they provided us with insights into the artist's training and development in regard to drawing, so they shed light on the relationship between drawing and sculpture. One of the best-preserved examples in this context is a small fragment of limestone of the time of Akhenaten (1365–1349/47 BC), found at Tell el Amarna. A seated princess is depicted in the act of eating on a relief which is only half complete. The surviving line drawing is simplicity itself, for only those indications that are essential as a guide to the carving of the stone have been essayed. Within these lines a rendering of the figure has been partially accomplished by a skilled sculptor. His use of the outlines alone as a guide shows that this was all that was necessary – inner modelling of the figure could be left to experience. It is fortunate that this piece was left unfinished, so

5–6

12

that a good deal of the drawing remains to demonstrate the quality of the draughtsmanship. It is to chance finds such as this that we owe much of our knowledge of the sculptor's process.

For the production of three-dimensional sculpture the procedure was necessarily quite different. The working method is again explained by unfinished pieces on which the drawing stage can be clearly seen. On the cubic block of stone three line drawings were made, one for the frontal aspect, and one on each of the two sides. The stone carver proceeded to join the three drawings by carving away everything outside the lines. Since most Egyptian sculpture has a distinctly frontal orientation, this method worked well in almost every case. A number of unfinished pieces were found in the Valley Temple of Mycerinus demonstrating the successive stages through which a statue would pass to completion. G. A. Reisner, the Egyptologist who excavated them, observed that at each major stage of completion the master sculptor would make new indications on the block in red paint as a guide to the worker who did the actual carving. This suggests that drawing not only functioned at the outset, but continued to be useful throughout the sculptural process. In other unfinished works it is not unusual to find indications in red or black paint of areas which needed to be further reduced, a practice which is still followed by sculptors who carve in stone.

It is certain that in either two- or three-dimensional sculpture the Egyptian master artist was by necessity an accomplished draughtsman. His training must have helped him visualize the end product and approximate it on a flat surface in line. There is not enough specific information about the early training of the craftsman, but it is possible that the initial instruction would have prepared him for the trade either of painter or sculptor. Since the approach to both specialities was based on an essentially linear abstraction, there would have been little difference at the outset. Only after the basic skills had been acquired would specialized instruction have been necessary. In some representations of sculpture (or the sculptor's studio) found in tomb painting, the

individual pieces are depicted exactly as they would have been drawn on the sides of the block. This might suggest that the artist who designed wall decoration was also employed in the initial layout of the sculpture, but of this we have no further evidence.

It is certainly not unusual in other periods in the history of art for practising artists to be both sculptors and painters. Since we know that sculpture in ancient Egypt was a studio art employing a number of craftsmen on the same work, it is possible that there were master craftsmen who created the designs for works of art in every medium. It must also be remembered that the notion of the artist as an individual with an occupation which separates him from other craftsmen and confers on him an exalted position in society is a relatively recent one. Egyptian artists and craftsmen worked towards the same ends, and, above all else, served the state and religious practice.

The subject-matter of Egyptian drawing

MAN

In Egyptian art the measure of all things was the image of man, so it is natural that the artist should first have had to become proficient at drawing the male figure in all its aspects. The images were created to last for eternity and are idealized, not intimate and incisive portraits. Even so, it is still possible to recognize individual differences and to associate depictions of a person done in different media. This is very well demonstrated by the several likenesses known to us of Senenmut, the architect and favourite of Queen Hatshepsut (1490–1470/68 BC). In his tomb, carved in the rock under the temple of his mistress at Deir el Bahri, Thebes, were found a number of portraits of him, both on the walls and on ostraka. Some still show the grid-squares by which the *IV, 2* proportions of the head were worked out according to the accepted canon. Despite the standardized method of drawing, Senenmut's aquiline nose, full lips and beginnings of a double chin are equally recognizable on tomb wall or ostrakon. Even a *4* practice piece for a relief carving, now in the Metropolitan Museum of Art, New York, has these same characteristic features.

The Egyptian artist was capable of observing and recording the various aspects of different races as well as those of individuals. Standard iconographies were developed, but they were based on direct experience. In the tomb of the vizier Ramose in the Theban necropolis (Dynasty XVIII), on a wall which was prepared for carving in relief but not finished, there is a justly famous drawing of foreign emissaries paying homage to the pharaoh, Akhenaten. *6* Whereas there are images of foreigners on many tomb walls, this group of eight, representing a Libyan, four Africans and three

Asiatics, stands alone as a demonstration of the ability of the artist to capture in line drawing the distinctive facial features of each type. Some of the preparatory red drawing may be seen, but so little as to attest to the sureness of the hand that designed these figures. The emissaries are grouped not according to place of origin, but in an ingenious manner to suggest variety and contrast. What could have been a rather ordinary record of foreign homage to the king becomes, instead, a remarkably dramatic composition. The accompanying scene of Egyptian

5 courtiers before Akhenaten reflects, conversely, the standard approach to the problem of delineating a number of people performing the same action.

Perhaps it was because non-Egyptian racial characteristics

8 afforded some opportunity for observation and invention that the draughtsman demonstrated more individuality in this area of his art. But the recording of foreign types was by no means the only field in which compositions were given something of the artist's own personal stamp. Below the level of royalty and nobility, men (and women too) were often depicted in an informal manner,

7 going about their daily pursuits. Whether it be a man squatting

9, 10 on the ground, boys burnishing a jar, or another man running, the artist's delight in observing humanity around him is clearly in evidence.

WOMAN

Second only to the depiction of the male form in the Egyptian artist's repertoire was the rendering of feminine grace and beauty. In three thousand years of pharaonic history the standard of female beauty changed very little. At almost all times a woman was considered attractive if she was slim, had small breasts and hips, fine features and large eyes. Female dress tended to move from, in earlier times, a simple garment, to one that was elaborately pleated. The material was usually sheer and in fact

23–5 revealed more of the female form than it concealed; at least this is the impression one gains from the tomb paintings and papyrus illustrations.

The female nude itself, however, was not one of the standard subjects of Egyptian art. Kenneth Clark's comments upon the Classical Greek nude, in his great study, *The Nude* (London 1956), are equally applicable to ancient Egypt: 'So rare are nude figures of women in the great period of Greek art that to follow the evolution of Aphrodite before Praxiteles we must not look for absolute nudity, but must include those carvings in which the body is covered by a light, clinging garment . . .' In Egyptian art, apart from pictures of children, dancing girls and handmaidens, there are no nudes of women such as are understood in Western art. Nut, the goddess of the sky, is the only exception, represented usually as a naked and graceful woman as she appears in a papyrus vignette from the Book of the Dead of Dynasty XXI, now in the *55* British Museum. Instead, artists became skilful at suggesting flesh under drapery. From the Amarna princess depicted on an unfinished relief of the time of Akhenaten (1365–1349/47 BC) to *12* the female figure (in fact Isis) drawn on a linen shroud of the *16* Ptolemaic or Roman period (after 332 BC), the Egyptian draughtsman was able to give a vivid impression of the female body, even if clothed.

Although many more sketches of men exist than of women, enough have been preserved of the latter to show women in a variety of roles, in life and death. Drawings on ostraka of the Ramesside period from Thebes, for instance, depict female nurses, *13, 14* mistresses and servants. The well-known 'erotic papyrus' of Dynasty XX, now in Turin, has explicit scenes of courtesans in a *21* brothel. While the papyrus from Deir el Bahri of Here-ubekhet, a priestess of Dynasty XXI, shows the deceased entering the Fields of *V, 17–20, 22* the Blessed. The range of subject-matter and styles mirrors the variety in Egyptian drawing as a whole.

THE ROYAL IMAGE

One of the most prevalent themes in all Egyptian art is the depiction of the king in his many roles and engaged in a variety of activities. The king offering to the gods, in the company of the *93, 39, 40* gods, presiding over ceremonies, engaged in warfare or at the *43–4, 28–9, 86*

hunt were all suitable subjects for the decoration of the temple and, in some periods, of the tomb. It was naturally necessary for the vast number of artists engaged in the production of these formal representations of the monarch to create a corpus of preparatory studies and stock drawings which would serve as the basis for finished works. This is what the majority of the drawings which have come down to us in fact were.

Throughout Egyptian history the king was considered to be a god, so he had to be shown as devoid of human imperfection. Our understanding of period style in the history of Egyptian art has developed to the point where we can recognize that this god-like perfection was handled differently at different times. The Old Kingdom royal portrait was an image of a god-king divorced from the day-to-day activities of man. The ruler in the Middle Kingdom, particularly in Dynasty XII, exhibits the strains of worldly care in his physical features. Even though we are very much aware of the particular likenesses of a number of individual kings, at all times the intention was the same, to create a super-human representation based in reality. We know what Zoser, Mycerinus, Tuthmosis III or Akhenaten looked like, and we can probably assume that the treatment of the face and figure of any of these began with a portrait and advanced to an idealized image.

32, 26–7, 30

GOD AND SKY

From the standpoint of drawing the representation of the gods offers an almost unlimited range of subject-matter, for under this general designation must be included a wide variety of different motifs. The depictions of the principal gods, Osiris, Isis, Horus, Hathor, Re, Atum, Ptah etc., and many of the minor deities as well, were by and large worked out relatively early. Generally speaking the gods were imagined in an anthropomorphic form, so the drawing of them would have been based on human types. But some deities were thought to have human figures with animal or bird heads (Thoth, Sekhmet, Bast, Re-Harakhty), and this demanded an ingenious combination of human and animal parts. The range of animals sacred to the gods was great, so the

57, 50

47, 53, 39, 40, 17

20, 56

artist dealing with religious subject-matter had to be a master in the depiction of falcons, ibises, cows, crocodiles and so on. In the age of Akhenaten, when the sun deity, Aton, was worshipped, the standard representation used was simply a sun disk which simplified matters for the draughtsman. In the mythological papyri and the elaborate royal tomb decorations of the New Kingdom a whole host of lesser deities were illustrated, which caused problems for the artist in that some of the types were not so familiar as others whose forms had become the subject of routine production.

53, 62

That the forms for important gods were standardized there is no doubt. Once the correct formula was worked out there was little need to change it except for the adding of special iconographic elements for unusual situations.

The sky or the heavens were imagined as supported by four pillars at the corners, or by Shu, the air god, supporting Nut, the personification of the sky. The vault of the heavens was also imagined as the belly of a celestial cow studded with stars. The night sky was the course through which the boat of the sun made its way and was closely associated with the activities of the gods. The stars were of great importance for the measuring of time and it is this aspect of them which seems to be illustrated in a number of celestial ceilings that have been preserved, for instance, the one in the tomb of Senenmut at Deir el Bahri. This is the earliest such ceiling known in Egypt. The constellations have been difficult to identify in modern terms but we can be certain of the ancient representations of Orion and the Big Dipper. Others cannot be related so clearly to their modern equivalents.

55

58–9

60–2

Of the daily life of the ancient Egyptian we have a rather limited number of subjects in drawing. For a full view one must turn to the reliefs and paintings which grace tomb walls, for in the drawings the activities that are recorded tend to be somewhat specialized. Among these must be mentioned scenes of music-making, dancing, hunting and combat. Perhaps the reason for a

particular emphasis on these subjects in the preserved drawings is that they were more difficult to realize, and as a consequence, needed more study. What seems consistent in the preparatory drawings and sketches is the need on the part of the artist to render important subjects, such as the king or the deceased, accurately according to the canon. The unusual poses of combat or the dance and the particular gestures of musicians would have required an equal amount of practice, so, as a result, more trial pieces exist of these subjects than of other aspects of daily life.

MUSIC AND DANCE

63–4, 66–7, VII, XV
65, 70–3

Throughout Egyptian history music was an important part of religious ritual and the general culture. From the Old Kingdom onwards there are many representations of groups of singers and musicians in the tombs. Singers clap their hands to mark the tempo, accompanied by a wide variety of instrumentalists. The harp, lyre and lute are the principal stringed instruments, the pipe, oboe and trumpet the main wind instruments, while the drum, tambourine, sistrum, and castanets make up the percussion. In the Old Kingdom tomb of Ptah-hotep the modern arrangement of the orchestra is foreshadowed in that the musicians represented play a harp, a pipe and clap hands, suggesting the basic division into strings, wind and percussion. When the artist was called on to depict any of these activities, he must have had to look carefully at the manner in which instruments were held and the attitudes of the performers. To catch the contorted forms of a harpist's fingers would have required much observation and practice. In tomb paintings the characteristic inclination of the players' heads as they strive to stay in tune suggests first-hand experience on the part of the artists. The impression conveyed is often so vivid that it seems a sad loss never to be able to hear the sounds of these ancient orchestras.

64

Music and dance were essentially inseparable. Wherever dancers are shown they are usually accompanied by musicians, who occasionally join in a dance step in a somewhat hesitant way. Dance was a part of religious ceremony and was depicted in

69, 71

tombs to honour particular deities. The ceremony of the transportation of a statue could be accompanied by a group of dancers. By far the most attractive type portrayed was a kind of acrobatic dance, attested to in a number of paintings and reliefs as well as in sketches. It may seem strange to the modern mind to associate the contortions of the acrobat with religious ritual, but from the evidence available the two were closely linked. Tumbling dancers appear even in scenes of funerary ritual, where they may have acted as a kind of relief activity but were more probably used to create a mood of physical intensity. It has been suggested by N. de Garis Davies, who wrote extensively about Egyptian drawing and painting, that their function was to help the onlookers 'reach a physical rhapsody, a throbbing emotion, which, as it is with difficulty excited in the crowd by the event or ceremonial alone, must be induced by the sight of rapid and violent physical action and the sound of strong, monotonous rhythm. . . .'★ In any case, the skill of the artist was taxed to the limit in capturing dancers bent backward, graceful and moving, evocative of the rhythm of the ceremony they accompanied.

VI, 67–8

FABLE AND HUMOUR

The inclination of the artist towards humour or satire must be as old as art itself, for at all times in the history of the graphic arts the humorous drawing has made some kind of an appearance. The Egyptian draughtsman was no exception to the rule. Like his Sumerian counterparts, his chief mode of satirical expression was in the use of animals as characters in what would normally be human occupations. One can imagine that the traditional Egyptian artist, trained to serve the king and court, would find much to satirize. His patrons probably did not always display the perfection of character that he was forced to bestow on them in formal representations and, as a consequence, he could use their shortcomings as the basis for humour. There are many such

★ 'The Egyptian Expedition, 1925–1927', *Bulletin of the Metropolitan Museum of Art*, New York 1928, section II, p. 62.

comic or satirical drawings preserved. It is a topsy-turvy world, *78* in which kings wait on queens, cats serve mice, and the fox is the trusted guardian of the geese. What better outlet for the frustrations of service could there be than poking fun at the mighty? These innocent pleasures could be extended to a point *83–5* where they became obscene, or at least erotic, but the underlying theme was the same, the rendering of tableaux which cast the familiar in a strange situation or vice-versa. In a world where the chariot was a luxury restricted to the mighty, the mouse is made a *80* charioteer; elsewhere a donkey is given a boat in which to ride, *75* and the lion plays Sennet (draughts) with an animal – the antelope – which would otherwise be his prey. These proto-cartoonists were among the most skilled of their trade.

But not all the drawings need have been humorous or satirical in intent. Many, particularly those in which animals act the roles of human beings, may actually have been illustrations for folk-*XIII, 71, 73–8, 90* tales or fables, now lost. There seem to be recurring types which may have appeared in cycles or groups of stories centred around stock characters. If such tales did in fact exist, it is a pity that not one has been preserved.

HUNTING AND COMBAT

Scenes depicting combat or warfare in Egypt are as old as the conventionalized representations on Early Dynastic palettes and mace heads, and they range from finished reliefs of the king *28, 93, 87–9* smiting the enemy to hasty sketches of paired-off wrestlers. Drawings of this type of subject might be formal studies intended to have been transferred on to wall surfaces or they might be quasi-satirical sketches done for the artist's own amusement. The drawing on an ostrakon from the Valley of the Kings showing a *90* queen in her chariot riding into battle beneath a hail of arrows is possibly one such piece of parody, although it could equally well illustrate a parable or legend now lost to us.

VIII, IX, 99 Hunting of, or combat between, animals is another theme with a long history in Egypt. The 'hunt in the desert' scene is commonly depicted on the walls of private tombs, in which the

deceased is shown accompanied by his hunting dogs, enjoying the pleasures of the chase. Many ostraka from Deir el Medina have been found with studies of such dogs pursuing antelope or hyaenas. Draughtsmen clearly had to work hard at capturing the dynamism of the animals and mastering the sense of movement. The relative freedom of design that was permitted in these scenes demanded a commensurately greater amount of skill and practice. It is therefore not surprising that more trial pieces exist of these 'difficult' subjects than of the more mundane aspects of daily life. Drawings of the latter often survive only where they appear as part of an unfinished wall decoration.

96–8

ANIMAL LIFE

Of all the categories of drawing that have come down to us those which depict the animal life of ancient Egypt offer the greatest variety and show the most incisive observation. In this century the specialized artist who styles himself 'animal painter' has all but disappeared. In the nineteenth century it was still possible for a painter such as Toulouse-Lautrec to experience a close association with animals important to the economy of his time; his drawings of horses, for instance, are among the most evocative ever done. Similarly the day-to-day familiarity of the Hudson Bay Eskimos with the animals on which they depend is evident in their telling stone carvings of seals, walruses and other Arctic creatures. For modern man, however, removed from a close association with animals, the depictions of birds and beasts created by the ancient Egyptian artist are even more impressive. Every variety of wild and domesticated animal is represented, many of them preparatory studies for the decoration of tomb walls, others simply the result of a momentary fancy on the part of the individual draughtsman. In the tombs of the New Kingdom it is not uncommon for the deceased or his wife to have the favourite family pet depicted under his or her chair; but the hunting of wild animals, fish or birds and the tending of domestic animals on the estate are carefully rendered too. It was important that the artist should have a facility for capturing the distinctive qualities of each

VIII–XIV, 94–124

species. The practice drawings indicate that this was probably one of the most enjoyable of his duties, that he excelled at it and that he often departed from the accepted formulas in order to achieve his aims.

ARCHITECTURE

Among the illustrations of daily life necessary for the tomb, there are a number which show craft practices and methods of construction. It is strange that this area of activity is one of the least well represented among trial drawings, for the production of these mural decorations must have necessitated some preliminary study. What have been preserved are a number of maps and architectural plans on papyri and ostraka. The plans were used by master-builders or architects to provide their overseers and workmen with construction directions. We have examples of tomb plans, layouts of parts of temple complexes and renderings of architectural detail. It is with a certain sense of immediacy that we can inspect the drawings of tombs from the Ramesside period or the sketch for the position of the trees in a sacred grove before a temple. Sometimes it was necessary for the designer to draw up a complete elevation for the guidance of the craftsmen who did the physical work in the construction of a shrine. By necessity, such drawings are not of the same artistic quality as those we have looked at previously, but they give us many useful insights into architectural methods. In certain instances the drawings are explained and amplified by written notation concerning the actual measurements of the parts of the structure. Axial lines indicate that the designer was concerned with a symmetrical arrangement of parts, while the use of a grid suggests that the layout of a ground plan was developed from a standard of intersecting rightangles.

One of the most important plans for an architectural project still preserved is on a papyrus in Turin representing a stage in the development of the tomb of Ramesses IV. Discovered by Lepsius and identified by him for what it is, this plan was long considered to be inaccurate in detail, but the joint work of Sir Alan Gardiner

129–30
125, 131

128

126–7

129

and Howard Carter on correlating the measurements of the plan with those of the tomb suggests that the discrepancies are due to the further evolution of the design after the Turin plan was made. The arrangement of a second Ramesside tomb is preserved on a large limestone fragment. Over 80 cm (32 in.) in length, it can be identified as a working drawing for the tomb of Ramesses IX. *130* Although not as detailed as the Turin papyrus, the inference to be drawn from it is plain – such a complicated building or rock-cutting project was not made without visual guides for the workmen who carried out the directions of the master-builder.

It can be seen, then, that the themes of drawing, as they have been preserved for us, reflect many of the major concerns of the Egyptian artist: man, woman, the gods and nature, particularly those aspects of nature which most affect the life of man. Within the limitations imposed on our study by the chance preservation of ostraka, papyri or unfinished tomb decorations, we can see the draughtsman at work and share in the moment of creation. Ultimately the drawings speak for themselves. They reveal a human aspect to Egyptian art which deserves our attention.

Notes on the colour plates

I Fragmentary head of a king
Ramesside period, c. 1305–1080 BC

So damaged that it contains only enough of the head to make the identification certain, this trial sketch on a limestone ostrakon from the Valley of the Kings is nevertheless a fine example of the art of drawing in ancient Egypt. What remains of the eye, nose and lips attests to the high quality of the work. The artist seems to have had trouble with the design of the cobra's tail above the brow, for a major change in its position can be clearly seen. The second serpent, above where the ear would have been, may be either part of a more elaborate headdress or simply an additional sketch in which the artist tried to correct the original drawing.

II Head of a king
Ramesside period, c. 1305–1080 BC

This drawing on an ostrakon from Deir el Medina is one of the most magnificent royal studies to have come down to us. The head is presented formally in the profile manner, with boldly drawn eye shown frontally according to the accepted canon. The original tentative lines in red have been gone over in black. It would have been necessary for artists to produce hundreds of such studies in preparation for the many representations of the king on public monuments.

III Hieroglyph of a frontal face
Ramesside period, c. 1305–1080 BC

Heads were not always drawn in profile in Egyptian art. This hieroglyphic sign on an ostrakon is the ideogram for the word 'face' and has another use as the phonogram *Hr*. It appears constantly in texts, and because of its unusual frontal viewpoint required constant practice on the part of the scribes. The difficulty this artist had with the full-face technique can be seen in the hesitant lines of nose and mouth.

IV Squared-off portrait of Senenmut
Dynasty XVIII, time of Hatshepsut, c. 1490–1470/68 BC

Senenmut was the architect and favourite of Queen Hatshepsut. This portrait on an ostrakon was found in his tomb at Deir el Bahri, and shows him with characteristic wig, aquiline nose and slight double chin. The drawing has been squared off in red paint into sixteen equal parts, a standard device to ensure the correct proportions of the head (though they are not quite correct here) and to help the artist transfer the drawing to another surface (such as a wall, *plate 2*). A comparison with other portraits of Senenmut (*plates 2–4*) is instructive.

V Here-ubekhet presents offerings to Ptah-Sokar
Dynasty XXI, c. 1000 BC or later

This is a detail from the papyrus shown more fully in *plates 17–20*. The priestess Here-ubekhet, beginning her long journey through the underworld and wearing a white gown, wig and cone of perfumed grease, makes offerings to the funerary god (Ptah-Sokar, shown in *plate 17*). On four offering-stands garlanded with petals are heaped joints of meat, squash, breads, lotus blossoms and grape leaves. The leopard skin hanging from a pole on the left is a fetish of Anubis, god of the necropolis.

VI Acrobatic dancer
Ramesside period, c. 1305–1080 BC

Justly famous and often illustrated, this sketch on a limestone ostrakon is one of the great masterpieces of

Egyptian drawing. It shows a girl, naked except for a short kilt and earrings, performing one of the acrobatic somersaults of a ritual dance (cf. *plates 67–8*). The artist seems to have drawn the body first and then the head, rotating the stone to a position where the profile could be done in the normal way – this is suggested by the placing of the earring in defiance of the laws of gravity, and a slight awkwardness at the junction of neck and shoulders. The arms too have been extended a little out of proportion to the rest of the body. But the composition is so harmonious, the sweep of the hair and curve of the body so graceful, that such minor inconsistencies seem not to matter.

VII Woman with a lute

Ramesside period, *c.* 1305–1080 BC

On an ostrakon from Deir el Medina a female musician, naked except for a broad collar, is depicted holding a stringed instrument which we may call, for want of a better name, a lute. She was originally looking to the left, but the stone surface has been broken so that only her neck and the bottom of her chin are preserved. Her left hand is held to her ear as if she listens to other players, an attitude often shown in tomb painting of the New Kingdom. The simple line which describes her arms, breasts and the instrument is beautifully drawn. The breasts are shown frontally, a viewpoint as unusual as the frontal face and generally reserved for women such as nursemaids and musical performers.

VIII A lynx bites the leg of a lion

Ramesside period, *c.* 1305–1080 BC

The king of beasts is attacked in a most disrespectful way by a lynx. In effect, the tables have been turned and the weaker animal is injuring the stronger. This would seem to be a simple kind of irony until one reads the inscription. The hieroglyphic characters are an abbreviation for the phrase 'the king of Upper and Lower Egypt' and identify the subject more precisely. The lion, as an animal associated with kingship, is attacked by one of the lower orders of animal; the king can be injured, if only in a satirical drawing, by the least of his subjects.

IX Two bulls fighting

Ramesside period, *c.* 1305–1080 BC

This colourful and spirited drawing on an ostrakon from Deir el Medina of a bull who gores and overthrows his adversary has few equals in the history of Egyptian art. The bull as a subject was well known and used from earliest times, but there are few compositions which compare with this one, though a combat between two bulls is illustrated in the tomb of Amenemhet (no. 82) at Thebes, *c.* 1480 BC. The bull is often depicted in Old Kingdom tomb painting, and in the Ramesside period one of the most arresting tableaux which has come down to us is the scene of Ramesses III hunting bulls on the first pylon at Medinet Habu. The phrase 'the mighty bull' was a standard part of the rulers titulary suggesting his strength, so it is not unexpected that an Egyptian artist should be able to portray an incident such as this, familiar as he was with the character and appearance of these powerful animals. In this composition the artist has included details of the colouring of the animals' hides, the hair of their tails and even the dropping of excrement in the heat of combat.

X Hieroglyph of an owl

Ramesside period, *c.* 1305–1080 BC

This coloured drawing of the frontal face of an owl is a preparatory study for part of an inscription which would have been executed in full colour, probably in an important tomb. Normally in Egyptian art the human or animal face is shown in profile, but one major exception to this rule is the owl, the hieroglyphic sign for the phonetic *M*, which is shown frontally simply because this is the most characteristic view of the owl's head. Here the eyes are intense and the gaze direct; it was apparently the face that interested the artist most, for the other parts have not been brought to such a finished state. The species of owl represented is not clear; perhaps it is a generalized bird based on several types.

XI Birds caught in a net

Dynasty V, *c.* 2450–2290 BC

On a wall in the Old Kingdom tomb of Neferherptah a flock of pigeons is shown caught in a clap-net. This is a preparatory drawing which would have formed the basis

of a wall-painting or relief carving. Such scenes have rarely been preserved in the unfinished state, and this one helps demonstrate the care and craftsmanship that were a normal part of the preparation of the wall surface. It is in fact one of the masterpieces of draughtsmanship to have come down to modern times. Cf. *plate 120.*

XII Spotted dog of the Pointer type
Ramesside period, *c.* 1305–1080 BC

Unlike many Egyptian drawings of animals which are quick sketches, this superb study of a dog approaches the finished state. Great care has been taken to describe the particular qualities of the breed. The well-shaped head, thick neck, heavy shoulders and finely delineated legs all seem to be the product of direct observation. Normally a greyhound type (Saluki) is represented because most scenes in which dogs appear are hunting scenes. But domestic pets are shown in scenes from the Old Kingdom, particularly the Middle Kingdom (Beni Hasan) and the New Kingdom (tomb of Rekhmire).

XIII A cat herds geese
Ramesside period, *c.* 1305–1080 BC

This drawing on an ostrakon from Deir el Medina is one of many humorous scenes depicted in Egyptian drawing, in which the roles of the natural world are reversed. Some may be satirical in intent, others, perhaps like this sketch, illustrations to fables or folk-tales now lost. Folk songs still exist in Egypt today in which the cat plays a dominant role. Here we see a cat acting as protector and guide to a flock of geese, his prey in the normal world. Above the geese is a simply drawn nest with four eggs. The cat, like any human herdsman, carries a small bag suspended from a stick over his back. He seems to be a stock type, because several other similar portrayals are known (e.g. *plates 76, 78*).

XIV Faience bowl with lotus buds and fish
Dynasty XVIII, *c.* 1554/51–1305 BC

The decoration of faience bowls in the New Kingdom ranges from simple designs and single figures (cf. *XV* and *plate 47*) to elaborate compositions such as this. Around a central pool of water have been arranged fish and lotuses both in flower and in bud. The organization of the parts is not entirely symmetrical for the two opposing fish do not balance each other. This has been accounted for by the adjustment of the size of one of the lotus buds. The informal arrangement gives the piece a distinct charm of its own.

XV Faience bowl with a female lute player
Dynasty XIX, *c.* 1305–1196 BC

The interior of this bowl is decorated with a nearly naked young woman, seated on a soft cushion, a perfume cone on her head, playing on a long-necked lute. The instrument is further embellished by an animal-head terminal, probably that of a duck. Above are stylized grape vines supported at each end by lotus columns. Over each of her two arms is draped a lotus as well, one open and one in bud. Her naked body is set off by a thin girdle, a necklace and yet another flower in her hair. A figure of the household god Bes is tattooed on her right thigh. Behind her a pet monkey seems to call for her attention. The subject of the seductive musician indicates that this bowl was meant for use at a banquet or similar entertainment.

XVI Detail of a study for a ceiling decoration
Ramesside period, *c.* 1305–1080 BC

This drawing on an ostrakon was probably a study for a ceiling decoration in a tomb at Thebes. The colourful repeated pattern of crosses in a grid may well be derived from floral forms. The ceilings of the tombs in the Theban necropolis are often covered with imaginative designs. Some consist of repeated bird patterns, others frontal heads of bulls. The tomb of Sennufer has vines with bunches of grapes which give the effect of an arbour. But by far the most common type of decoration is a geometric design such as this.

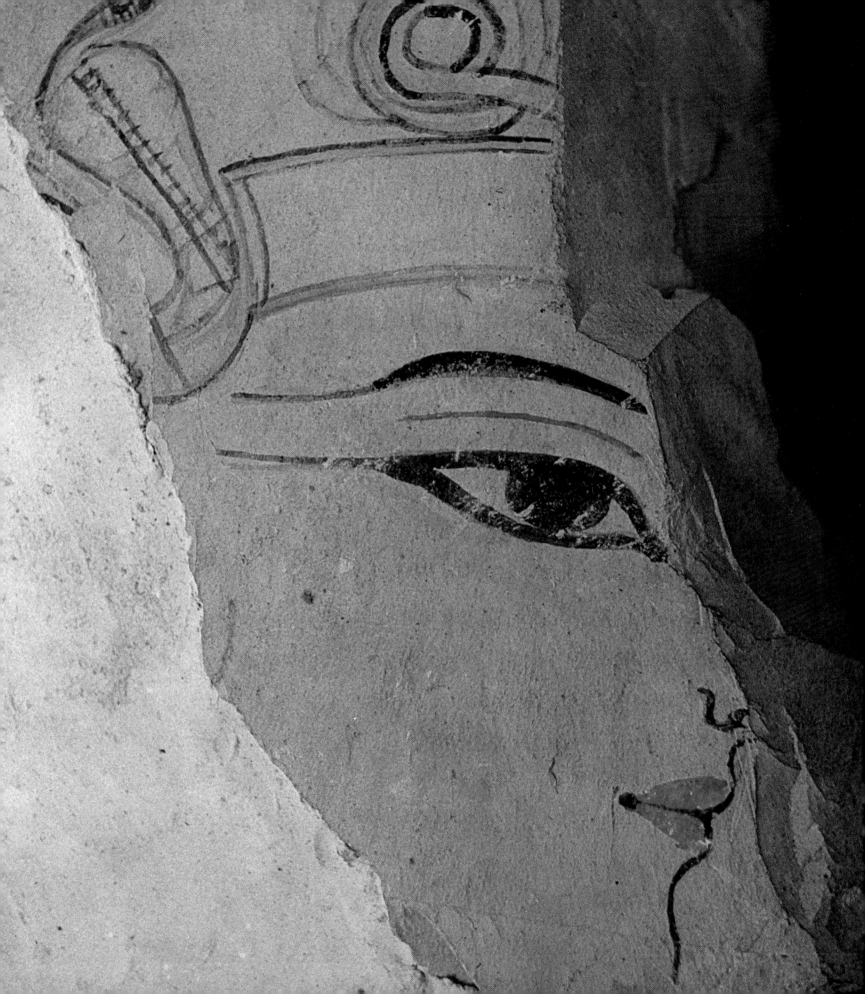

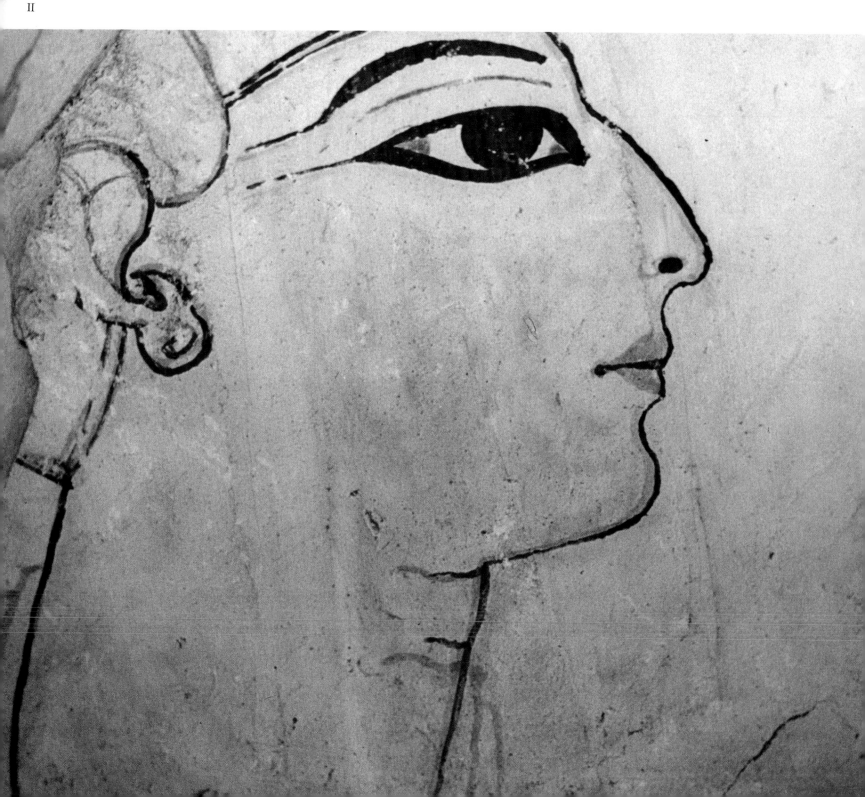

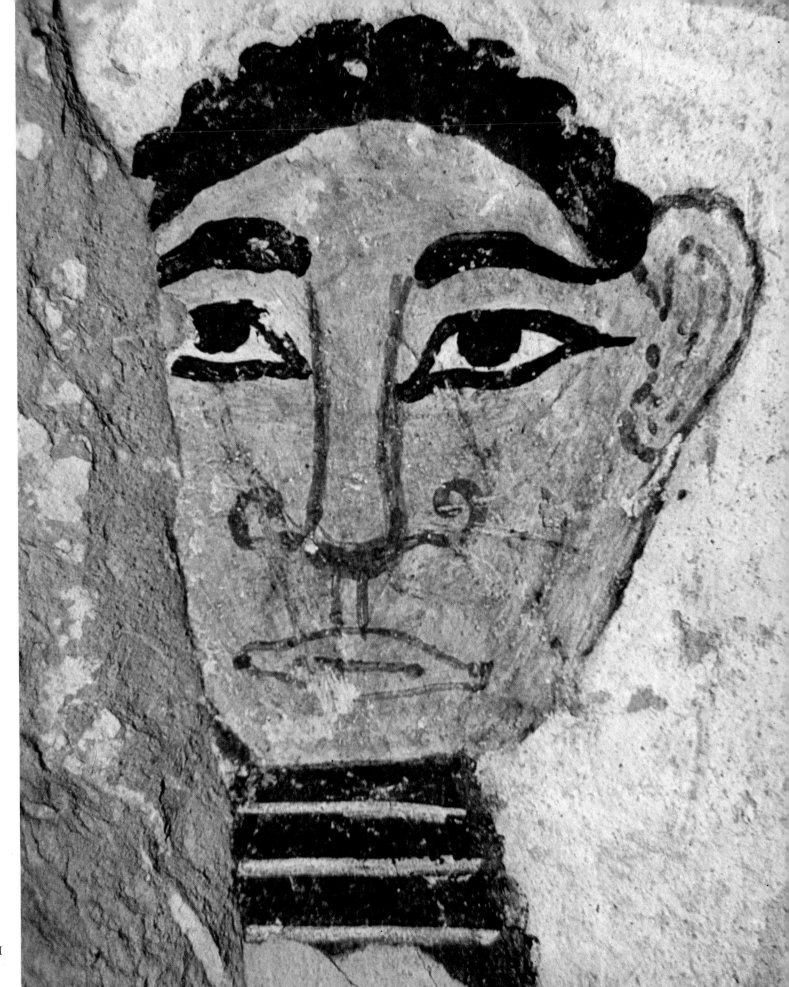

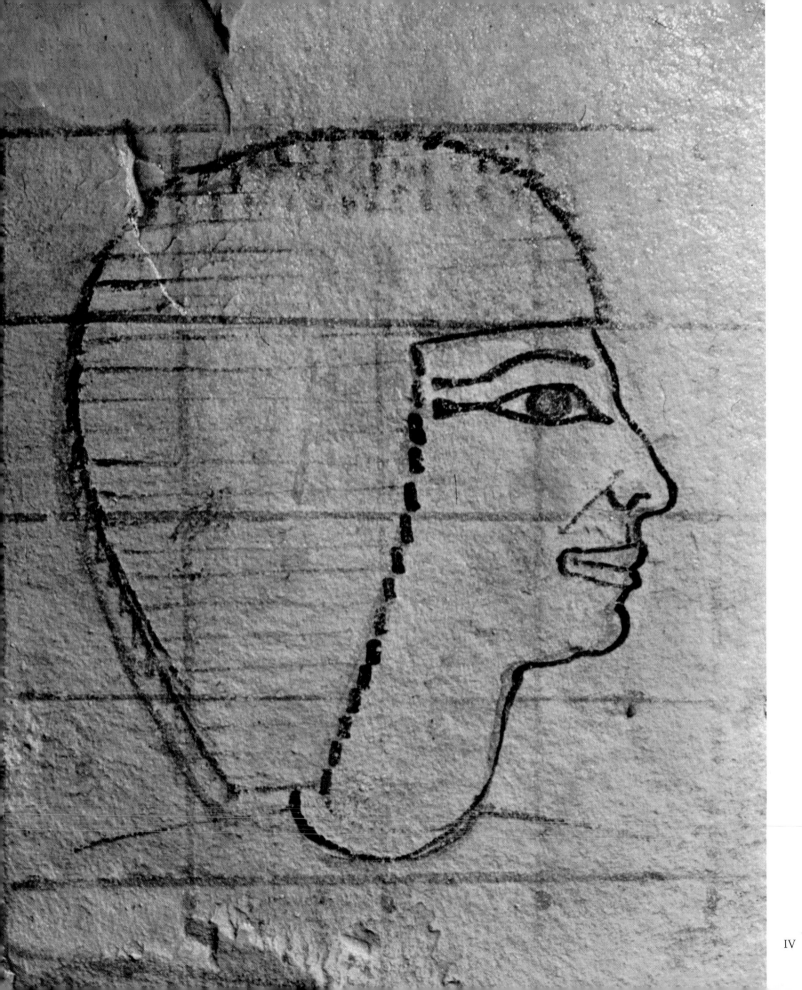

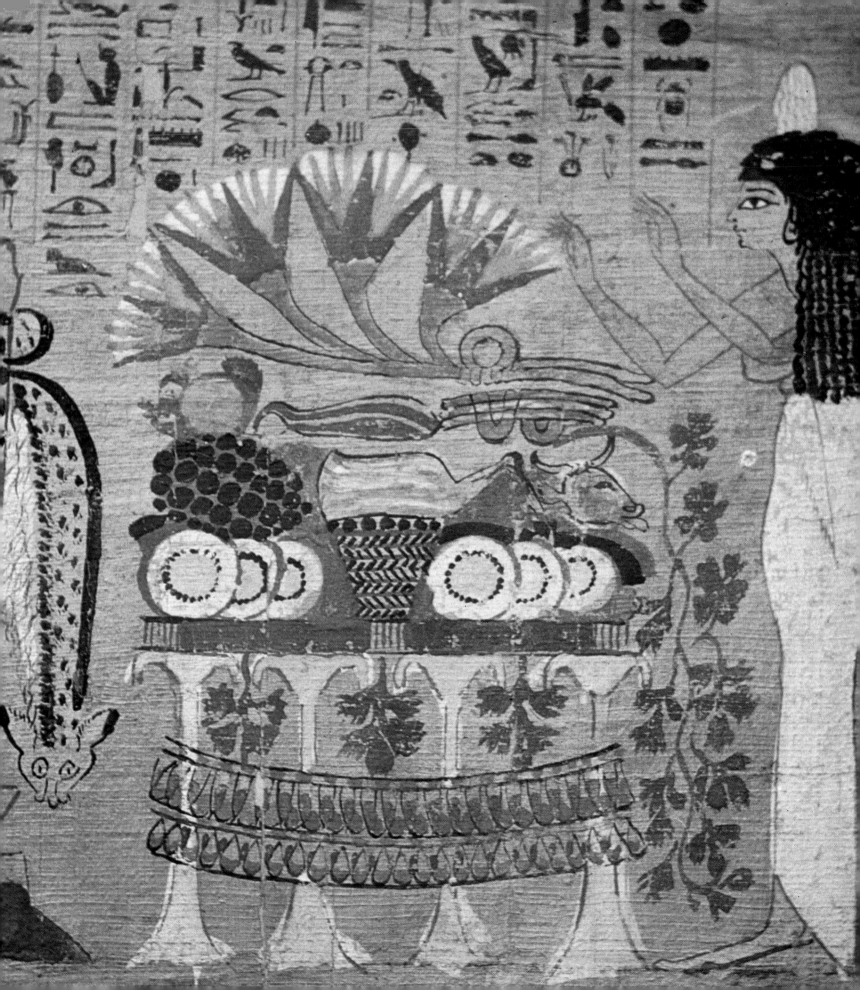

VII

VI

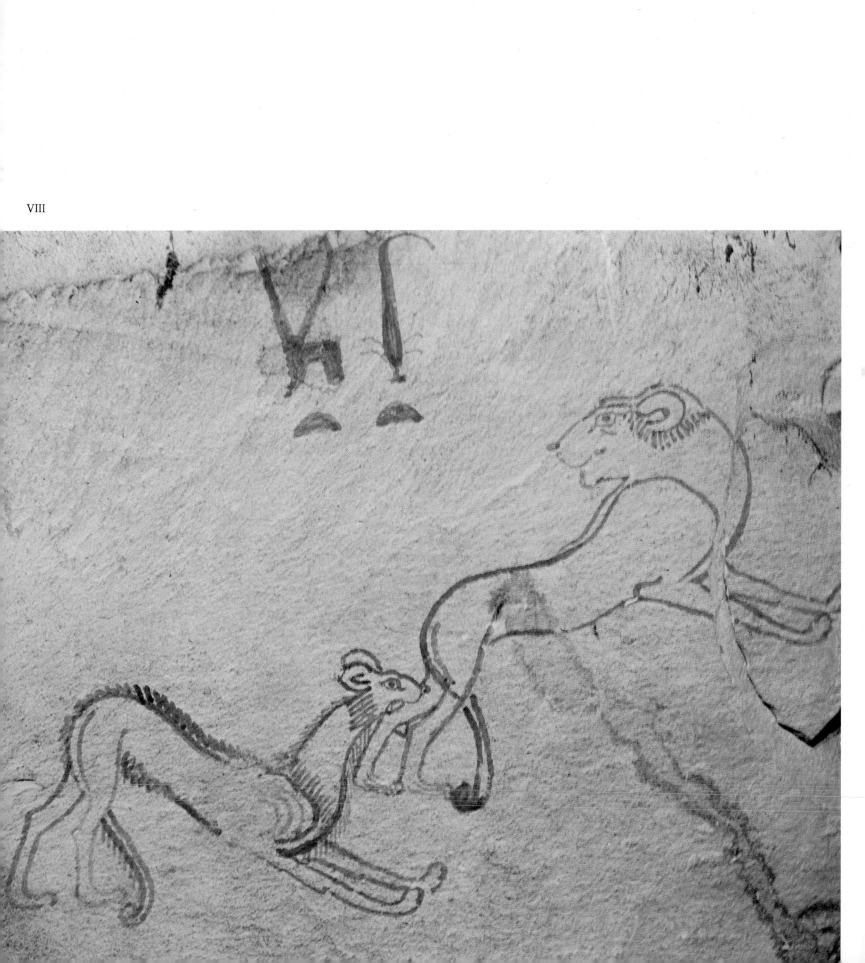

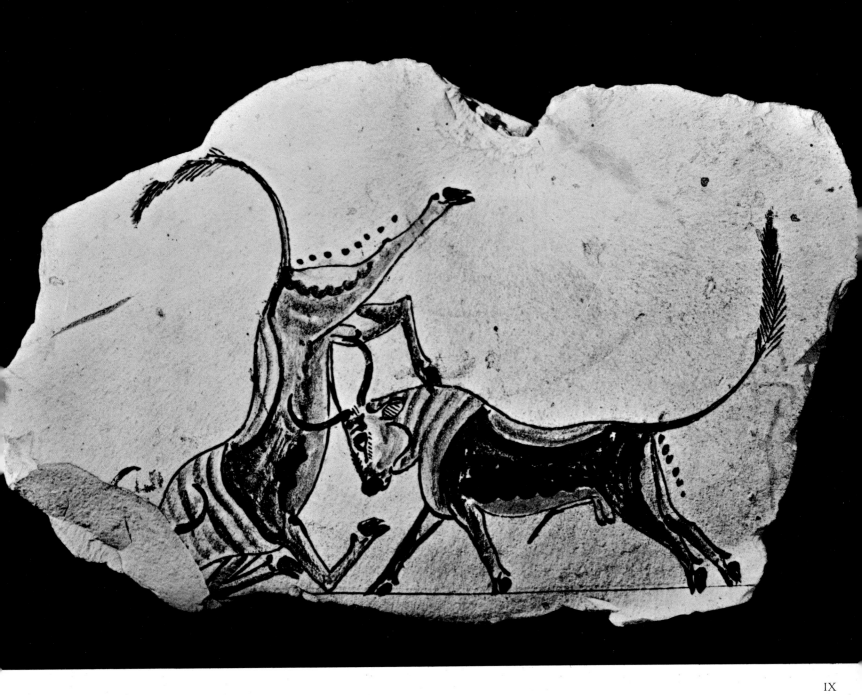

IX

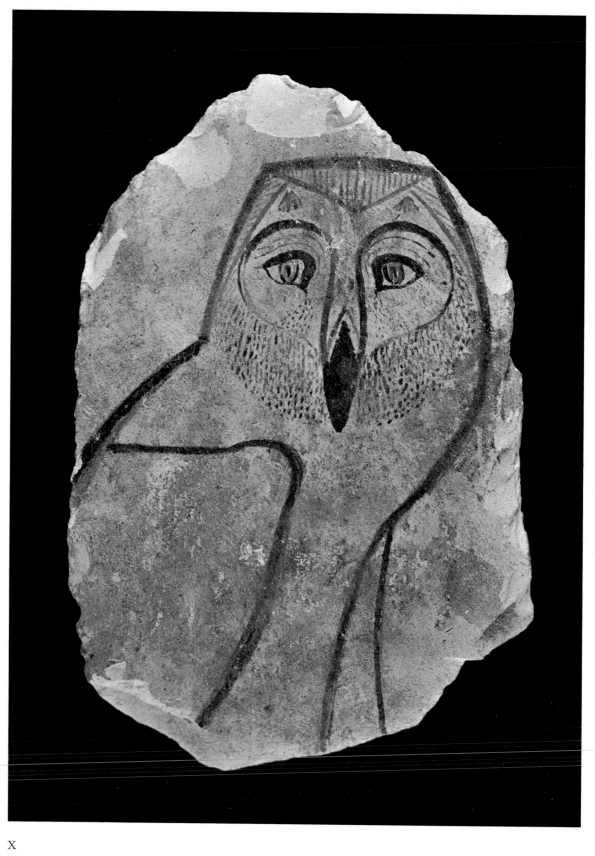

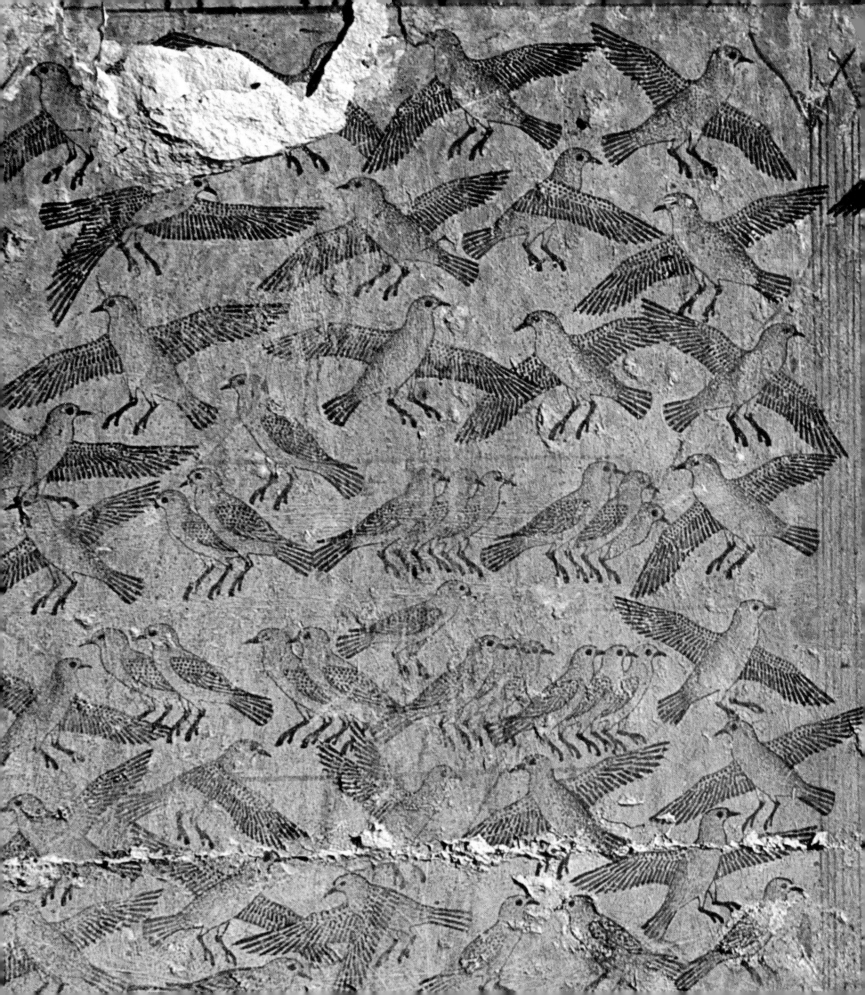

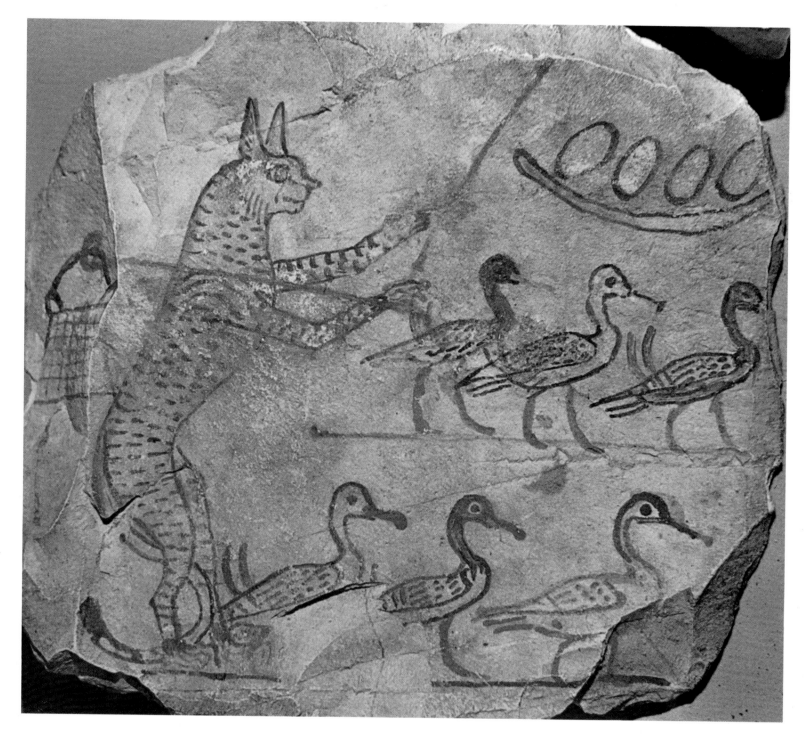

XIV

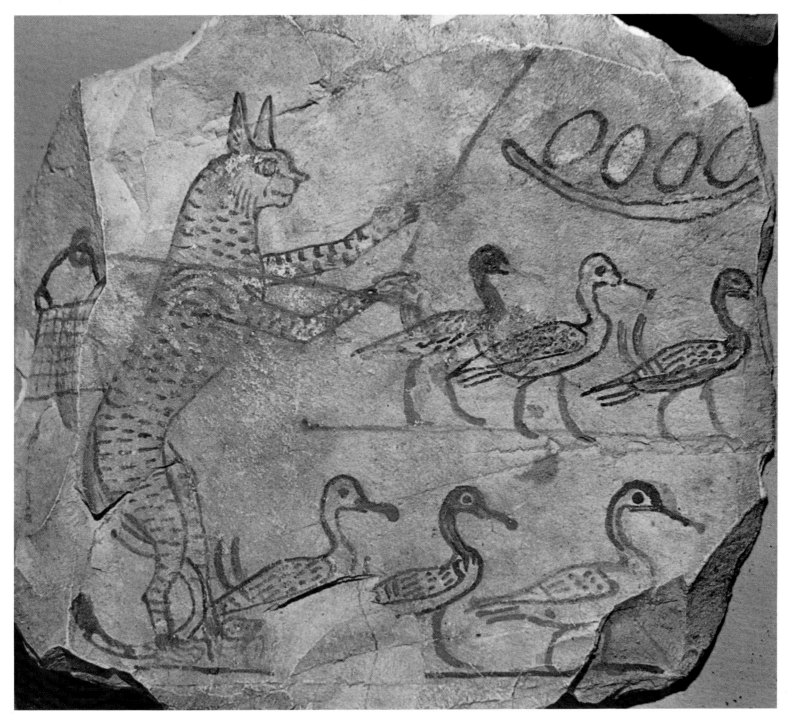

XIII

XIV

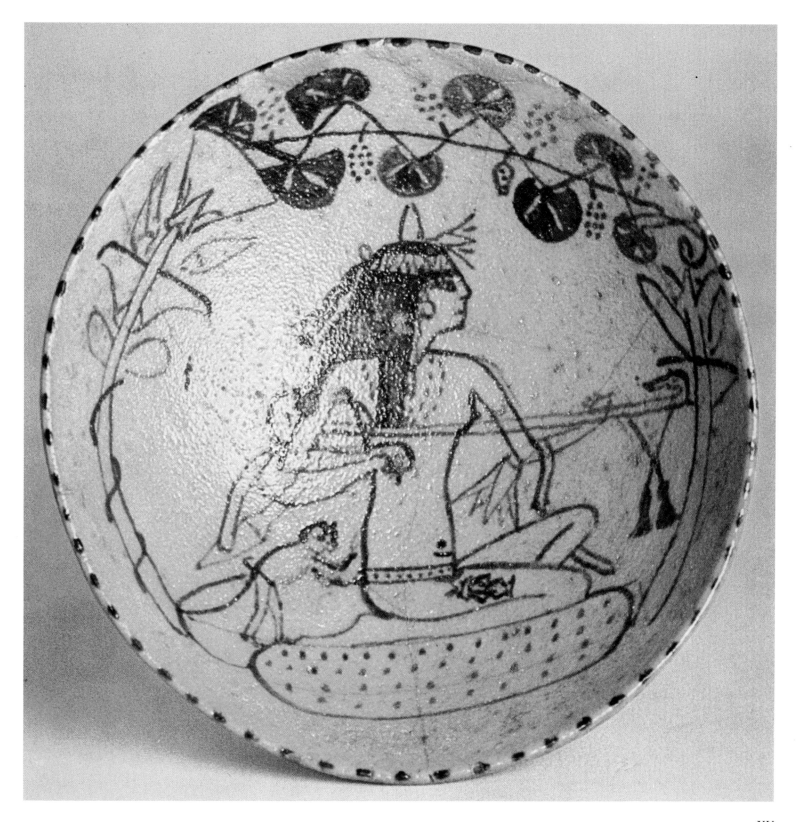

The monochrome plates

Man

1 Head of a man in profile

Ramesside period, c. 1305–1080 BC

One of the most unusual renderings of the male head to have come down to us is this simple line drawing. Taken outside the context of Egyptian art it would be difficult to place in history. The inclination might be to think of it as a head of the Classical period. There is much about it that suggests the work of a relaxed artist who enjoyed the feel of the pen or brush as it moved across the smooth surface of the stone. The profile has been reduced to a bare outline in a manner reminiscent of certain styles of South Italian vase painting or even some modern draughtsmen; Picasso might have sketched a 'Classic' face in this way. Only the sure hand of a master could have summoned up an image of man with so little detail.

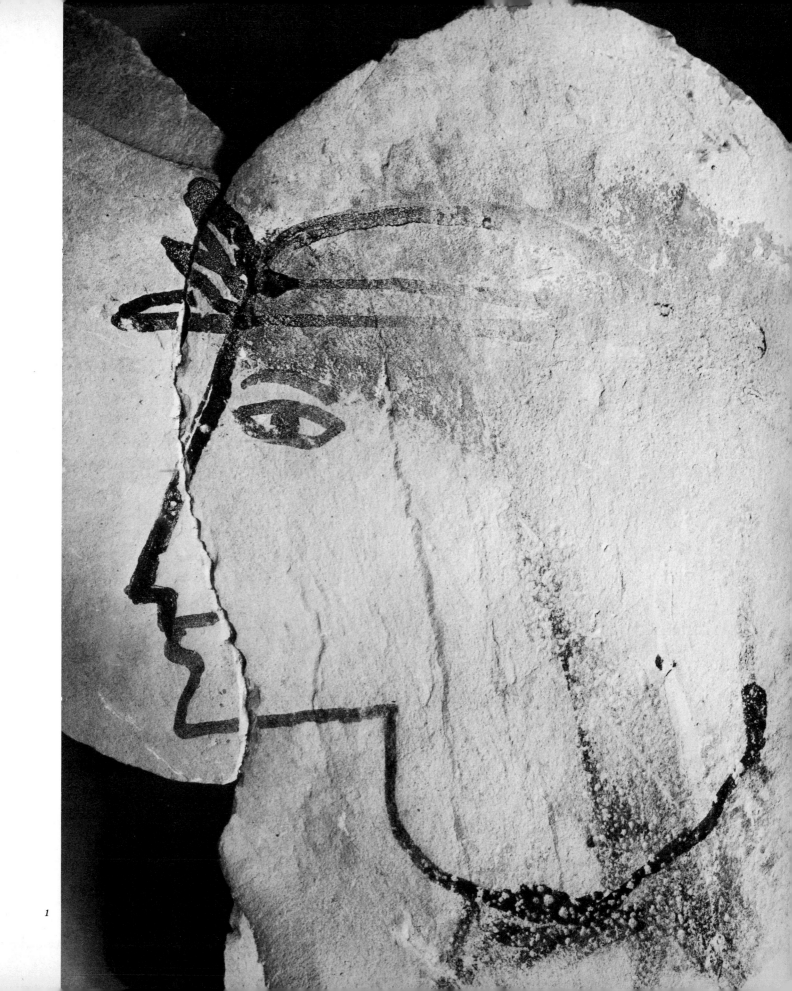

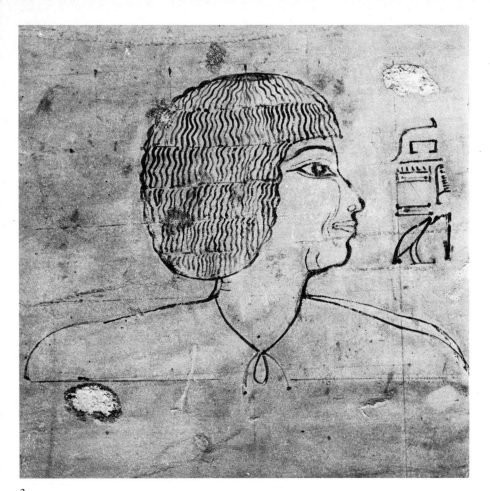

2

2 'The Steward of the House of Amun, Senenmut'

Dynasty XVIII, time of Hatshepsut,
c. 1490–1470/68 BC

Senenmut, architect and favourite of Queen Hatshepsut, is shown sketched on a corridor wall of his tomb at Deir el Bahri. The grid-squares used to achieve the correct proportions of the head can be clearly seen, and were perhaps transferred together with the rest of the drawing directly from a squared-up preparatory study on an ostrakon similar to *colour plate IV*. But the inclusion of complete shoulders is unique to this portrait. The accompanying short text identifies Senenmut with one of his titles, 'Steward of the House of Amun'.

The draughtsmanship is confident. Only in the area of the lower chin and neck does the artist seem to have faltered slightly and corrected his work. The faint lines of the cheek, folds of the neck and double chin – characteristic of the subject (cf. *plate 4*) – are a sensitive touch.

3 Squared-off portrait of Senenmut

Dynasty XVIII, time of Hatshepsut,
c. 1490–1470/68 BC

This portrait of Senenmut on an ostrakon from his tomb at Deir el Bahri, shown in *colour plate IV*, is reproduced again here to make comparison easier with *plates 2* and *4*. The drawing was perhaps a study for a more finished portrait on a wall in Senenmut's tomb, such as *plate 2*, although there are a number of slight differences between the ostrakon sketch and the wall-portrait shown here – in the shape of the nose, lips and chin, the length of the neck and the curve of the wig, for example. The grid-squares in red paint might well have been intended to help the artist transfer the sketch on to the wall surface, as well as maintain the accepted proportions of the head.

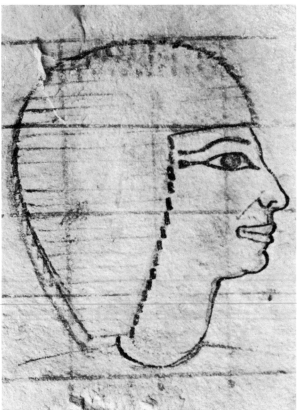

3

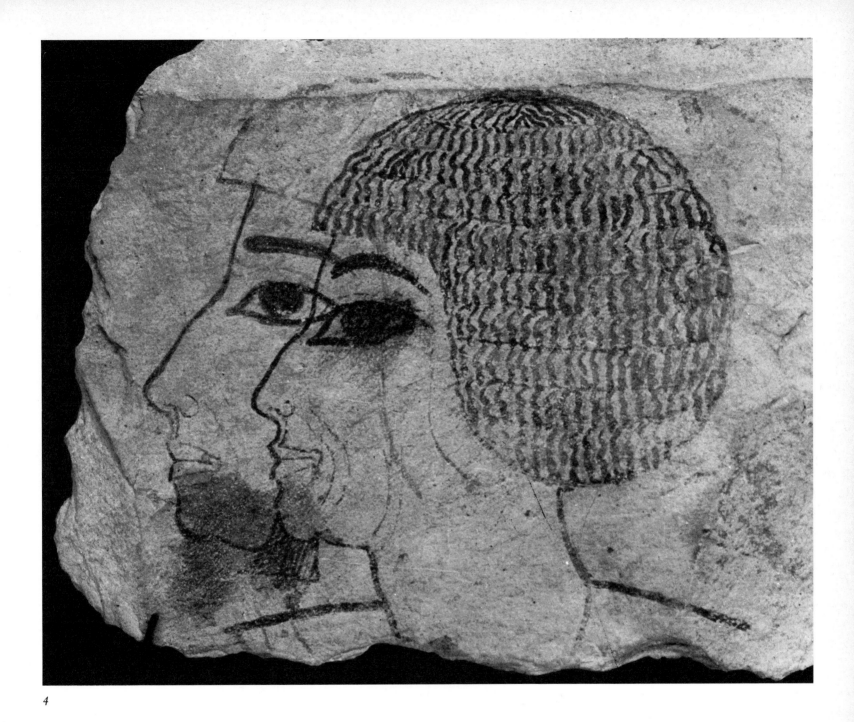

4

4 Two profiles of Senenmut

Dynasty XVIII, time of Hatshepsut,
c. 1490–1470/68 BC

These two superimposed drawings on an ostrakon
suggest very vividly the artist at work. The left-
hand sketch may have been the preliminary design,
the right-hand one the finished version to be
transferred on to a wall. Alternatively the
complete head may have been a student work
corrected on the left by the master, a hypothesis
perhaps supported by the more usual horizontal
position of the eye in the unfinished profile.
Whatever the interpretation, the sensitivity of the
artist(s) is not in question. As in the very similar
wall-portrait (*plate 2*), the line is bold, the
observation of wrinkles around the mouth and
chin assured.

5 Egyptian courtiers pay homage to the king

Dynasty XVIII, time of Akhenaten,
c. 1365–1349/47 BC

This is one of a number of unfinished wall carvings from the tomb of the vizier Ramose in the Theban necropolis. Here the artist has sought to convey not individual likenesses, as in the portraits of Senenmut (*plates 2–4*), but the sense of the countless masses who pay homage to the king. The noblemen are bowing before Akhenaten, the pharaoh who revolutionized Egyptian art and religion. The style in which they are drawn hints at some of the changes he introduced in the visual arts, such as elongated profiles and exaggerated facial features. The repeated heads and bowing bodies set up a powerful rhythm which is carried on into other parts of the tomb. Interestingly enough, however, some adjacent walls reflect an earlier style, for Ramose was in the royal service during the transition from the rule of Akhenaten's father, Amenophis III, to that of Akhenaten himself.

5

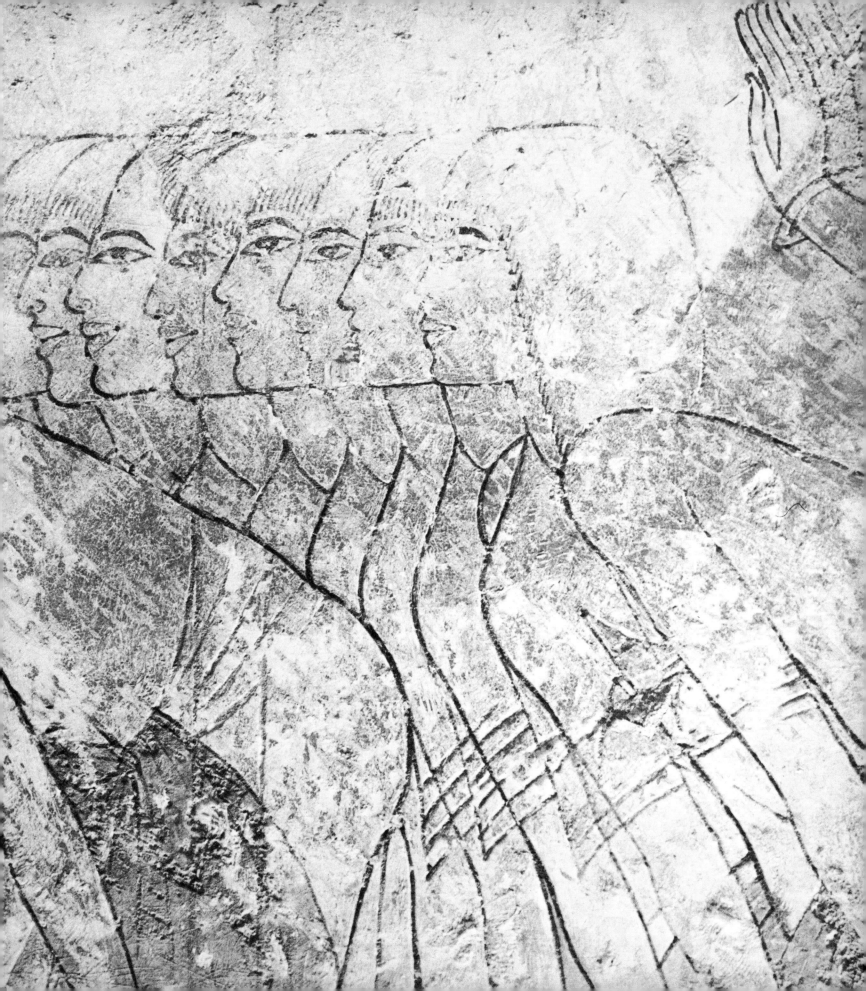

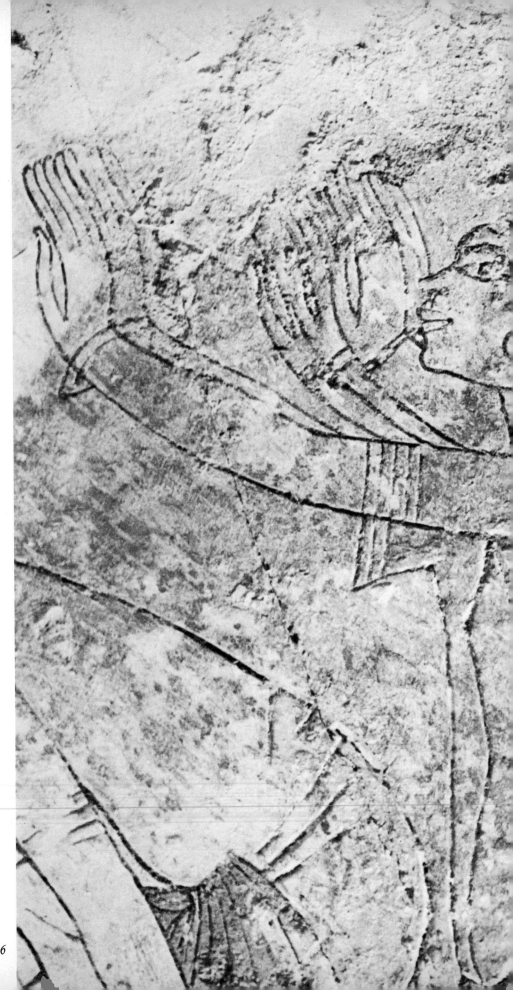

6 Foreign emissaries pay homage to the king

Dynasty XVIII, time of Akhenaten,
c. 1365–1349/47 BC

This is a continuation of the scene shown in *plate 5*, only here those paying obeisance are foreign emissaries, not Egyptian courtiers. Slight traces are still visible of the original red line used in the layout of the figures, before the drawing was finished in black. The figures have been interpreted in a number of different ways, but basically they are meant to represent emissaries from the three parts of the Mediterranean world, East, West and South – three Asiatics, one Libyan and four Africans. The artist has not grouped them like this, however. With only eight figures at his command he needed a much more dynamic arrangement to indicate the innumerable foreign visitors to the court. Instead, an African in the front is followed in the second row by an Asiatic, an African and another Asiatic, and in the third row by an African, an Asiatic, another African and a Libyan. Monotony is thus avoided and the eye tricked into imagining a whole host of ambassadors come to pay homage.

 This and the preceding plate bear witness to the consummate artistry of the Egyptian draughtsman and his skill in portraying a wide range of human types within the accepted canons of his time.

6

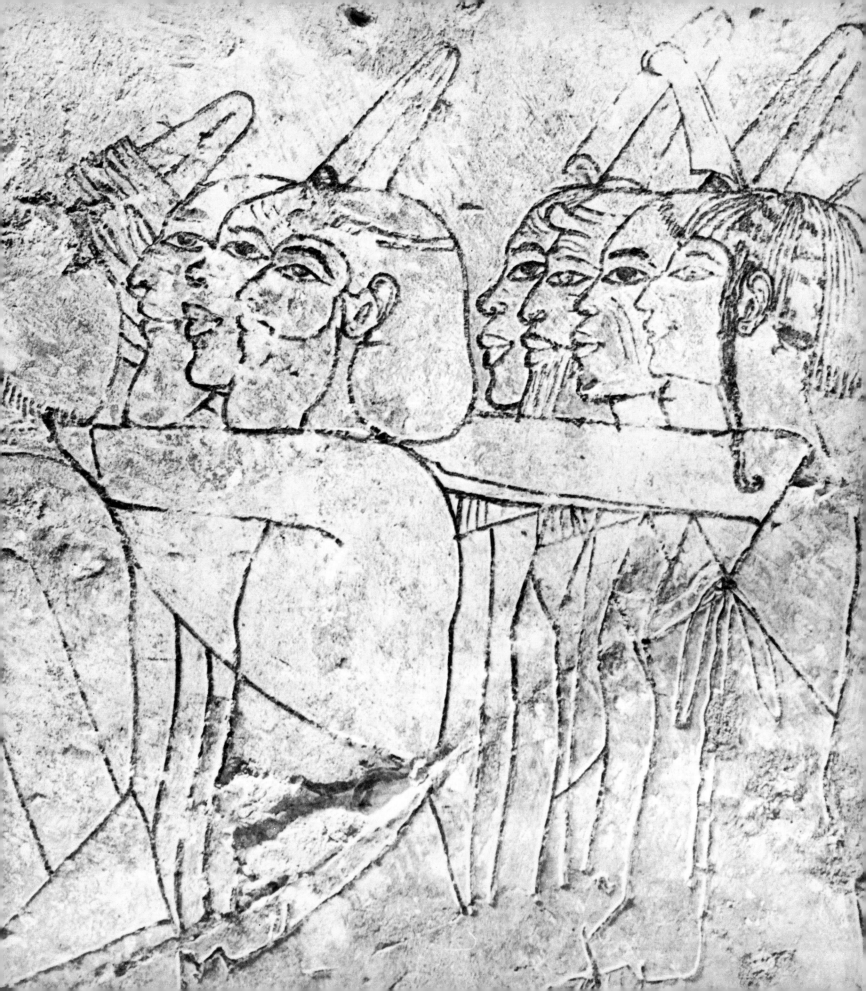

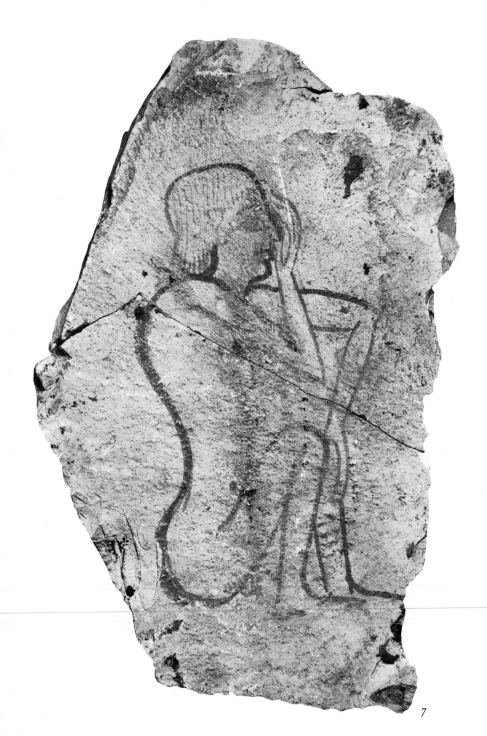

7

7 Seated man

Ramesside period, *c.* 1305–1080 BC

This small sketch on an ostrakon from Deir el Medina suggests the attempt of one artist to capture a little of the life he saw around him. A man sits on the ground with his knees drawn up, one hand on his left leg and the other raised to his face in a thoughtful manner. The posture is an unusual one in Egyptian art and clearly required practice, as is indicated by the re-drawn line of the back. No doubt this would have been a trial sketch for one of the many genre subjects included in tomb paintings of the New Kingdom.

8 Two Nubians and a ?lynx

Ramesside period, *c.* 1305–1080 BC

Of the foreign types the Egyptian artist had to master, the one that came most easily to him was the black from the south. The intercourse between Egypt proper and the lands to the south had been carried on since Predynastic times, so it was natural for the Nubian to be well known and easily rendered. This drawing on an ostrakon from the Valley of the Kings was probably sketched in preparation for inclusion in a tomb-wall scene of a procession showing the bringing of foreign tribute. But, unlike the foreign emissaries from the tomb of Ramose (*plate 6*), the overlapping of the two figures, the heads turned in different directions and the poses of the bodies all suggest that this is a scene from life not yet completely formalized. The animal which accompanies the men has faded; it may be a lynx, to judge from other drawings. The object carried by the right-hand figure could be a bow. The animal-hide costumes and the large earrings add to the picture of exoticism. One detail which should be commented on is the pose of the two men's feet; they seem to be stepping lightly on their way. In a subtle manner the artist has suggested a feeling of motion which is not common, although not completely unknown, in Egyptian art.

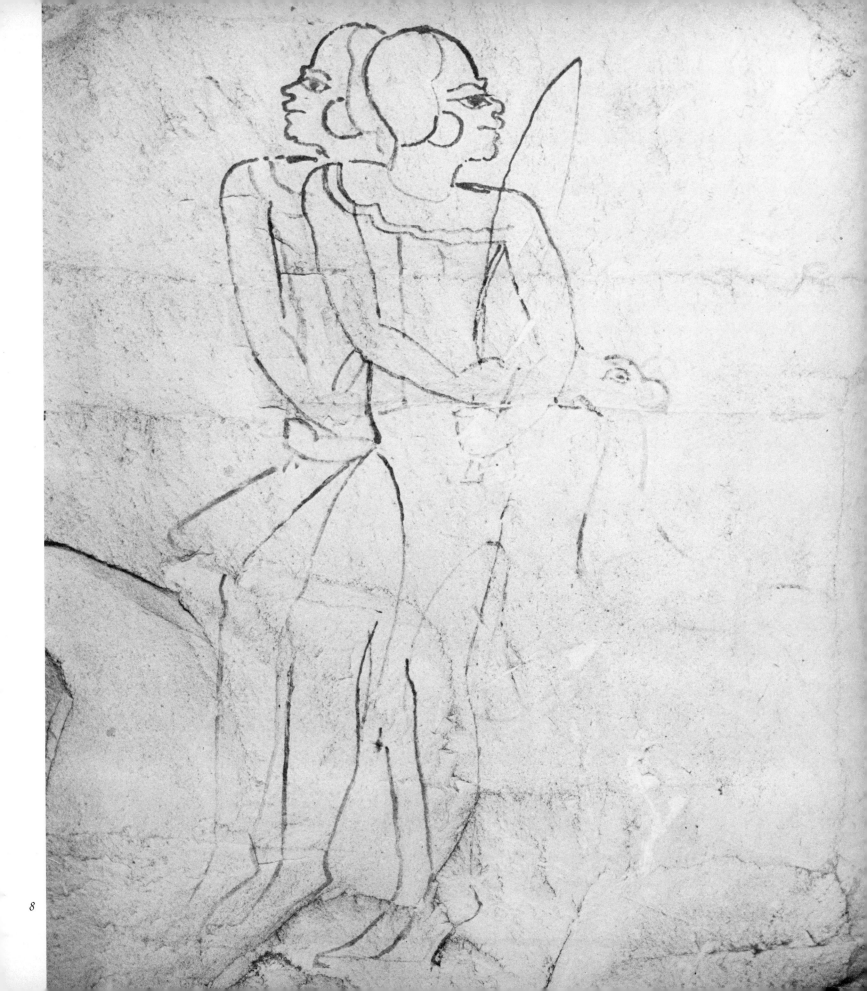

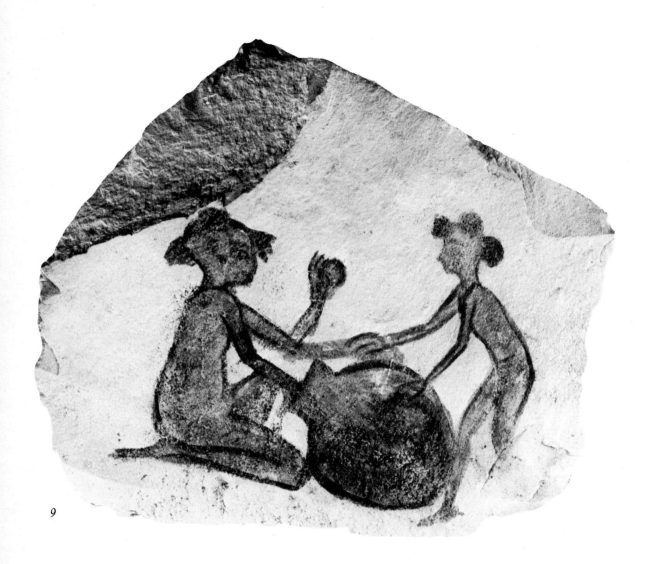

9

9 Two boys burnishing a jar
Ramesside period, *c.* 1305–1080 BC

Similar in style to the sketch of two boys driving cattle (*plate 115*), this ostrakon from Deir el Medina is somewhat unusual in showing a scene from daily life not often encountered in drawings. Two boys are seemingly burnishing a vessel with a pebble. Perhaps this was a study for one of the many tomb paintings depicting different aspects of the potter's craft. From the Old Kingdom there are preserved limestone figures of 'servants' carrying out a similar activity.

10 Figure of a man
Ramesside period, *c.* 1305–1080 BC

This rather enigmatic drawing of a man on an ostrakon lends itself to various interpretations. Perhaps drawn from life, it may represent a kneeling figure or possibly a running man to judge from the zest with which it was executed. Whatever the correct view, the figure undoubtedly holds some kind of object to his breast while he turns his head back, as if looking over his shoulder at some activity to his rear. The vitality of the whole drawing is exceptional.

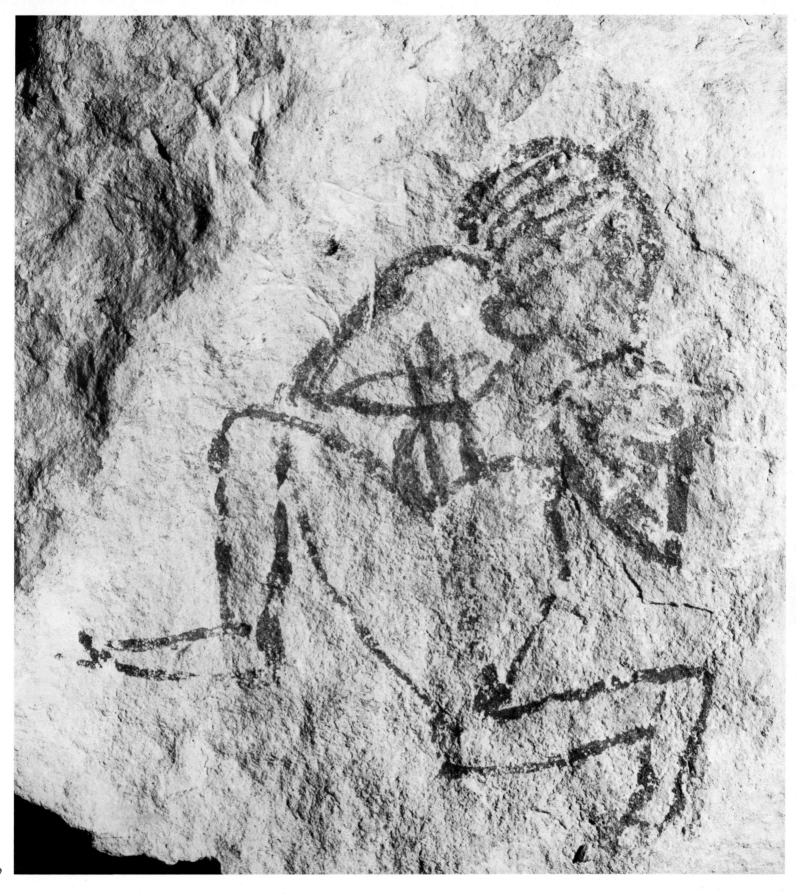

Woman

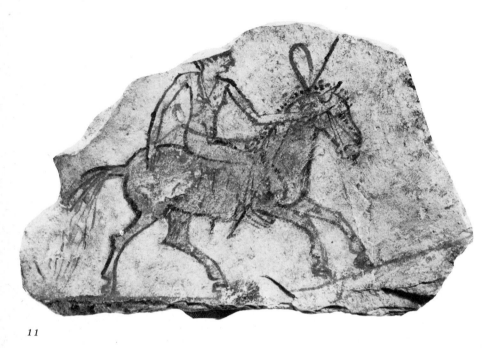

11

11 Woman on horseback

Ramesside period, *c.* 1305–1080 BC

Figures on horseback are not common but do occur in ancient Egyptian art. This example depicts a nude woman who seems to carry a stick or staff in one hand. Across her breasts is a decoration – beads or tattoo, it is difficult to determine. In Berlin there is a very near parallel in which the figure has been identified as the Syrian goddess of love and war, Astarte. It is impossible to be so precise here, but the unlikely occurrence of a nude female rider suggests that the intention may have been the same.

12 A princess at table

Dynasty XVIII, time of Akhenaten, *c.* 1365–1349/47 BC

Although there is no identifying text, this beautiful and delicate drawing from Tell el Amarna almost certainly represents one of the six daughters of Akhenaten as she enjoys a meal. It is one of the most graceful renderings of the immature female body to be preserved from ancient Egypt, yet the preparatory design was never meant to be seen and would have been completely destroyed if the relief carving begun at the bottom had been carried to completion. The young woman sits on a cushion, her left hand languidly resting on a table piled high with cakes and other foods. In her right hand she holds a dressed fowl which she presses to her mouth. Many of the stylistic peculiarities of the time of Akhenaten are evident – full lips, sagging stomach, thin arms, long neck, high eyebrow and jutting chin. Both feet are drawn up in front of the cushion, the big toe of the left foot shown somewhat enlarged to emphasize its presence. The princess wears a diaphanous gown, which is indicated by a few lines sketched with a deftness characteristic of the whole piece.

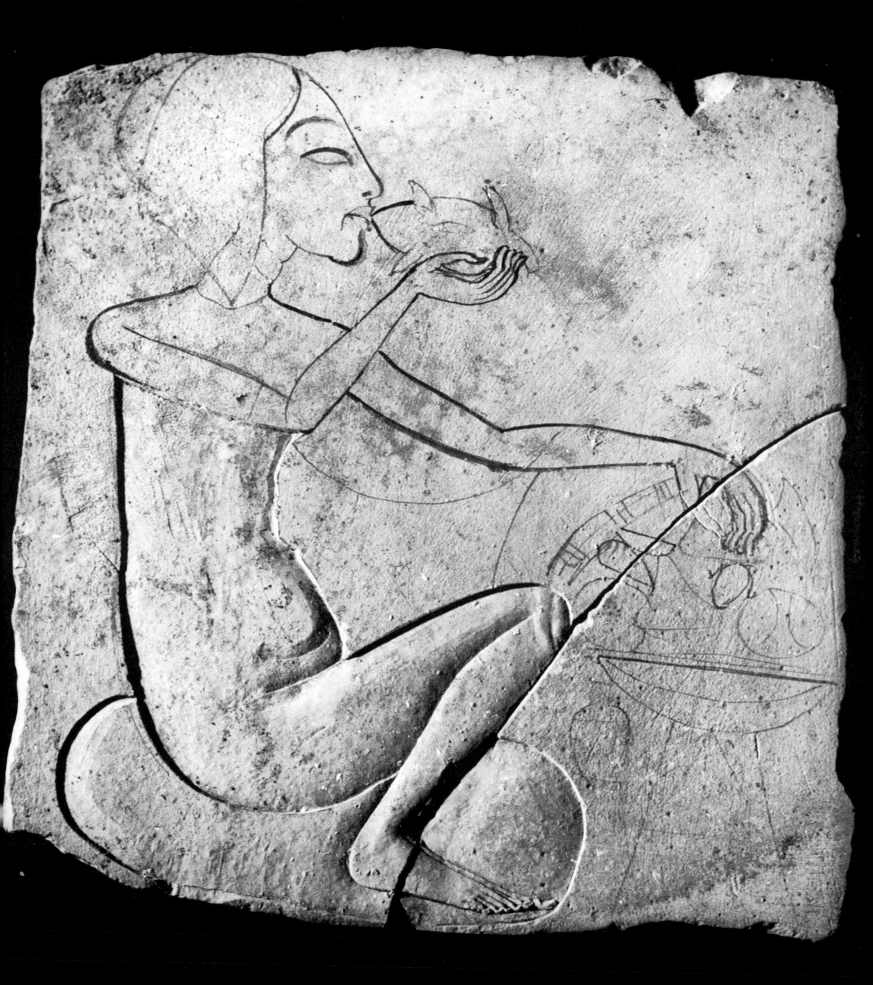

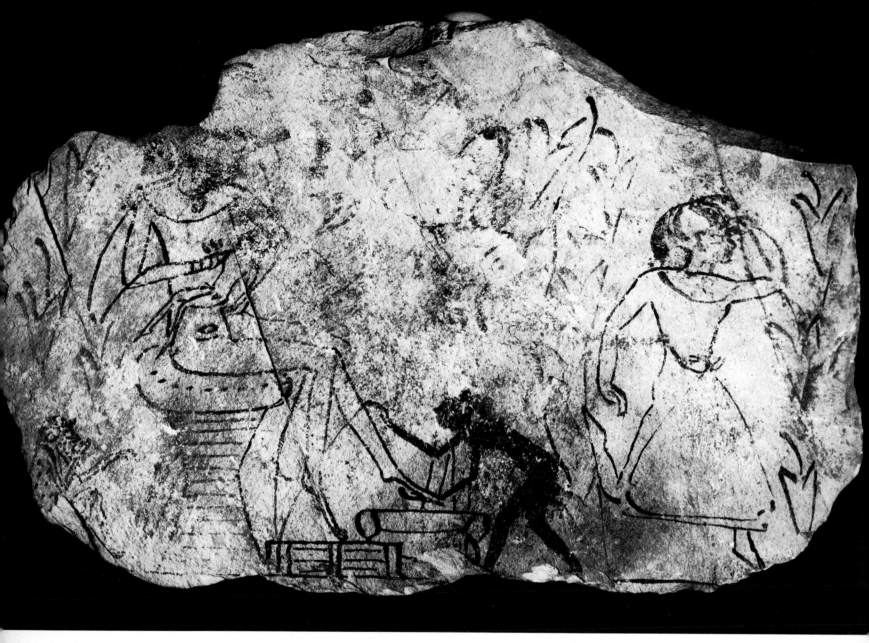

13 A woman nursing a child

Ramesside period, c. 1305–1080 BC

This unusual scene from Deir el Medina shows an elegant woman seated on a high stool, nursing a child. Of her two attendants, one is a small, dark-skinned girl, and the other is not so easily seen because of damage, standing behind the girl and probably holding a mirror. Two other figures complete the composition – on the left a small baboon, probably the household pet, seated behind the nursing woman; on the right a man with a long kilt and a partially shaven head. The many other details are hard to interpret because of the condition of the drawing. The seat has a cushion for additional comfort; there are plants or leaves in the background which may indicate an outdoor setting. What are we to make of this group of figures? It is seldom in Egyptian art that a living person is shown in the act of nursing. The goddess Isis is often depicted suckling the infant Horus, but the woman in this drawing is not a goddess, rather a courtly woman of rank. Perhaps we have here a princess or another member of the royal family. The following example is of substantially the same type.

14 A woman nursing a child

Ramesside period, c. 1305–1080 BC

This fragment from Deir el Medina bears
exactly the same subject as the preceding
sketch. If both were not known, the
temptation would be to think each of them
unique. Minor details are changed in this
version but the effect is the same. The
attendant who accompanies the small girl in
plate 13 has been here placed in the lower
register, and carries a mirror and an eye-paint
stick in a tube. The seated woman has been
given sandals with upturned ends and her feet
rest on a cushion rather than a footstool. The
stylization of the female figure is very much
like that in the other drawing, and even the
dotted line which describes the seam of the
cushion on which the figure sits is indicated
in the same way. From the evidence of the
two drawings we might conclude that the
subject was important enough to achieve a
strong degree of standardization. It is often
the case that a single drawing of a scene seems
to be the product of imagination and
invention, until the discovery of others of the
same type proves that the subject was
sanctioned by common usage and needed
practice.

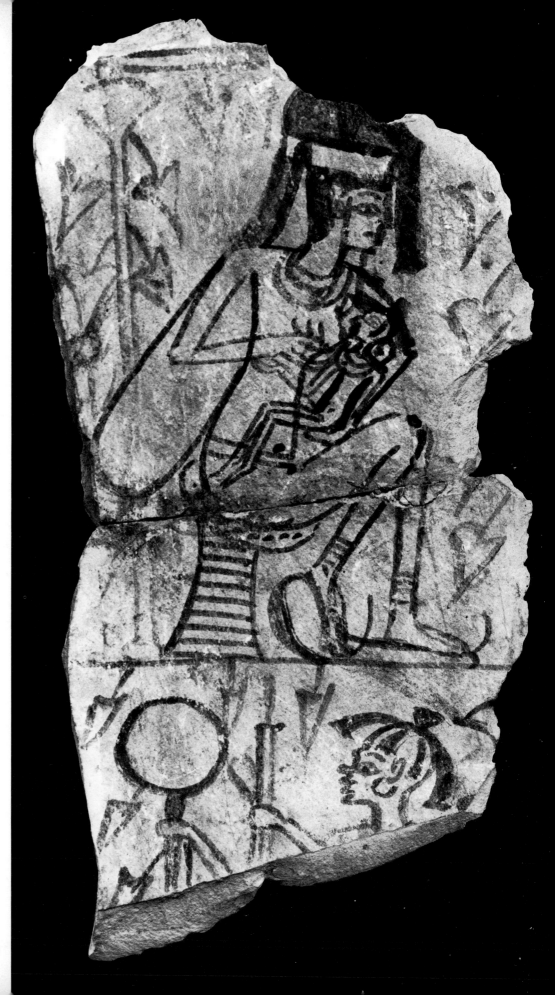

15

15 Torso of a woman
Ramesside period, *c.* 1305–1080 BC

In this sketch on an ostrakon from the Valley of the Queens the female torso is turned slightly from the strict profile, suggesting that some special activity was to be illustrated. A preliminary outline has been corrected by the thick, dark strokes, perhaps an indication that the artist was working out the particular problems of the pose. The left arm, as it crosses the upper body, was placed over the breast, showing that the outline of the figure was done first and the position of the arm decided later. The lightly sketched lines of a transparent garment seem not to have been the major concern of the draughtsman, but were added to show how the body, first conceived as nude, would have been draped.

16 Drawing on a linen shroud
Ptolemaic or Roman period, after 332 BC

This image, in ink on linen, actually represents the goddess Isis wearing a diaphanous gown, but serves well to illustrate the handling of the female form in the Late Period. The attenuated proportions and the style of drawing indicate a Ptolemaic or Roman date. Compared with earlier delineations of the figure this seems almost a caricature, but it was intended as an erotico-religious symbol. The thin waist, protruding breast and prominent hips suggest an artist who knew the figure but had difficulty in putting the parts together. Tentative attempts to describe the anatomy of torso and limbs only underscore the ease with which these problems were solved in the drawings of Dynasty XVIII or the Ramesside period.

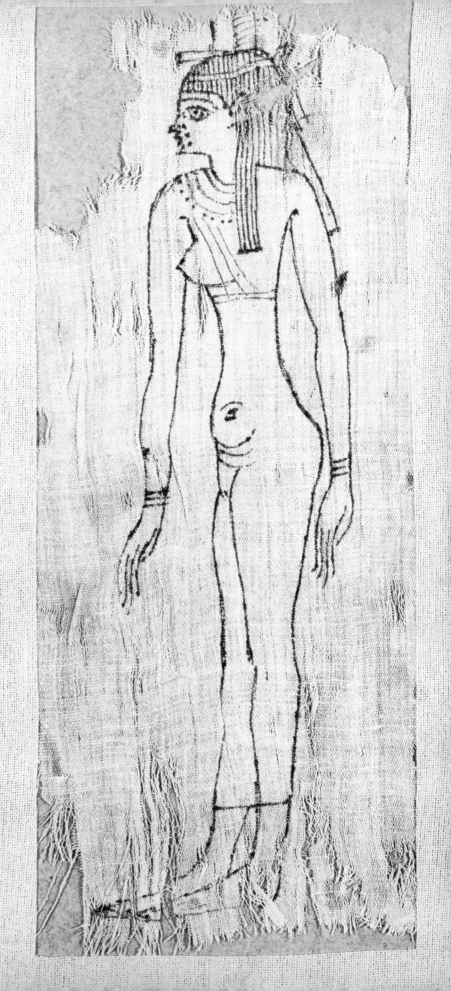

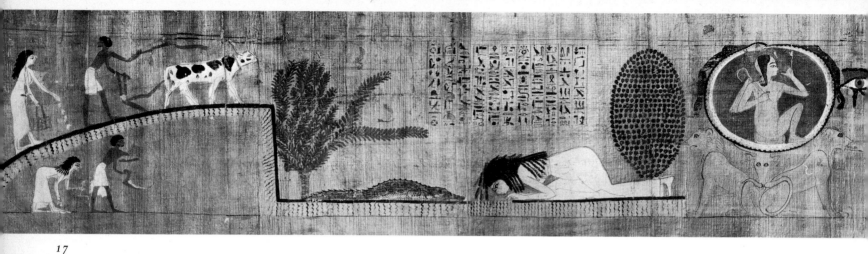

17

18

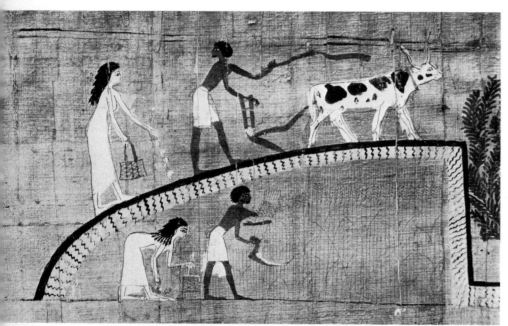

17–20 Here-ubekhet enters the Fields of the Blessed

Dynasty XXI, *c.* 1000 BC or later

Here-ubekhet was a 'Chantress of Amun' and granddaughter of the High Priest of Amun, Menkhepher-Re. This papyrus from Deir el Bahri appears to be an abbreviated Book of the Dead for her, a collection of spells to guide her in death through the perils of the underworld. It is one of the masterpieces of Egyptian draughtsmanship.

Intended to be read visually and textually from right to left, it begins (*17, colour plate V*) with a scene in which Here-ubekhet, wearing a simple white gown, wig and cone of scented grease, presents offerings to the god Ptah-Sokar in his manifestation as Osiris, god of the dead. Behind him stands the goddess Isis. On the step of the dais is a pole supporting a leopard skin, emblematic of Anubis, god of the necropolis.

In the next scene (*17, 20*) the deceased kneels on a low platform while two gods, Ra-Horus on the left and Thoth on the right, pour over her purifying streams of the *ankh* (the hieroglyph for 'life') and the *was* ('to have dominion'). The following scene shows Here-ubekhet greeting the new sun of the morning, accompanied by a baboon, the animal most often associated with the rising sun, and the protective Eye of Horus. Then (*17, 19*) she is portrayed drinking pure waters before a crocodile, representing the earth god, Geb. This vignette is framed by a poplar (left) and stylized sycamore. In the final scene (*17, 18*) the priestess has achieved eternal salvation in the Fields of the Blessed. Along a curving river bank she sows seed corn in the furrows made by a ploughman; below, she gathers in the harvest in the wake of a reaper.

19

20

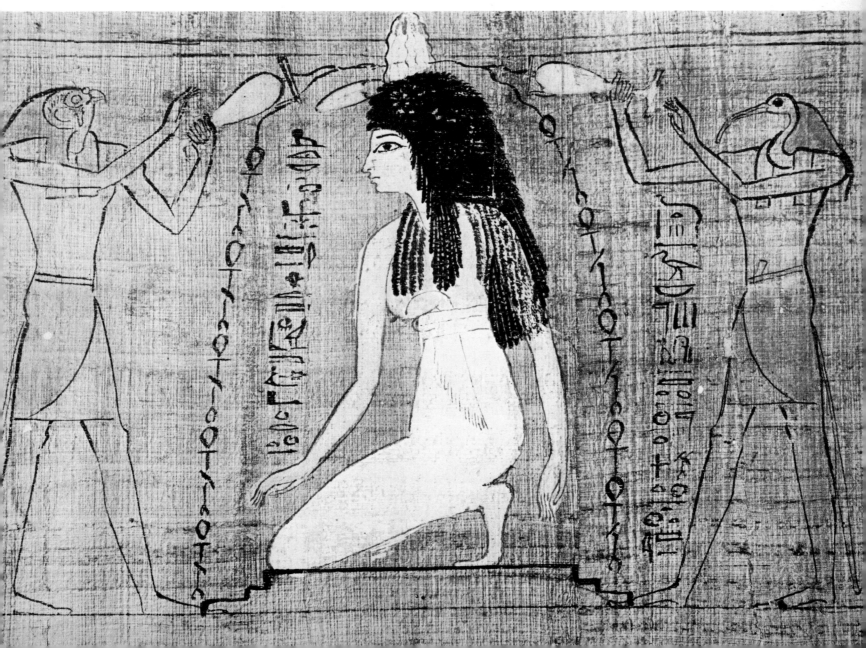

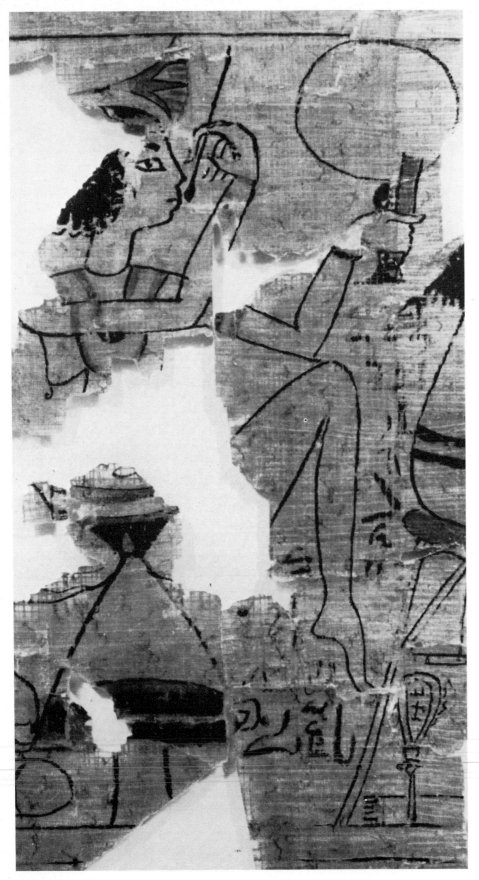

21 Courtesan at her toilet

Dynasty XX, *c.* 1196–1080 BC

This detail is from the so-called 'erotic papyrus' in Turin which describes and illustrates a series of adventures in a brothel. In this section one of the young women, lotus bud above her head and pubic triangle displayed, is seen in the act of painting her lips while she judges the effect in a mirror. The complete papyrus is very fragmentary but the parts still preserved show the work of a master draughtsman. The gestures of the hand holding the cosmetic brush and the down-turned foot are very graceful. The apparent reserve found in much of Egyptian art has given way here to what may be described as free invention. The nature of the subject being what it is, there were probably not the same rigid standards and stock forms to follow.

22 Here-ubekhet pays homage to the gods

Dynasty XXI, *c.* 1000 BC or later

This detail from another papyrus of the same woman as in *plates 17–20* suggests that both were of the same high quality. In this vignette Here-ubekhet is shown in a kneeling posture with arms upraised in prayer or praise. Of all the details so far illustrated this one emphasizes her personal characteristics most vividly: her double chin is more pronounced, the folds of her abdomen more obvious.

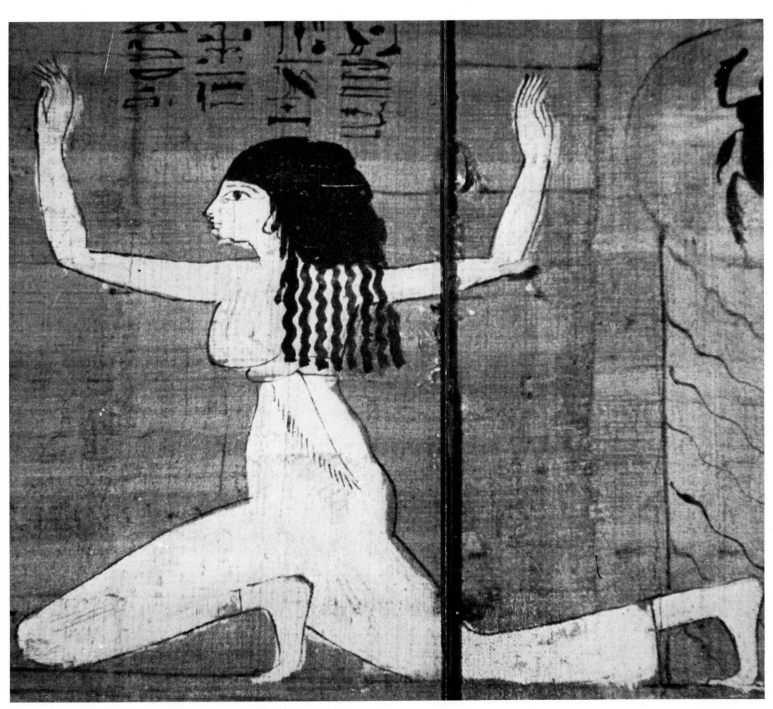

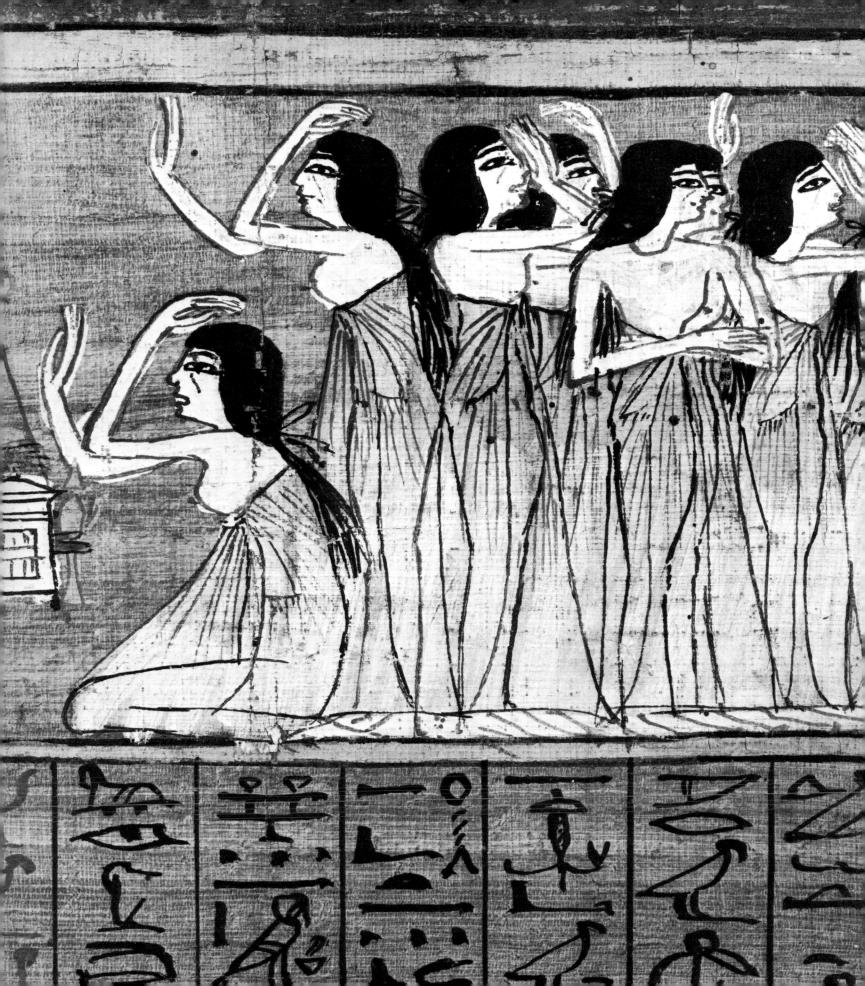

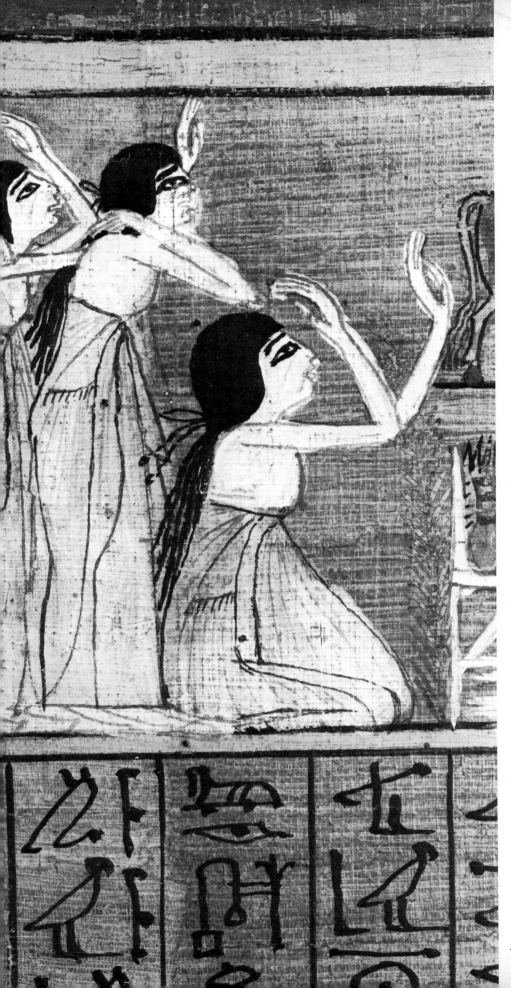

23 Mourning women

Dynasty XVIII, *c.* 1554/51–1305 BC

In Theban tombs of the New Kingdom and in papyri such as this detail of a Book of the Dead belonging to the scribe Ani, groups of mourning women were commonly illustrated. They, or sometimes children, functioned as part of the funerary ceremonial and would meet the procession bearing a mummified body to the tomb. The drawing of this group suggests the limitations of papyrus illustration. There is little differentiation between the figures, although the poses of the head are varied, giving the impression of types drawn from stock models. The effect of a chanting, wailing crowd is well conveyed, but the anatomy of each individual is only slightly developed.

23

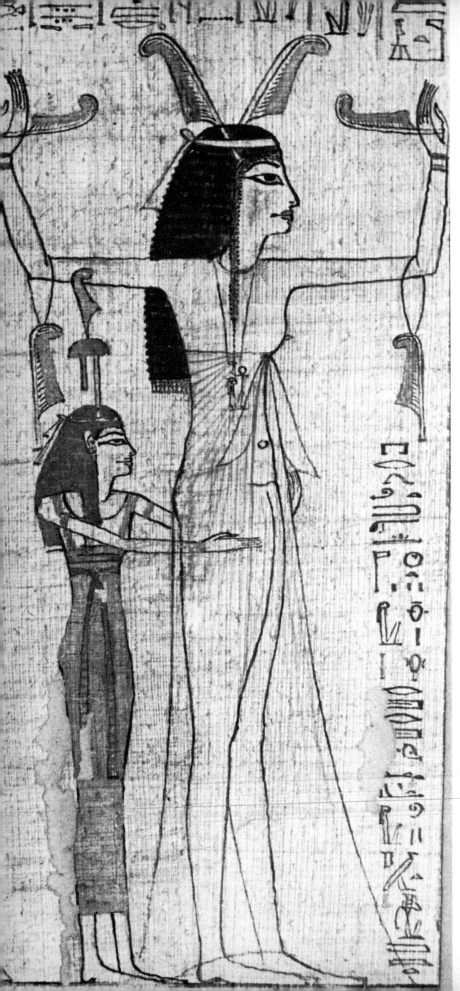

24 Papyrus of Anhai (detail)

Dynasty XX, *c.* 1196–1080 BC

This and the following plate show scenes from
another Book of the Dead. Here the deceased is
depicted with the smaller figure of the personified
West, the land of the Dead. Anhai is garlanded
with ostrich feathers symbolic of truth, which
identify her as one who has passed her test at the
Last Judgment. Hanging from a cord around
Anhai's neck is a tiny pendant of the goddess
Maʿat ('Justice') who holds an *ankh* sign. The
suggestion of transparent costume is conveyed by
fine lines which virtually disappear as they move
down the body. The drawing of the female figure
is a good example of the careful and meticulous
draughtsmanship of the late Ramesside period.

25 Papyrus of Anhai (detail)

Dynasty XX, *c.* 1196–1080 BC

As the deceased passes through the underworld she
must pause, say the correct prayers and make
offerings. In this vignette she is shown before an
offering stand, holding a sistrum, the rattle
used to accompany such devotion, and she is
garlanded with a convolvulus. The figure is slender
and delicate. The complexity of the upper half of
the composition, with wigged head, necklace,
upraised hands, musical instrument and plant
leaves is in direct contrast to the simplicity of the
lower half. Within the limitations of the
standardized representation acceptable for the
Book of the Dead the artist has created a design of
striking beauty.

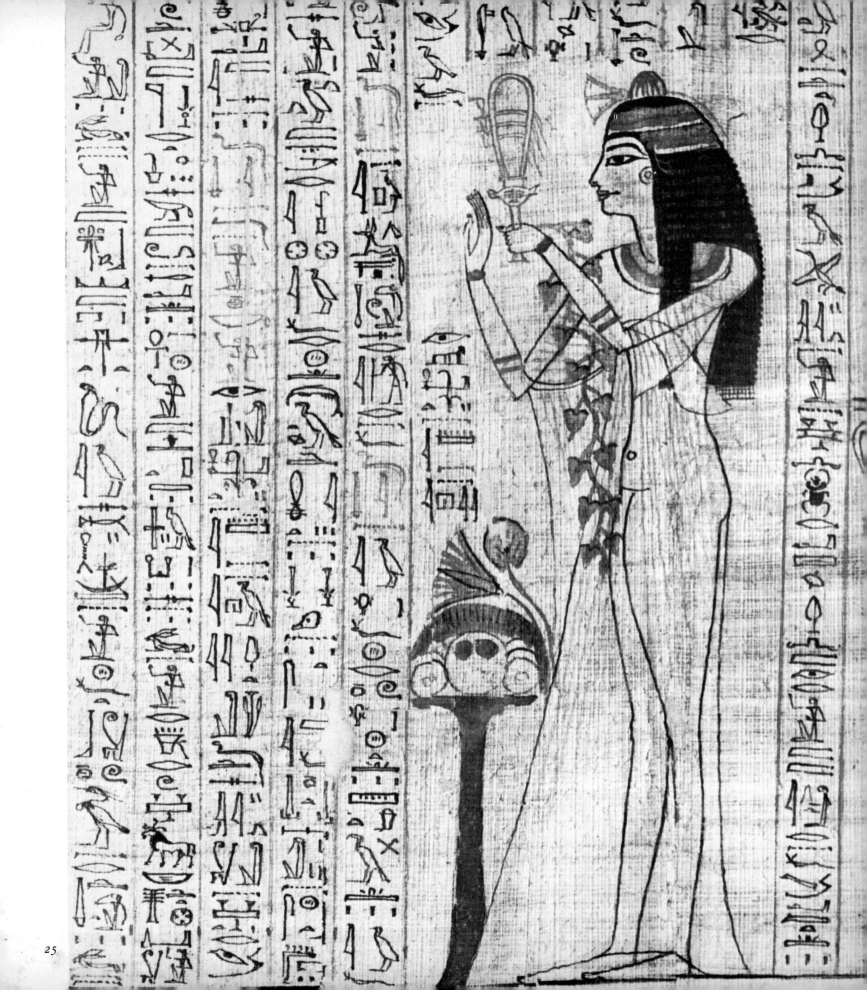

The royal image

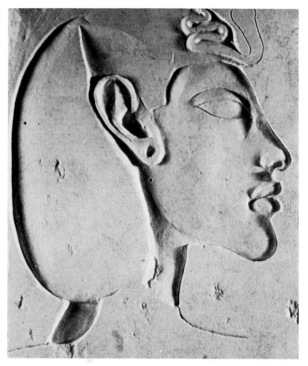

26

26 Partly carved head of Akhenaten

Dynasty XVIII, time of Akhenaten,
c. 1365–1349/47 BC

This plate illustrates one of two heads on a limestone model relief used by a sculptor to work out the details of royal representations. The head not illustrated here has been identified as Smenkhkare, this head as Akhenaten, his elder brother and co-regent; both are in the later style of the reign. The linear quality of the carving is a direct result of the use of a careful preparatory drawing. The remains of the original design can be seen in the unfinished uraeus (symbol of kingship) on the forehead and in the lines of the neck. In both cases the carving has been begun by inscribing the ink lines but no further work has been carried out. Within the initial linear conception the sculptor was free to develop modelling in a normal manner, as can be seen in the area of jaw and ear. Cf. *plates 27* and *30*.

27 Unfinished relief carving of Akhenaten

Dynasty XVIII, time of Akhenaten,
c. 1365–1349/47 BC

In this head, which belongs to the earlier style of the reign of Akhenaten, the hair, eye and eyebrow are still very much in evidence as an ink drawing. The nose, lips and chin, by contrast, have already been carved quite deeply. The carved areas are more accomplished than the drawing (as it is preserved), suggesting that the layout was a simple one which was to have been brought to completion by a skilled relief carver. There are many such trial pieces from the period of Akhenaten. It seems that the idiosyncratic art style favoured by this monarch required constant practice.

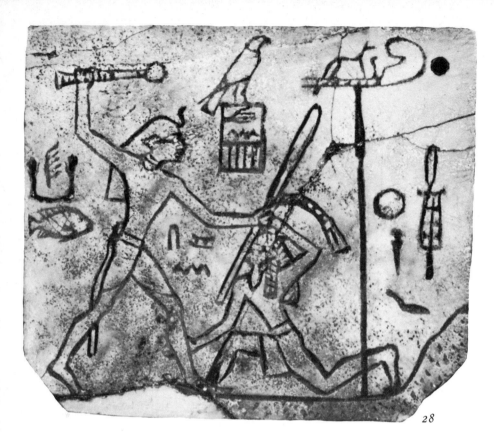

28 *King Den smites an enemy*

Early Dynastic period, Dynasty I, *c.* 2900 BC

On an ivory label for a pair of sandals from Abydos, King Den is shown raising a stone-headed mace to dispatch a kneeling enemy. He wears a royal headdress with uraeus and, attached to his kilt, the bull's tail of kingship. Between him and the smitten foe is his Horus-name surmounted by the falcon of that god. Behind the foe is an inscription which reads: 'Year of the first time of smiting the East'. The whole drawing has been incised. This early work records a pose and format which was to endure throughout pharaonic history, as the next plate demonstrates.

28

29 *A Ramesside pharaoh slays a lion*

Dynasty XIX, *c.* 1305–1196 BC

The king, wearing the Red Crown of Lower Egypt, is shown in the act of dispatching a lion already pierced by a number of arrows. He is accompanied by a sprightly hunting dog that leaps to the attack. The hieratic script above reads: 'The slaughterer of every foreign country, the pharaoh – may he live, prosper and be well!' (Hayes 1959, p. 390); the intention of the scene is therefore to describe the king not in some sporting activity but rather as the mighty conqueror who smites the enemy, personified by the lion. It is a descendant of the scene depicted in the preceding plate, dating from over fifteen hundred years earlier.

It is difficult to decide whether this is a preliminary study or an artist's note after a work he has seen. The proportion of the royal figure is distorted, the head is too large for the body. But the small size of the lion is dictated by the laws of aspective (see introductory text).

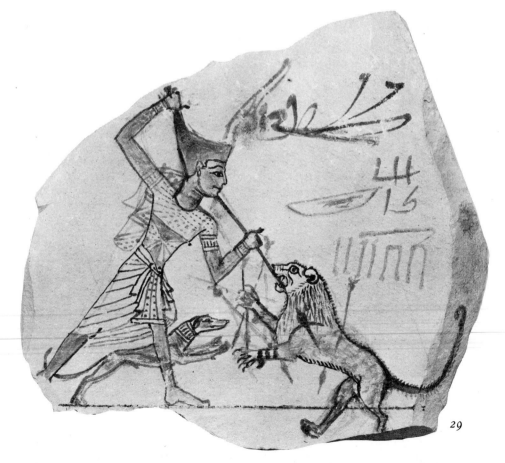

29

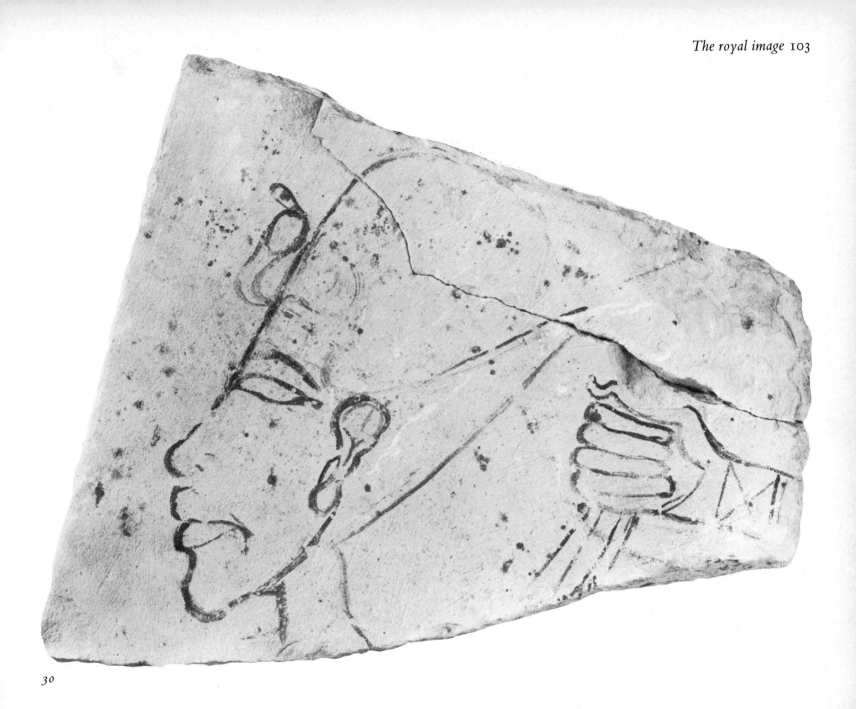

30

30 Head of Akhenaten and fist

Dynasty XVIII, time of Akhenaten,
c. 1365–1349/47 BC

Crude as this drawing on a limestone flake may at first appear, it succeeds in capturing in a few strokes much of the peculiar physiognomy of the pharaoh Akhenaten – the prominent nose, thick lips and jutting chin. The inclusion of the hand on the right is not an accidental juxtaposition: the closed fist was a unit of measure used to work out the correct proportion of different parts of the body. Its presence here, and the somewhat heavy line of the drawing, suggest that this was a practice piece done by a student. It is interesting to compare this apprentice work with the trial carvings of Akhenaten, *plates 26* and *27*.

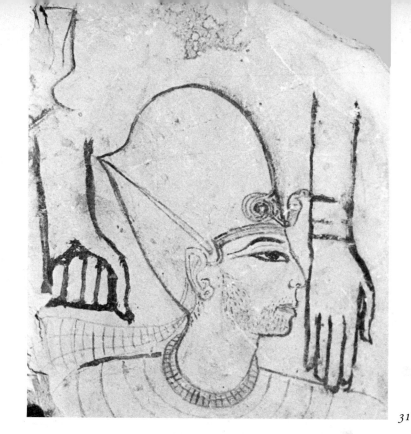

31 Head of a king wearing the Blue Crown

Ramesside period, *c.* 1305–1080 BC

This curious sketch has much about it that is of interest for a study of Egyptian drawing. The king is shown wearing the Blue Crown of the warrior, a headdress not used in Egypt until the New Kingdom; from the crown descends a fluttering streamer. His ear-lobe is pierced but he wears no earring, which was generally discarded at puberty. Around his neck are two necklaces of honour and a broad collar. The stippling of a growth of beard indicates that he is in mourning. The two hands shown clenched and open seem to be the work of a different artist. Perhaps a student drew the head and the master artist added the hands to demonstrate the correct proportions. The extended hand shows the correct distance from the shoulder to the hairline or crown. The clenched fist describes the thickness of neck, the distance from eye to chin and other interior measurements. Above the hand on the left can be seen the beginnings of another head with a crown.

31

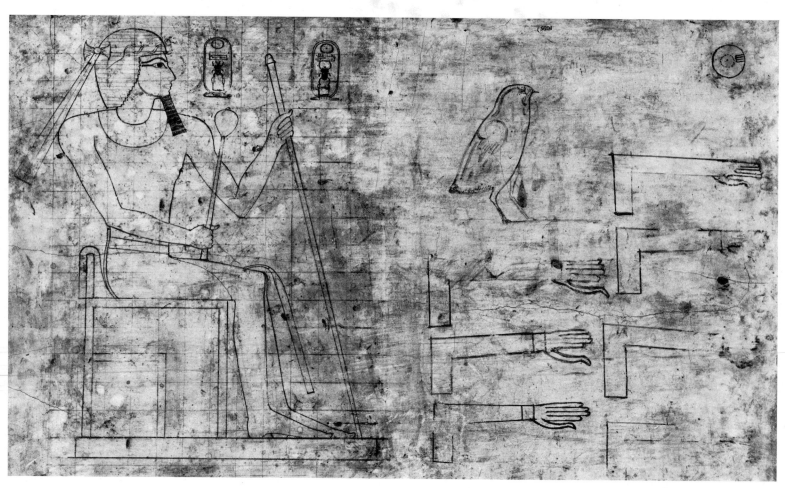

33

34

32 Master drawing of Tuthmosis III
Dynasty XVIII, time of Tuthmosis III,
c. 1490–1439/36 BC

Executed on a wooden board which was coated
with plaster gesso, this drawing was probably
intended to serve as a standard reference for the
layout and proportion of the seated figure of the
king. A squared-off grid originally covered the
whole surface and a second figure was drawn on
the right, later replaced by a series of drawings
meant to illustrate basic units of measurement. The
image of the king is 14 squares high from the
bottom of the feet to the hairline, the standard for
the type. On the basis of such drawings, as well as
unfinished paintings and reliefs which also
preserve the grid-squares, the canonical
proportions of figures have been deduced.

33, 34 Two royal heads
Dynasty XIX,
c. 1305–1196 BC

(*Above left*) This finished drawing depicts a monarch with kingly
uraeus wearing a wig. The shape of the face and nose suggest that
it could be a portrait of a Ramesside king, for it compares with
known representations of the period. Above the head is a faint
sketch of a king facing right and wearing the Blue Crown. On the
reverse of the limestone flake (*above right*) is another head, less
well preserved than the finished drawing on the obverse. As
evidenced by the side-lock, drawn so as to cover the ear, the subject
here is a prince rather than a ruling king. The side-lock was the
traditional Egyptian hair arrangement for children, who are usually
shown with shaved head and one large braided lock of hair. As a
means of designating the children of the king, mature men are shown
with the same side-lock, which has become stylized to the point
where it seems an artificial element like the false beard of kingship.

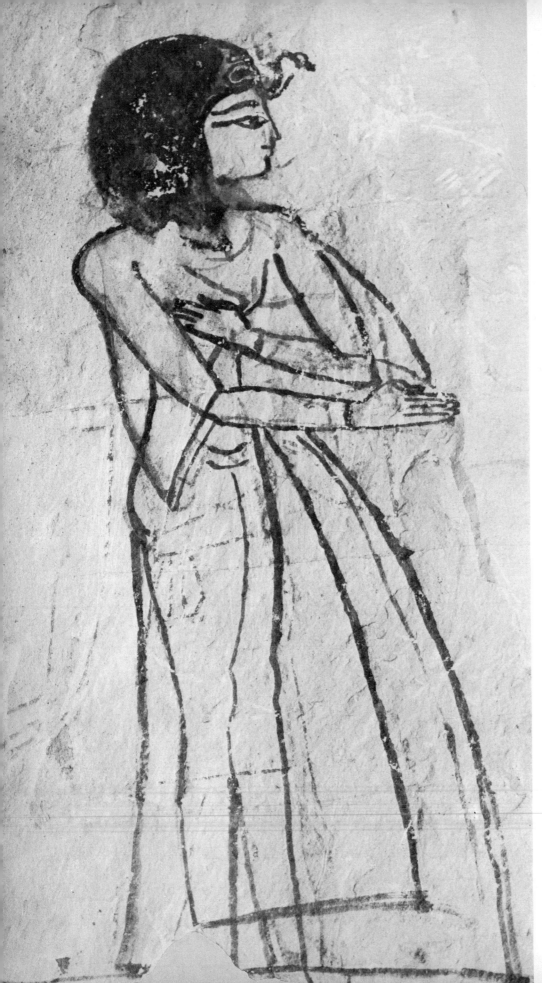

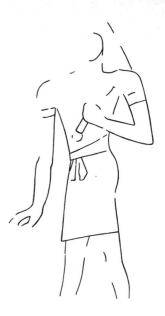

35 Standing queen

Ramesside period, *c.* 1305–1080 BC

This rather crude drawing on an ostrakon from the Valley of the Kings depicts a queen wearing a heavy wig surmounted by the royal uraeus, her body enveloped in several layers of an elaborate dress. The number of correction lines to the dress suggest that this was perhaps a study of costume. The finished drawing is somewhat confused by the presence of an earlier sketch, faintly visible underneath the queen and isolated *above* for ease of reference. Apparently what was originally planned in the underdrawing was a male figure facing left, wearing a short kilt with belt, with one arm down and the other raised across his chest, holding a standard, fan-stock or other instrument.

36 A king's head and two figures

Ramesside period, *c.* 1305–1080 BC

This is another trial portrait of a king wearing the Blue Crown (cf. *plate 31*), but here the drawing has been overlaid by sketches of two other figures. According to the accompanying inscription the male on the right is a man (priest?) named Pay and the female is his Nubian wife Meresger. There is undoubtedly something rather amusing about the tall, thin Pay and his corpulent spouse, naked except for a bead girdle at her waist and without her long wig.

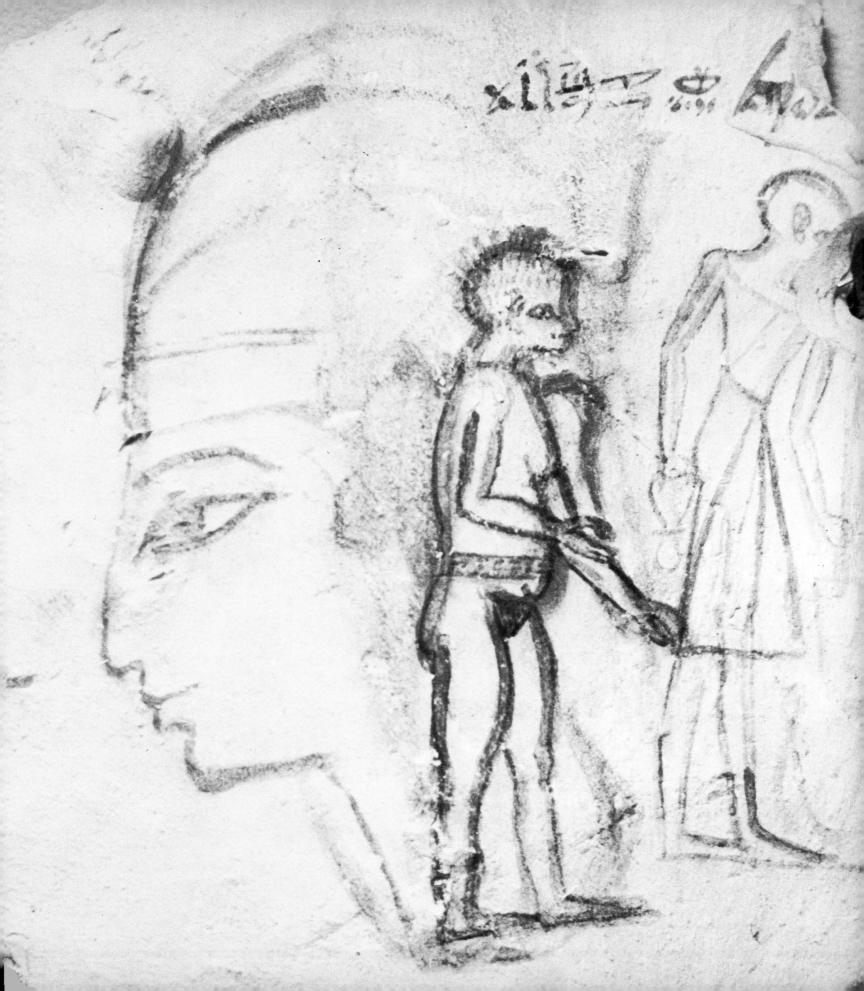

37 A king wearing the Blue Crown
Ramesside period, c. 1305–1080 BC

This simple and somewhat crude drawing appears to be a casual sketch used by an apprentice artist in the early stages of the layout of a royal head. The indecision as to relative sizes is apparent in the re-positioning of the crown and the eye. The subtle curves of the Blue Crown were not easy to capture at the first attempt and here a complete rearrangement seems to have been necessary. The original, lower placement of the eye relates to the first (left) line of the crown. The simplified facial profile suggests a rapid sketch done as a rough guide to the placement of the features, not a finished design. The delineation of standard types must have required a great deal of practice. In the New Kingdom the king was so often shown in the Blue Crown of the warrior that it would have been incumbent upon every student artist to conquer the peculiar problems of this typical motif.

38 Figure of a king
Ramesside period, c. 1305–1080 BC

A male figure is shown wearing a cap-like headdress surmounted by the uraeus, symbol of kingship. He raises his hands in a gesture of adoration and may possibly have been intended to hold offerings or perhaps a censer or libation vessel. The figure is blocked out in a sketchy fashion – only the head has been brought to a finished state. Barely discernible is a median line which runs from the base of the neck down through the torso to between the legs. This line was the basis for any drawing of the standing figure and, taken with the tentative quality of the rendering of the arms, it suggests that the sketch was done by an apprentice. The much more finished head may have been a correction drawn by the master over the preliminary outline. It gives us an insight into the process by which the apprentice learned the correct way to create the standard images, be they king, god or man.

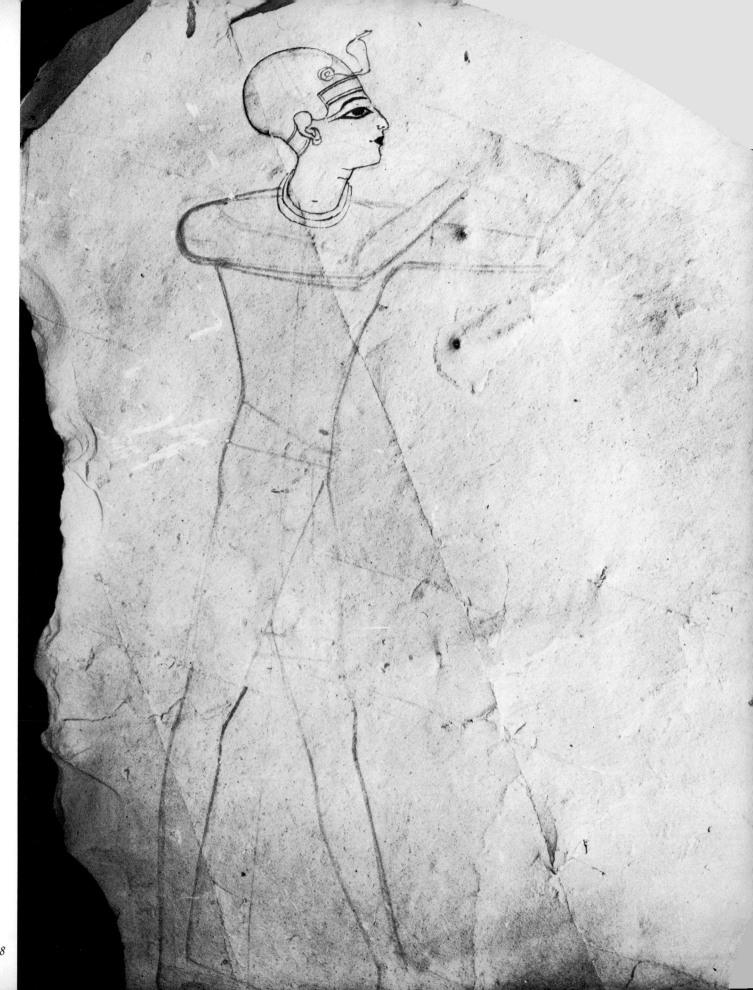

38

39, 40 Seti I and the god Atum

Dynasty XIX, time of Seti I, *c.* 1303–1290 BC

In the complex tomb of Seti I cut deep into the hillside in the Valley of the Kings at Thebes, there are many relief carvings of high quality. A number of them, however, remained unfinished, thus leaving preserved equally fine preparatory drawings of the kind illustrated here. On one side of a square pier the king is shown in the company of the sun-god, Atum, who can be identified with Re. This is one of many such images serving to illustrate the king's relationship with the various gods. Some corrections in the drawing can be detected, as in the lappet of the royal headdress on the left and the arm of the god on the right, but the general impression conveyed is that of a sure and skilled hand.

39

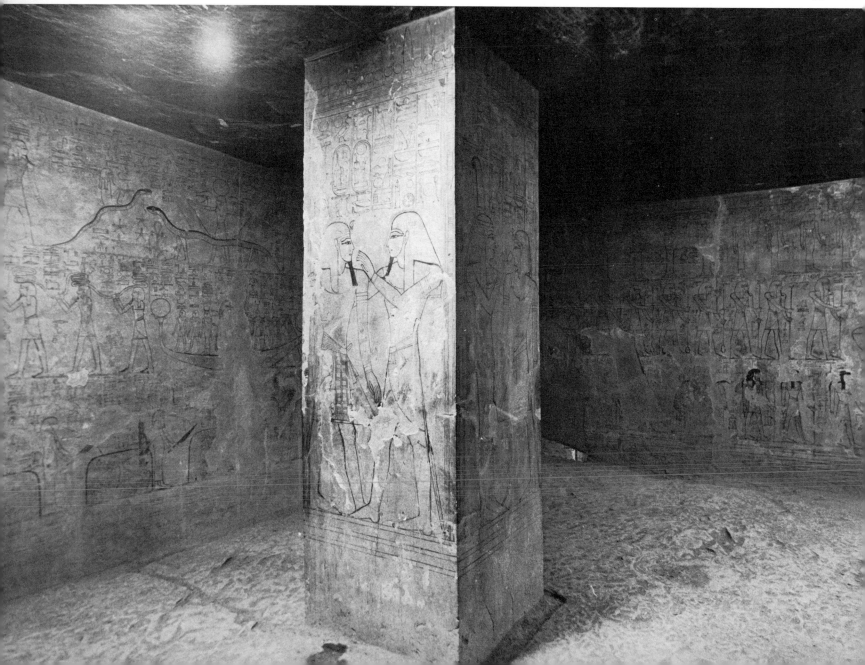

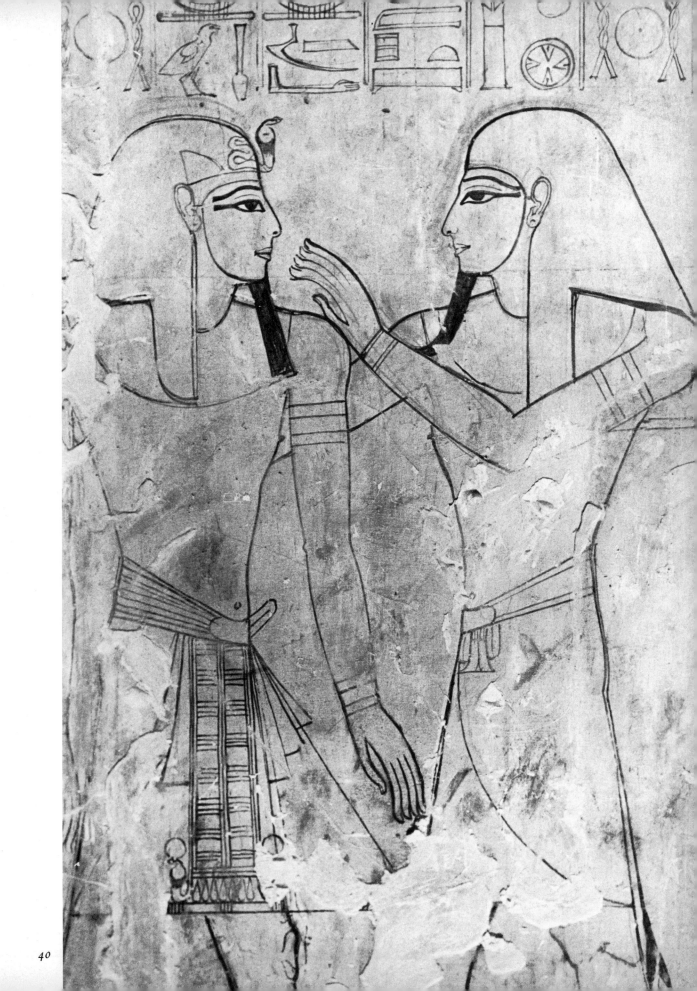

40

41 *Tuthmosis III as a ferryman*

Dynasty XVIII, time of Tuthmosis III,
c. 1490–1439/36 BC

The burial chamber of the tomb of Tuthmosis III
in the Valley of the Kings, Thebes, is decorated in
a style which suggests writing on papyrus more
than painting on walls, for what it contains are
religious texts concerned with the welfare of the
king's spirit rather than depictions of daily life.
Figures are drawn in a schematic style. Here
Tuthmosis and a goddess are depicted in a papyrus
boat with high prow and stern; in effect the king
functions as a boatman who ferries his passenger
across the waters of the underworld. The desire to
suggest the unrolled papyrus scroll of a religious
text on the tomb walls has dictated the use of a
type of drawing which would achieve this effect.

41

42 *Tuthmosis III nourished by Isis*

Dynasty XVIII, time of Tuthmosis III,
c. 1490–1439/36 BC

Positioned in a register directly below that
showing Tuthmosis as a ferryman (*plate 41*), the
small drawing here depicts the king being suckled
by a tree, identified by the inscription as the
mother goddess, Isis. The tree is painted in red
with green leaves, the figure of the king and the
breast of the tree in black. To the modern eye the
image of a tree which has sprouted arms and a
breast is difficult to understand. For the ancient
Egyptian it was the most direct manner of
suggesting the relationship between the king and
the mother goddess. The stylization of the royal
figure with uraeus is beautifully simple,
particularly when it is compared with the complex
arrangement of the tree limbs above. The manner
in which the breast is proffered by the hands of the
tree, while the hands of the king clutch one arm, is
particularly sensitive. Cf. *plate 100*.

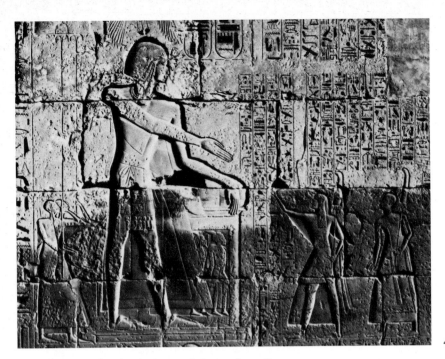

43 Ramesses III reviews the results of a war

Dynasty XX, time of Ramesses III, *c.* 1196–1162 BC

44 *Ramesses IX receives suppliants*

Dynasty XX, time of Ramesses IX, *c.* 1137–1119 BC

Many drawings must have been inspired by scenes on existing monuments. One such scene with a wide currency was that of the king receiving tribute or reviewing prisoners. A wall relief (*left*) in Ramesses III's mortuary temple at Medinet Habu shows the king on a balcony being presented with the results of his second Libyan war (*c.* 1185) by the crown prince and two viziers. Half a century later a drawing was executed on an ostrakon (*below*) on a similar theme, only here it is Ramesses IX who conducts the review from the balcony, one arm resting on a cushioned sill, the other raised in a gesture of reception. The crown prince (with side-lock) is again in attendance, accompanied this time by a single shaven-headed vizier; both are smaller than the king, as befits their lesser importance. The drawing may be the work of a student who wanted to adapt a scene similar to the Medinet Habu relief for a new project or who was simply copying a contemporary monumental carving which is now lost.

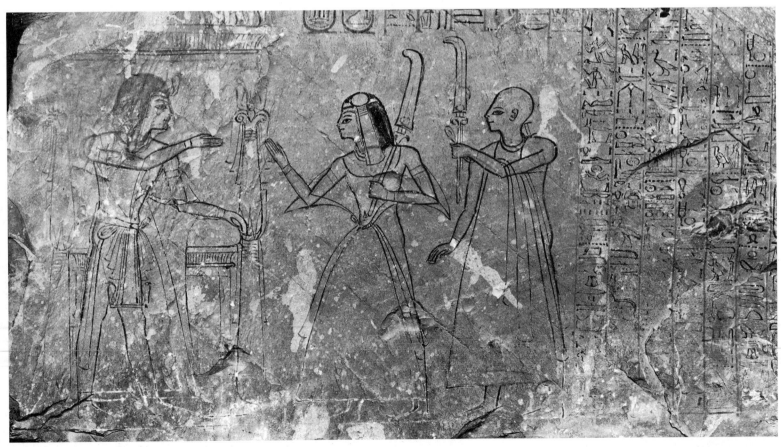

45

45 The Queen of Punt
Dynasty XVIII, time of Hatshepsut,
c. 1490–1470/68 BC

46 Sketch of the Queen of Punt
Ramesside period, c. 1305–1080 BC

One of the few Egyptian drawings which can be
identified with any certainty as a copy from an
existing monument is this small sketch (*right*)
found at Deir el Medina. It is undoubtedly based
upon a much earlier relief in Queen Hatshepsut's
temple at Deir el Bahri which portrays the obese
'Queen of Punt' (*above*), whom the Egyptians had
encountered on an expedition through the Red Sea
to Punt on the Somali coast during Hatshepsut's
reign. Clearly the outlandish size of the Puntite
queen fascinated the Egyptian artists, particularly
since their own ideal of feminine beauty
emphasized the slenderness of the body. One can
imagine a workman from Deir el Medina visiting
the nearby temple at Deir el Bahri and being struck
by the exotic figure carved on the wall, so much
so that he felt impelled to sketch it in a few lines.
A comparison with the relief shows how well the
drawing captures the spirit of the original portrait.

God and sky

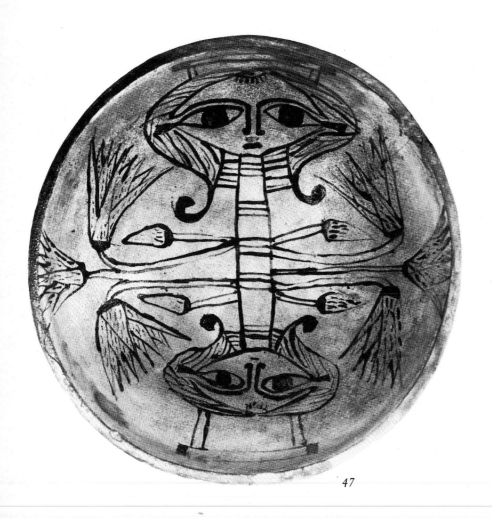

47

47 Decorated bowl

Dynasty XVIII, *c*. 1554/51–1305 BC

The interior of this faience bowl, bright blue in colour, is decorated with a design comprising two heads of the goddess Hathor crossed with two groups of lotus flowers. Hathor, goddess of many functions, among them that of the universal mother, could be shown as a cow (*plate 53*) or as a human being with cow ears; here, although not clearly drawn, the latter form has been used. In fact what is represented are two sistra or ceremonial rattles which have Hathor heads as part of their decoration, but the rattles are so stylized as to be almost unrecognizable as such.

48 Two Nile gods

Ramesside period, 1305–1080 BC

This working drawing on an ostrakon from the Valley of the Kings, the fragmentary inscription tells us, was made by the scribe, Neb nefer. It represents two Nile deities in a heraldic arrangement in which they unite the two symbolic plants of the North and South signifying the unity of the two lands. This important device was often used to decorate the sides of the king's throne and consequently would have been committed to memory or repeated by reference to a sketch such as this one. (See *plate 99* for the drawing on the other side of this ostrakon.)

48

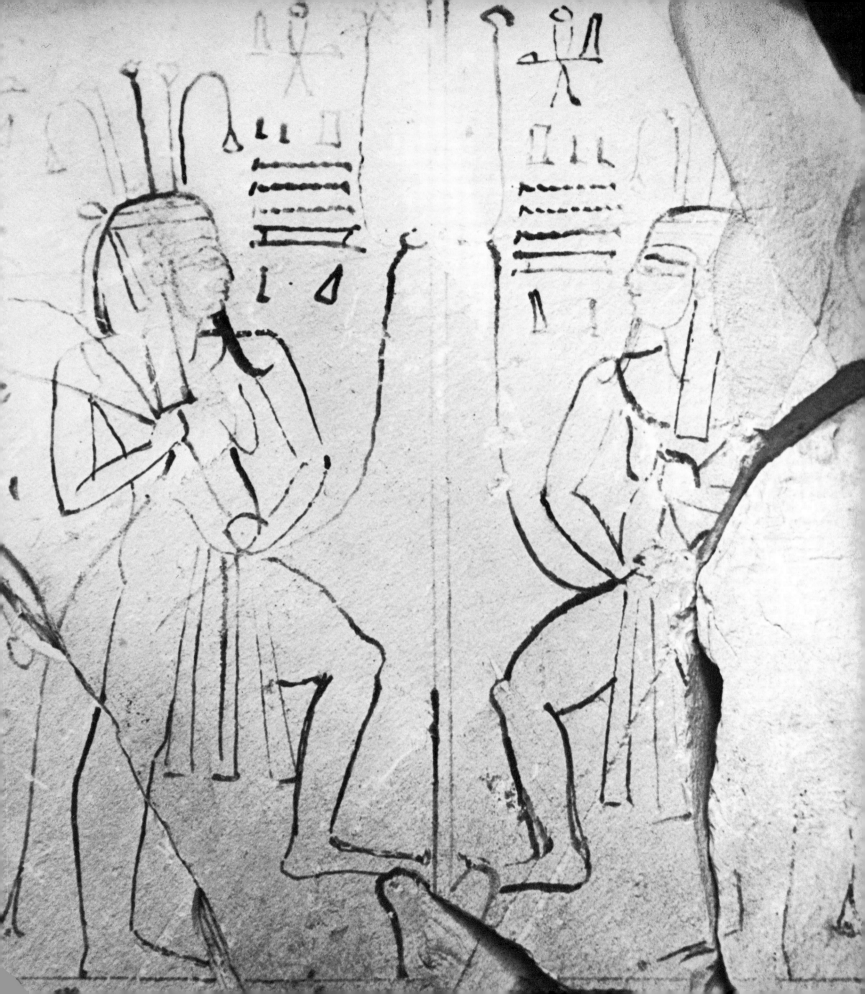

49

49 Man in adoration

Ramesside period, *c.* 1305–1080 BC

The text of this ostrakon from the Valley of the Kings is an invocation to the god Thoth on behalf of the scribe Amunhotep. It is entirely possible that the drawing and the text were both done by the man named, but this is by no means certain. The kneeling figure with upraised arms and sheer, transparent garments was drawn first. Then the lines for the text were ruled and the hieroglyphs written. The impression conveyed is one of joyful adoration. The near smile on the face and the well-rounded body bespeak a life of affluence.

50 Kneeling Isis

Ramesside period, *c.* 1305–1080 BC

In all her various aspects the goddess Isis, the divine mother, is usually depicted as a beautiful woman, and this small drawing on an ostrakon from the Valley of the Kings is no exception. The inscription gives the names of the artists 'Made by the scribe Neb nefer, and his son Hori'. We may suspect that this work was intended as a votive offering on their behalf. The text above is too fragmentary to be understood with any certainty, but it is possible that Isis is meant to be shown paying homage to the names of a king. As an example of direct drawing this figure can hardly be surpassed.

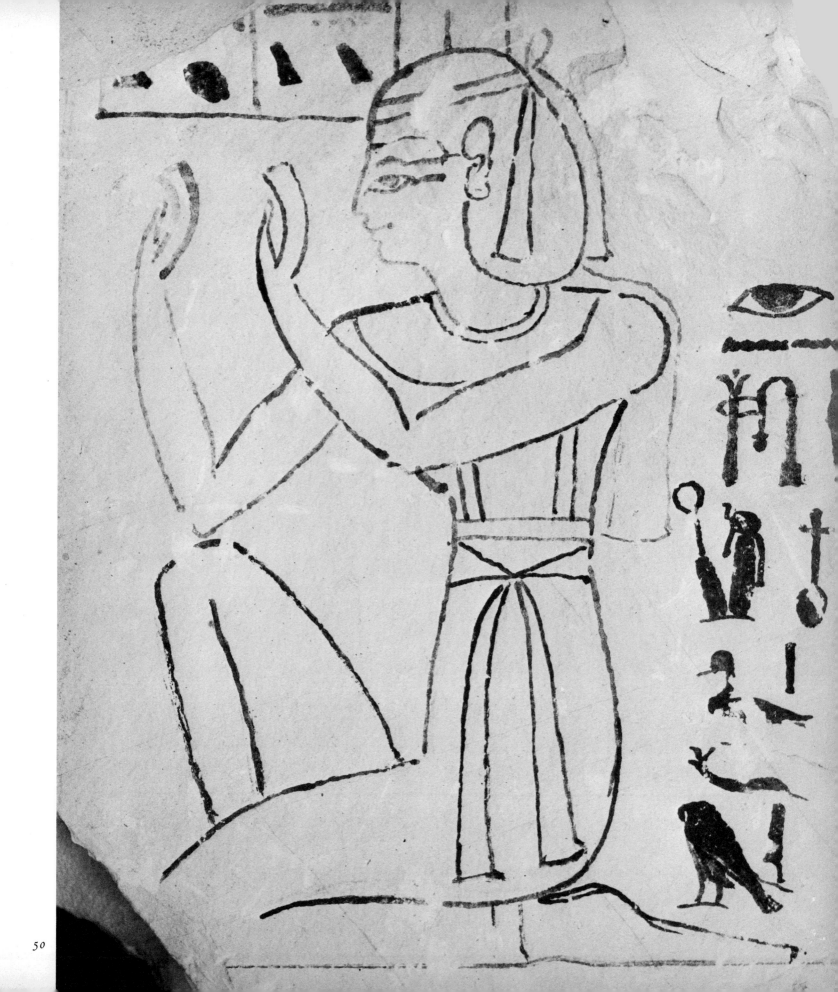

51 Four sketches
Ramesside period, *c.* 1305–1080 BC

The trial sketches on this ostrakon from the Valley of the Kings have to do with the illustration of religious subject-matter popular in the New Kingdom. The serpent head, cow head with sun disk, the horned animal head with two arms attached holding an offering and the thin figure with outstretched arms would all have found their proper place on the walls of Ramesside tombs in the vignettes of religious texts. It is possible that the artist was simply practising new motifs not completely familiar to him. From free studies such as these would have been developed the finished drawings for more formal use.

51

52

52 Bound oryx, seated goddess and scarab

Ramesside period, *c.* 1305–1080 BC

This calligraphic sketch from the Valley of the Kings includes notes for two or more compositions. The bound oryx is a typical study for an offering to the gods, the seated figure in the upper-left-hand corner could either be a preparation for a depiction of a goddess or part of an inscription. The character of the animal has been well caught in a few free strokes, contrasting with the figure which is done in an entirely conventional style. She is seated, with her legs drawn up tightly against her body. In one hand, which is not shown, she holds an *ankh*, the sign for 'life'. The configuration in the upper-right-hand corner is the greater part of a scarab glyph. The lines in the centre of the oryx's body are difficult to make out. One assumes that the artist was at work on a number of problems and simply used the same surface without regard to the proximity of various clashing subjects.

53

53 The cow of the goddess Hathor

Ramesside period, *c.* 1305–1080 BC

This spirited drawing depicts the sacred cow of Hathor, goddess of many functions but among them that of the universal mother. It comes from the Valley of the Kings and was made for the scribe Neb nefer, but the text is so damaged as to be almost unreadable, although Hathor is clearly mentioned. The goddess in her cow-form has been given a decoration of a beaded collar with counterpoise which is shown above her back. The normal cow's eye has been replaced by the falcon eye of Horus, the royal god who took the form of that bird. Although the cow is shown in the standard profile view the horns are seen in the characteristic frontal view.

54 Horus-name of Ramesses IV

Ramesside period, time of Ramesses IV,
c. 1162–1156 BC

What seems at first glance to be a group of
separate studies is, in fact, the Horus-name of
Ramesses IV. Each of the drawings is a standard
hieroglyphic sign: the bull, the arm holding a
stick, the seated goddess Maʿat and the *ankh*.
Together the signs describe the king as 'victorious
bull, living in truth'. This is then an artist's sketch
layout which was to be translated into carving or
painting. The workmanship is about average in
quality but there would have been no need for any
particular skill to be expended on such a stock
item.

54

55 *Vignette from the Book of the Dead*

Dynasty XXI, *c.* 1080–946 BC

Nut, the sky goddess, shown nude and balancing on her fingertips and toes to indicate the vault of the heavens, is lifted by Shu, god of the void, above the reclining figure of Geb, the earth. Shu is aided by two *Ba*- or soul-figures with rams' heads while other gods and spirits look on. The illustration is a standard version of one conception of the cosmos. It is Nut who gives birth to the sun in the morning, who swallows it at sunset and through whose body it travels during the night: 'Her mouth is the Western Horizon, her vulva is the Eastern Horizon.' The figures are based on carefully worked out and standardized models, but nevertheless have great vitality and grace.

This papyrus is part of the copy of the Book of the Dead, found at Deir el Bahri, which was prepared for one Nesitanebtashru, daughter of the High Priest of Amun, Pinudjem I.

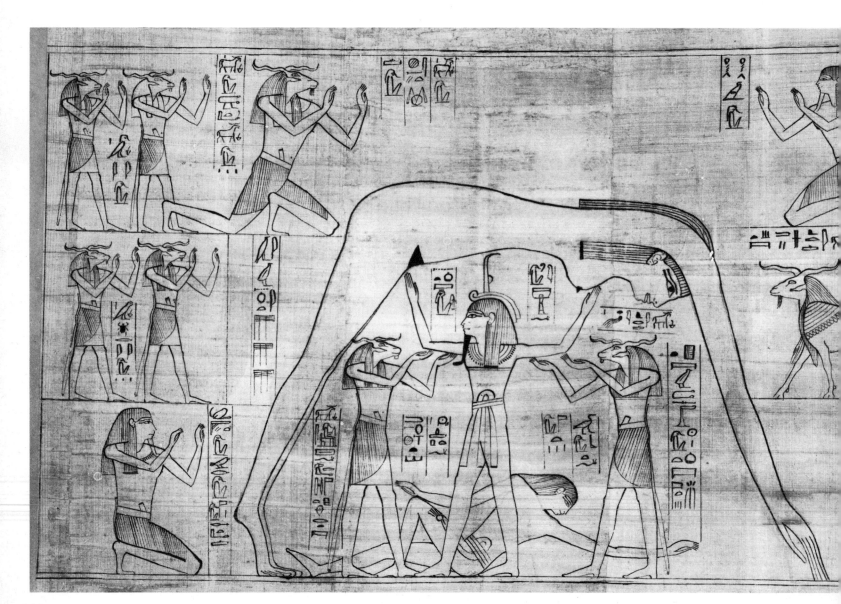

56 Vignette with the gods Re-Harakhty and Thoth

Ramesside period, *c.* 1305–1080 BC

The god Thoth, the ibis-headed patron of writing and scribe of the gods, advances before Re-Harakhty, the sun-god in his guise as a falcon-headed man. Thoth holds the writing-case or scribal palette in his left hand, and with his right dips his writing implement into one of the two containers of ink, red or black. Re-Harakhty is

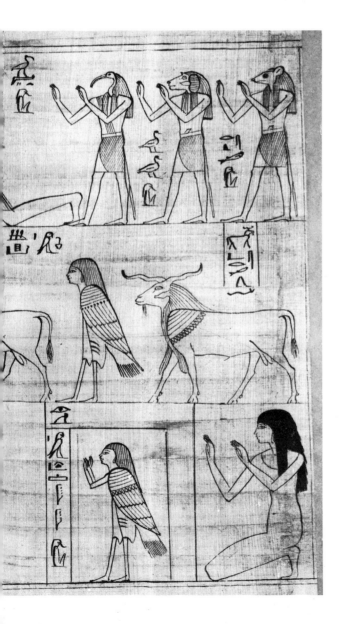

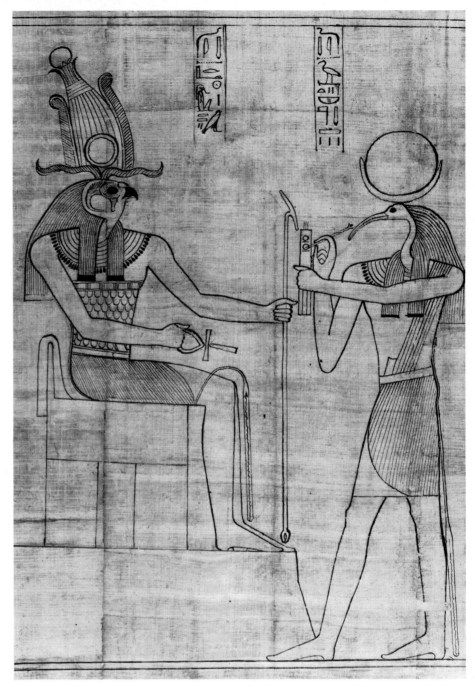

56

enthroned as a king of the gods. He holds in his two hands the *was* sceptre and the *ankh*, attributing to him the ability to control 'power' and 'life'. The inscription simply identifies the two deities and adds the title of Thoth as 'lord of divine speech'. For an illustration of the patron of scribes and draughtsmen, it is particularly appropriate that the figures on this papyrus should be so finely drawn.

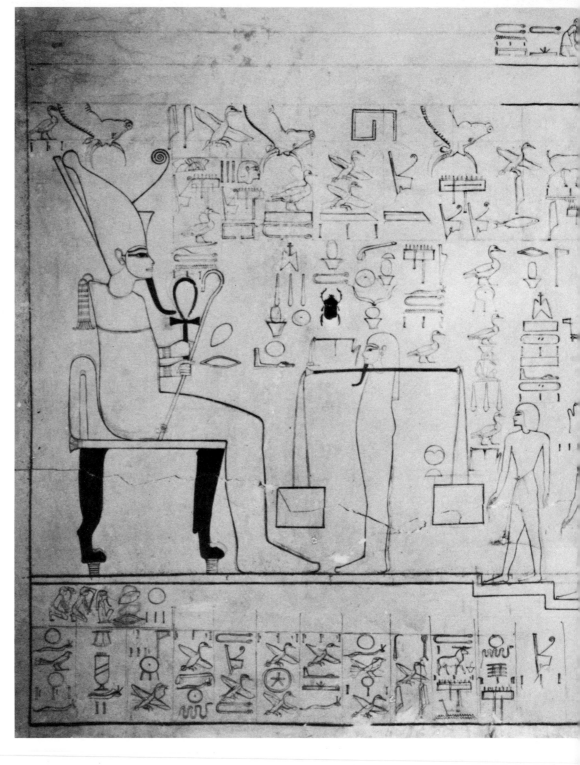

57 The hall of Osiris in the tomb of Horemheb

Dynasty XVIII, time of Horemheb, *c.* 1332–1305 BC

The tomb Horemheb had prepared for himself as pharaoh lies in the Valley of the Kings at Thebes. This unfinished wall decoration is taken from the fifth division of the Book of Gates, one of the elaborate religious texts used on the walls of the royal tombs of the New Kingdom, which describes the progress of the sun-god and the spirit of the king through the underworld. The hall of Osiris, which occupies the back wall of the sarcophagus chamber in Horemheb's tomb, depicts Osiris, as god of the dead, sitting in judgment. He holds the crook and the *ankh*, before him is a balance with its cross-bar supported by a mummy. From the ceiling are suspended four bubalis-heads,

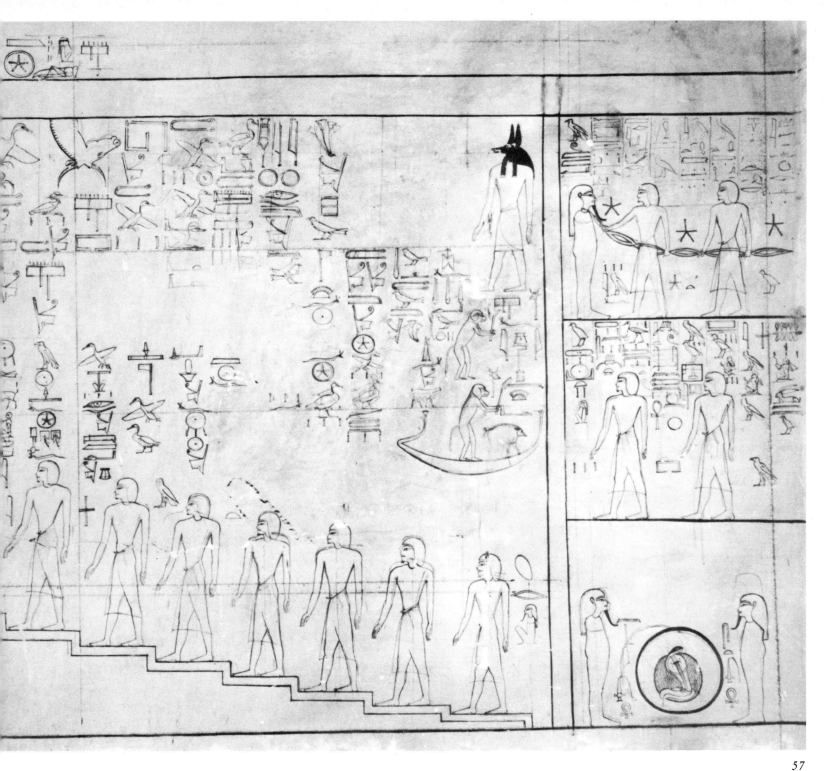

in the upper-right-hand corner is an image of Anubis, protector of the cemetery, and on the steps before Osiris are nine figures identified as the 'enemies' of the god. The texts are particularly difficult to interpret but the intention of illustrating the judgment of the spirit is clear. As an example of drawing this section of wall demonstrates well the preparation for final carving. Two stages can be discerned, the initial lay-out of the design and the corrected and finished drawing. Much of the wall decoration in the tomb is incomplete, but this gives us an opportunity to observe the work in progress as it was halted in antiquity.

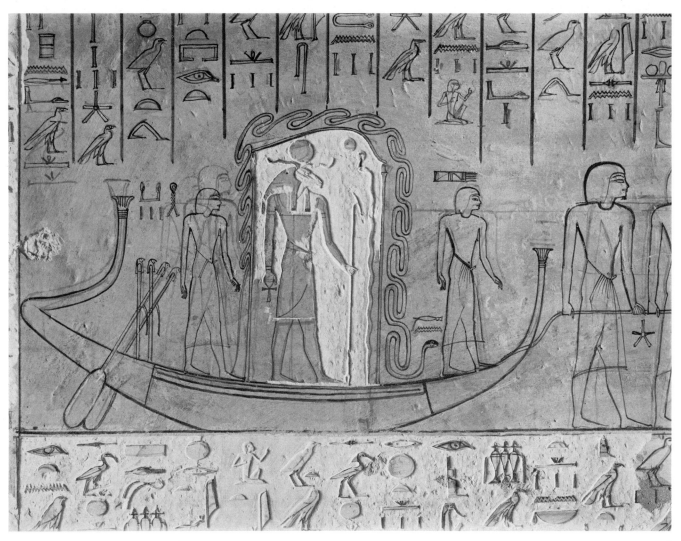

58

58, 59 Two views of the barque of the Night Sun in the tomb of Horemheb

Dynasty XVIII, time of Horemheb, *c.* 1332–1305 BC

Horemheb's sepulchre in the Valley of the King's offers many interesting insights into the stages of preparation for tomb decoration. Some of the walls have only the preliminary drawings, others are in various phases of the process of carving in relief, while still others have been completed by painting the scenes. *Plate 59* is still in the earliest stage and depicts the barque of the Night Sun as it

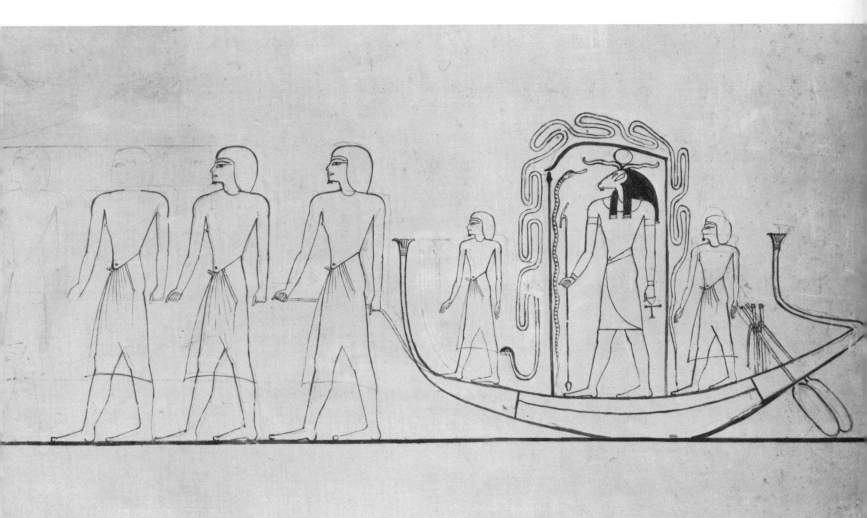

59

is pulled in procession through the underworld. The ram-headed Night Sun stands in a shrine protected by two serpents. Although this is only the preliminary drawing and some correction is evident, it is essentially a complete statement ready to be translated into relief carving. *Plate 58* shows the barque of the Night Sun from another section of the tomb, but in a slightly more advanced state. The guidelines on which all figures were constructed can be seen, particularly the verticle line for the figure of the Sun. A number of corrections of size and position are also in

evidence. The two attendants in the boat with the god have been re-drawn several times, while the stern post and the steering oars have been re-positioned. In the inscription above, several similar alterations can be observed, even to the complete re-drawing of whole characters. From these indications we can see clearly that the final effect of a wall decoration was dependent on a series of careful changes carried out by a draughtsman under the supervision of a master artist who had very definite ideas about composition and proportion.

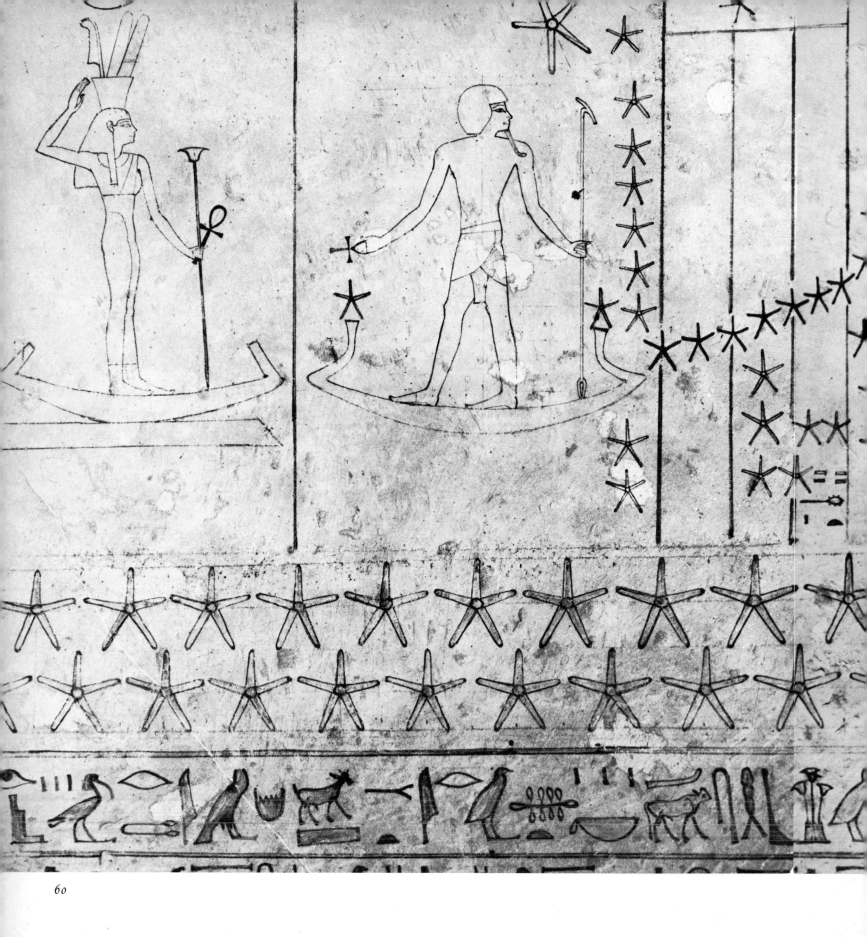

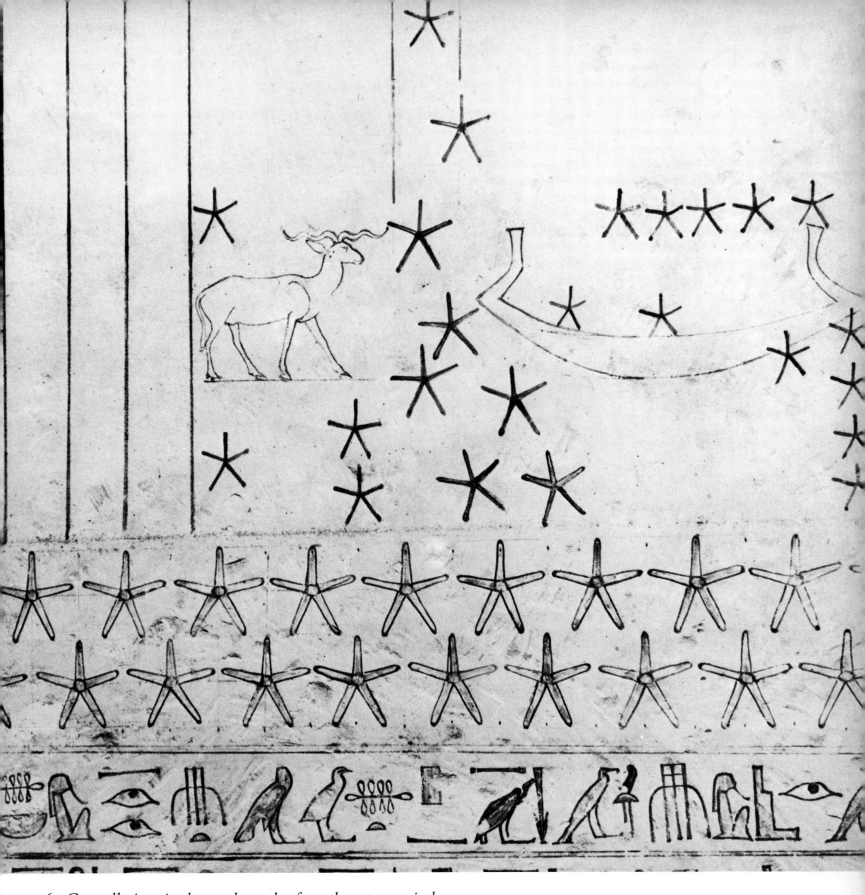

*60 Constellations in the southern sky from the astronomical
ceiling in the tomb of Senenmut at Deir el Bahri, Thebes*

Dynasty XVIII, time of Hatshepsut, *c.* 1490–1470/68 BC

60 (previous two pages)

In the tomb of the architect and favourite of Queen Hatshepsut, Senenmut, there is preserved the earliest astronomical ceiling known from Egypt (Parker 1974). Portraits of this important official are included in the section on 'Man' (*plates 2–4*), which give us some idea of his appearance. Here we see the use of draughtsmanship for a somewhat different purpose. The constellations of the ship and the sheep are included in this detail of the southern sky which also shows figures which can be identified with Orion and Sothis. The stars and groupings are carefully drawn, and according to Dr R. A. Parker, the layout of the ceiling is based on a star clock which ultimately dates back to Dynasty XII.

61 Detail from the astronomical ceiling in the tomb of Senenmut

Dynasty XVIII, time of Hatshepsut, *c.* 1490–1470/68 BC

This diagram illustrates four parts of the calendar of the lunar year. Since the circles are divided into 24 sections, the intention seems to have been an illustration of the 12 feast days of the months. In this detail those of months 5–8 are included, or the second of the three Egyptian seasons. Above are five-pointed stars and below gods with the disk of the sun on their heads. The circles in this calendar diagram were drawn with a compass on a string after the area had first been divided into quarters. Traces of the over-all grid in the background are plainly visible.

62 Constellations in the northern sky, from the astronomical ceiling in the tomb of Senenmut

Dynasty XVIII, time of Hatshepsut, *c.* 1490–1470/68 BC

At the bottom of the depiction of the northern sky, the constellation known as the 'Crocodile' is shown. The figure of a man opposes it in the gesture of spearing, but the spear is missing (Parker 1974). The details of each figure have been drawn with great care, almost as if the addition of paint were unnecessary. In this ceiling, the function of the artist was to reproduce the work of the ancient astronomer. He was allowed little room for invention and had to operate within the restrictions laid down for him. The skill of the artist was exhibited only in the degree to which he could be faithful to an original.

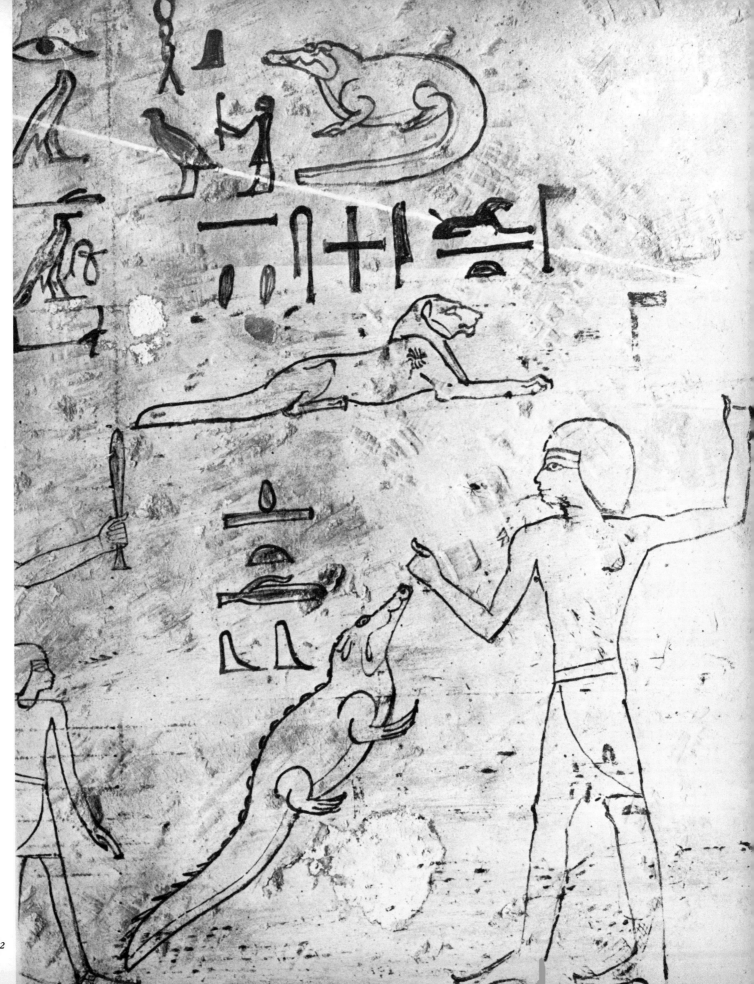

Music and dance

63 Seated harpist

Dynasty XXVI, *c.* 664–525 BC

This small drawing on an ostrakon from Deir el Bahri is deceptive in its simplicity. With great economy of line the artist has captured the essential form of the blind harpist, crouched at his instrument. The subject is standard (cf. *plates 64–5*) and can be seen in many Theban tombs, so it is possible that this work is an imitation of an earlier painting. Details such as the positioning of the fingers, the delineation of the rib cage and the bottom of the foot all point to a perceptive eye for the minutiae of a musician's posture.

64 The hands of a harpist

Ramesside period, *c.* 1305–1080 BC

In this fragment from the Valley of the Kings the artist originally sketched a male harpist, probably blind like others of his trade, playing a large, heavy-stringed harp. From the developed compositions in Old Kingdom tombs there are a number of examples of groups of musicians, usually including at least one harpist. The tradition of including an orchestra in tomb decoration persisted, so that we can trace the modification of the instruments and the change in membership of the group. One of the most difficult details for the draughtsman to depict was the position and movement of the harpist's hands. The artist here has caught very well the unusual splaying of the hand necessary for the plucking of a stringed instrument. But clearly such subjects required a good deal of practice.

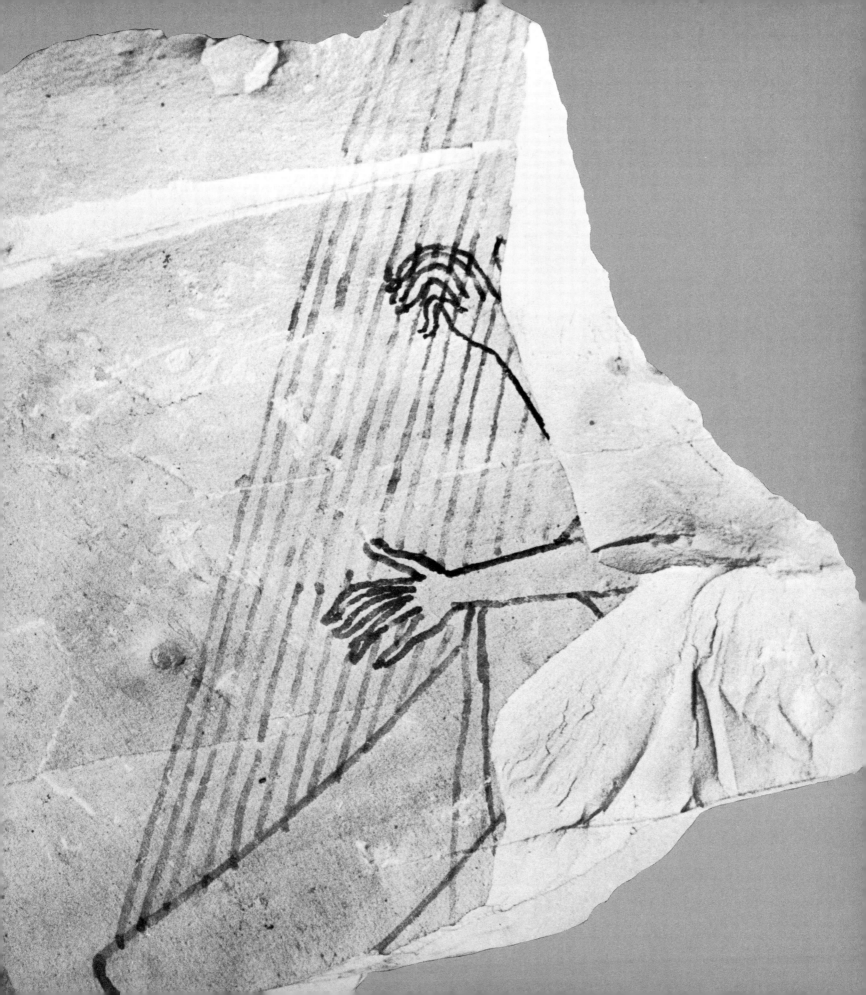

65

65 Hunchback playing a double pipe
Ramesside period, *c.* 1305–1080 BC

This small drawing from the Valley of the Kings is among the most charming depictions of musicians to have been preserved for us from ancient Egypt. A fat little hunchback plays a double pipe; he stands on a ground line, below which are two shapes that are hard to understand, although the artist may have been experimenting with the torso of another figure. The fact that this is a sketch is further verified by the faint drawing above and behind the figure of a falcon looking to the right. It is as if the artist, while practising standard subjects, erased the surface and used a moment of his time to satirize some casually observed acquaintance.

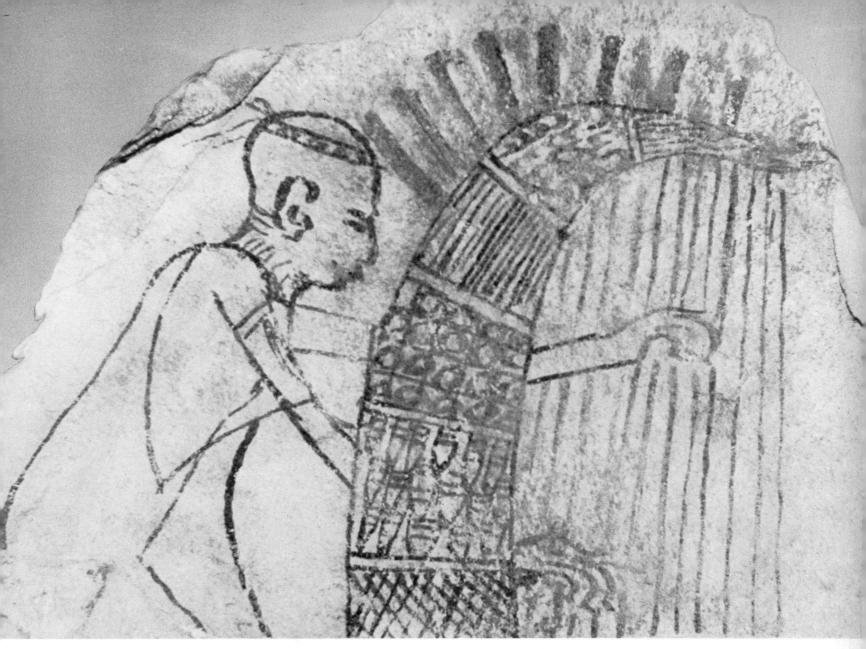

66 Harpist

Ramesside period, *c.* 1305–1080 BC

Like the sketch in *plate 64*, this drawing depicts a harpist who plays the largest or standing harp. In this instance we have more than just the hands remaining: the subject is nearly complete except that a limestone chip has flaked off reducing the surface by one-third. A shaven-headed man is shown with a richly decorated instrument which is probably of a type used for temple ritual. This drawing compares very closely with a painting of two harpists making music in the presence of the gods, from the tomb of Ramesses III in the Valley of the Kings. It is possible that the sketch illustrated here was a preparatory drawing for a similar tomb decoration. This is further suggested by the manner in which the harp and the figure have been drawn. It seems as if the artist made a study of the decoration of the harp without thought as to how it was to be played, later adding the figure of the performer with both arms behind the body of the instrument, a position difficult to imagine. The tuning pegs seem to have been re-drawn as well, another indication of the tentative nature of the sketch. By contrast the harpist has been executed with a sure hand and fine flow of line.

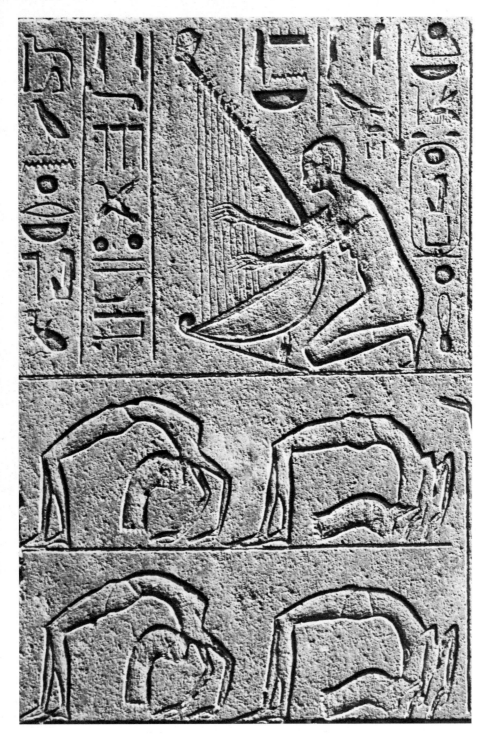

67 Relief of gymnastic dancers and a harpist

Dynasty XVIII, time of Hatshepsut,
c. 1490–1470/68 BC

This illustration is included as a comparison with
plate 68 and *colour plate VI*, because it suggests the
type of composition for which the two sketches of
acrobatic dancers may have been designs. The pairs
of dancers on this relief from Karnak seem to be
shown in two stages of the same ritual acrobatic
display, those on the left being slightly higher off
the ground than those on the right. While the
differences between these carved relief figures and
the drawn examples are obvious, it is still possible
to see a distinct relationship between the two; it is
only that in the medium of hard stone the images
which originated in drawing have been somewhat
regularized. If one compares the harpist here with
those in *plates 64* and *66* the same effect of the
transition from one medium to another can be
observed.

68 Acrobatic dancer

Ramesside period, *c.* 1305–1080 BC

Very similar in subject-matter to the dancer in
colour plate VI, the acrobat on this ostrakon from
Deir el Medina is treated in quite a different way.
Where the Turin example is a gem of graceful
agility this drawing is somewhat lacking in spirit.
The artist has not given the figure the same elegant
arched back; the treatment of the hair lacks
movement. The type of woman represented is
different and although she wears the same kind of
skirt she is also decorated with tattooing on her
torso, bracelets, armlets and a choker as well as
another tattoo on her upper thigh. But the actual
drawing has been done with skill and care, and is
undoubtedly superior to a similar sketch on the
verso (not illustrated) which may be a copy by a
less-accomplished apprentice.

68

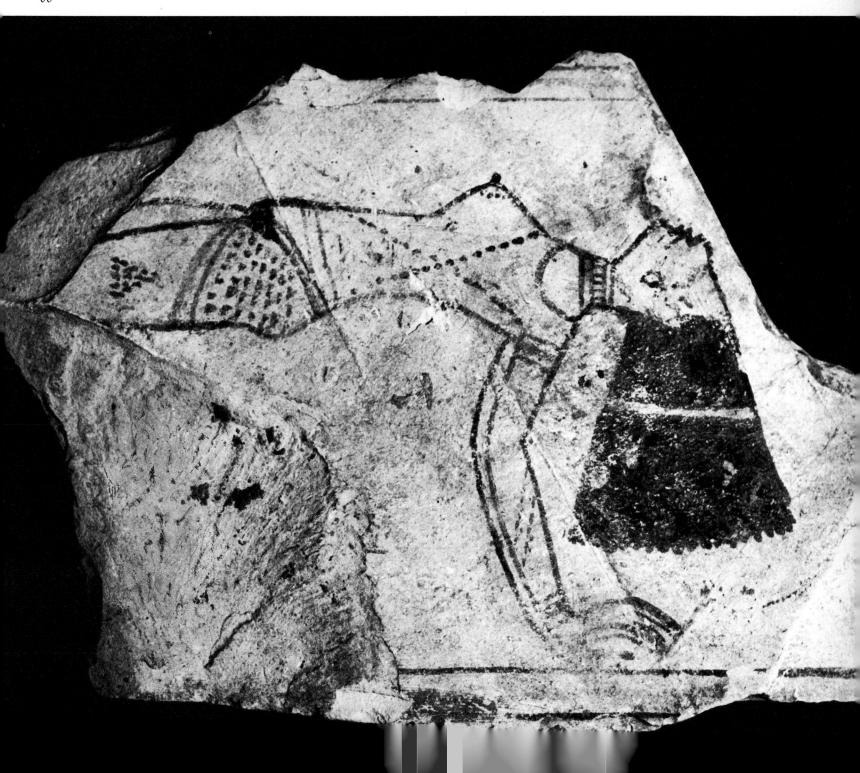

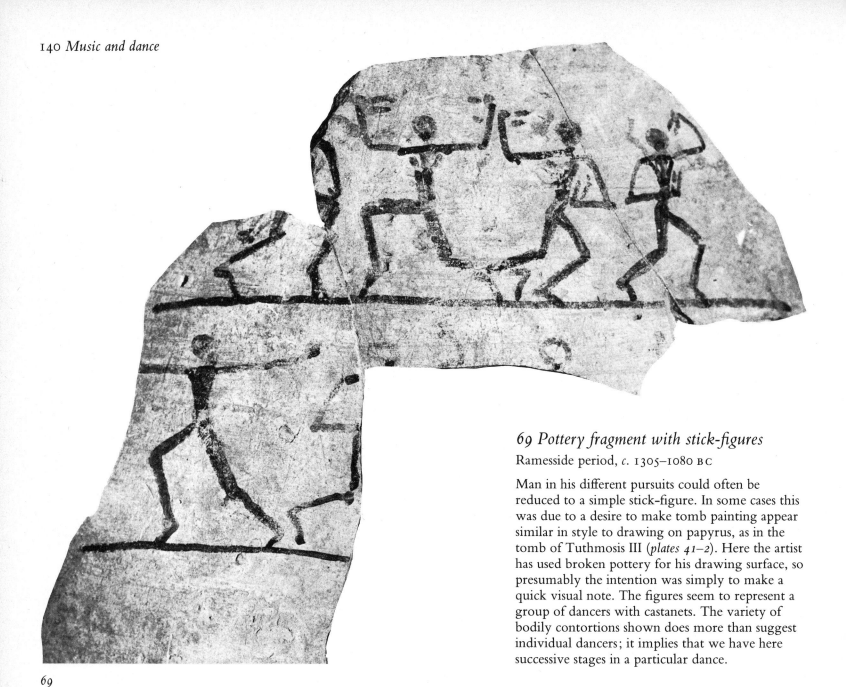

69

69 Pottery fragment with stick-figures

Ramesside period, *c.* 1305–1080 BC

Man in his different pursuits could often be reduced to a simple stick-figure. In some cases this was due to a desire to make tomb painting appear similar in style to drawing on papyrus, as in the tomb of Tuthmosis III (*plates 41–2*). Here the artist has used broken pottery for his drawing surface, so presumably the intention was simply to make a quick visual note. The figures seem to represent a group of dancers with castanets. The variety of bodily contortions shown does more than suggest individual dancers; it implies that we have here successive stages in a particular dance.

70 Study with figures of men and a monkey

Ramesside period, *c.* 1305–1080 BC

This study on an ostrakon from the Valley of the Kings is interesting because it suggests the stages an idea for a composition might pass through on one drawing surface. The largest and most complete subject depicts a man with a monkey on his shoulder. The animal, which is carefully held by the upraised hand of the man, is shown playing on a double pipe. There may possibly be some satirical intent here, but the reasons for it are not clear. The figures of man and animal are well drawn but suggest a haste in execution. In the right half of the limestone fragment three other men are sketched in various stages of completion, almost as if they were intended as demonstrations of other possible poses which might be utilized for the major composition. Of particular interest is the stick-figure, technically very similar to the dancers of *plate 69*.

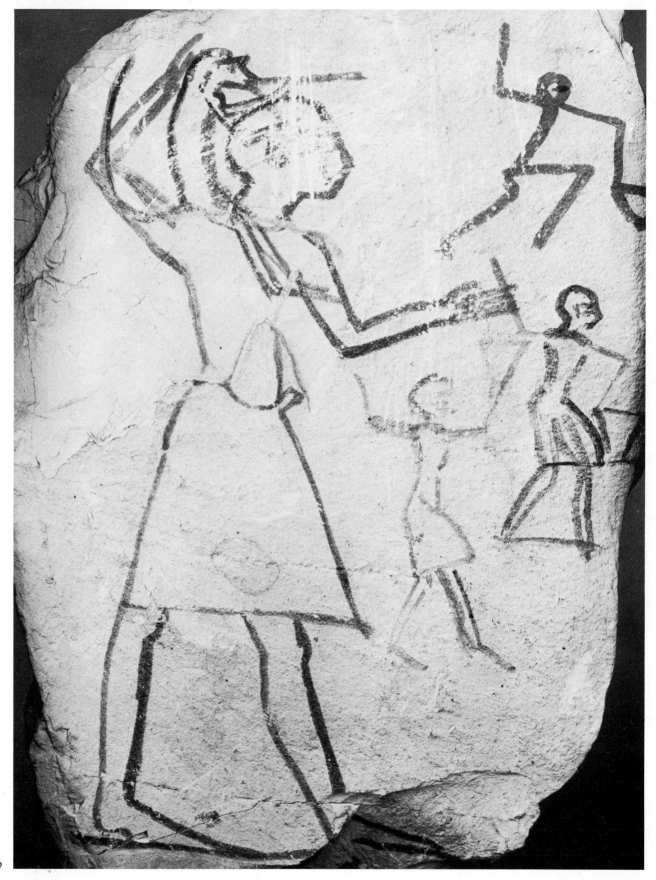

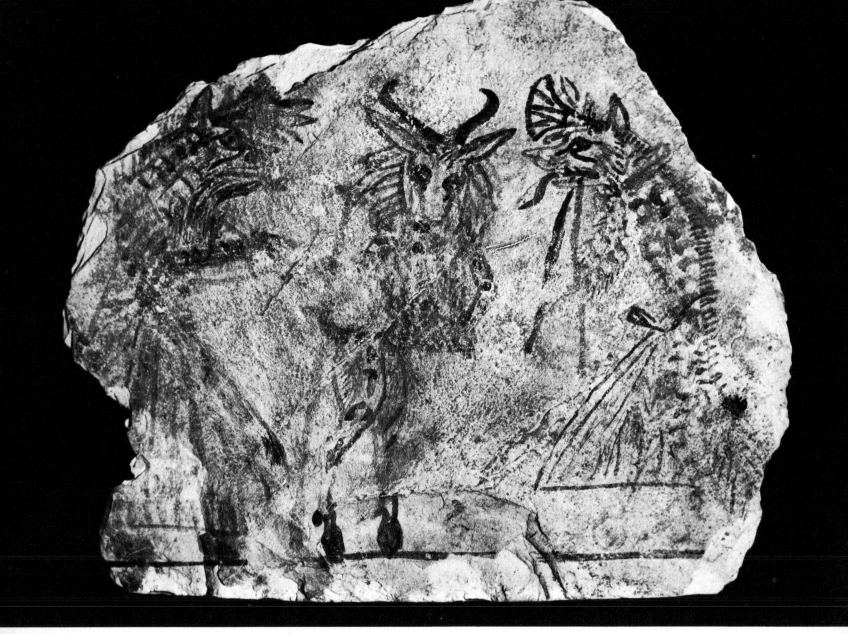

71 Animal dancer and two animal musicians

Ramesside period, c. 1305–1080 BC

Two wolverine animals dressed in long kilts and bedecked with lotus flowers stand on either side of a goat dancer. The animal on the right with extended tongue plays with difficulty on a double pipe while the one on the left may be either singing or keeping time by clapping his hands. This scene, on an ostrakon from Deir el Medina, is familiar from a number of tomb paintings in which instrumentalists and dancers are shown. Certainly the intention is to compare the awkwardness of the animal participants with the actual postures and gestures of human beings who perform the same activities.

72 Monkey and boy

Dynasty XX, *c.* 1196–1080 BC

What seems at first glance to be a unified composition in which an animal is led by a boy is revealed after examination as two separate studies. The monkey on the left is drawn with considerable care and attention to his animal qualities, but he plays a double pipe, a human activity, and this drawing from Deir el Medina can be compared with others in which human occupations are carried out by animals. The smaller figure appears to be a later addition done with less care.

73 Two animals

Ramesside period, *c.* 1305–1080 BC

Similar in composition to the example of the boy and the monkey (*plate 72*), this ostrakon from Deir el Medina also suggests two separate studies. The principal drawing is of a wolverine animal playing on the double pipe. Secondary to it is a sketch of a goat with curved horns, added in the space left available. It is impossible to tell if these sketches were done in preparation for some other work or if they were meant as little more than practice pieces.

72

73

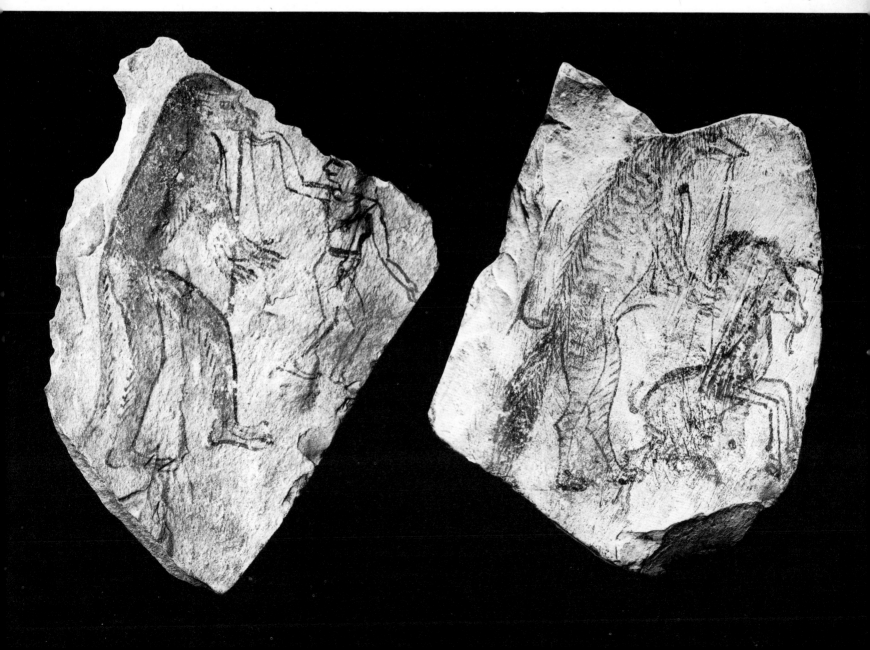

Fable and humour

74, 75 Humorous papyrus and detail showing animals playing Sennet

Ramesside period, *c.* 1305–1080 BC

This papyrus, now in the British Museum, depicts various animals in a number of human occupations. In the vignette (*plate 75*) two natural enemies are shown at the gaming-board enjoying a heated session of Sennet. Played on a narrow surface divided into three parallel paths, with pieces of two distinct shapes, this game was not unlike draughts and had a great popularity among the ancient Egyptians. A number of examples of the board and the 'men' or pieces have been found, but the rules for play are still a subject for study. The lion and the antelope seem to be caught up in the spirit of competition. The details of table and chairs contribute to the sense that a standard subject has been parodied. The basis for such a humorous rendering of the two animals was probably a stock funerary scene in which a man and wife were shown, playing a similar board game. See also *plate 76*.

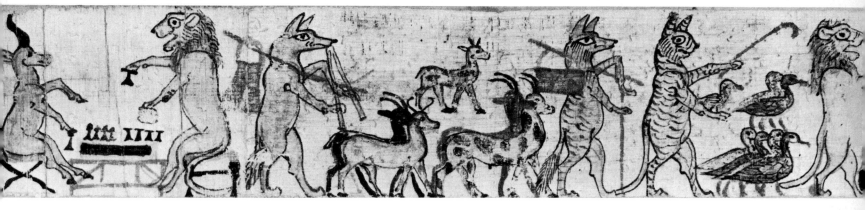

74

75

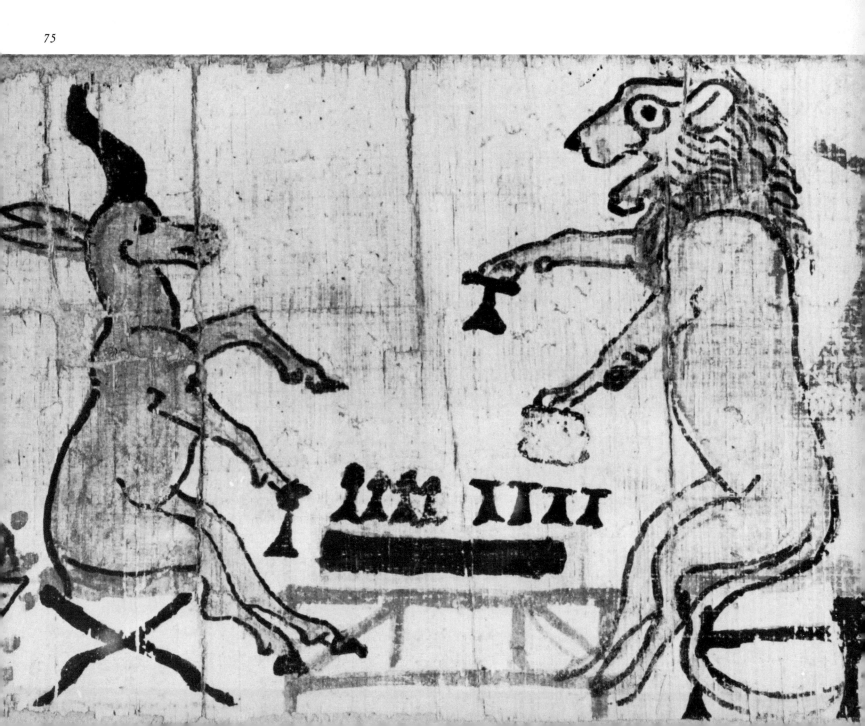

76 *A procession of animals with geese*

Ramesside period, *c.* 1305–1080 BC

In this detail of *plate 74* a familiar character, the cat who walks upright, reappears (cf. *colour plate XIII*). He is accompanied by a fox-like animal and a lion, and assumes the role of the goose-herd once again. In this case it is the animal following him which has the pack slung over his shoulder. The cat also raises his stick to prod his charges with one hand, while he carries one of the smaller fowl in his other hand. A comparison of this cat with those in *plate 78* and *colour plate XIII* suggests that each was derived from a common model. Perhaps they were all part of a popular illustrated folk tale which is now lost. An interesting comparison can be made with the decoration of a harp from the Sumerian burials at Ur in Mesopotamia. Pre-dating the British Museum papyrus by over fifteen hundred years, the inlays represent animals playing musical instruments and carrying offerings.

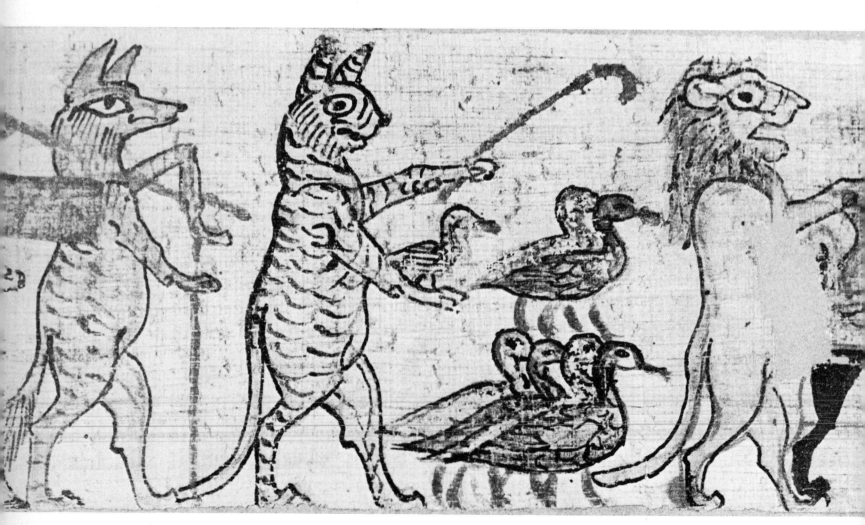

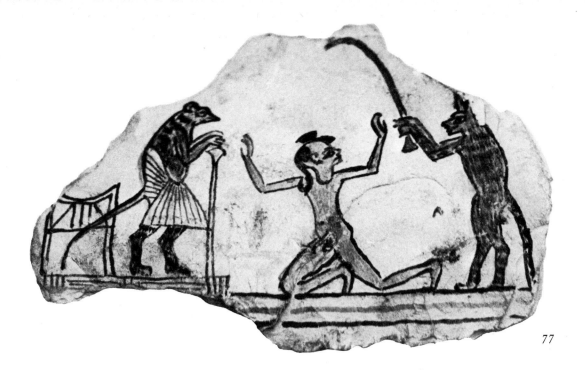

77

77 Two animals chastise a youth

Ramesside period, *c.* 1305–1080 BC

In another scene where the roles of the real world are reversed, a youthful male is brought into the presence of a mouse-noble by a servant cat. The characters are the same as in *plate 78* with the addition of the youth. Egyptian children were usually represented nude, with head partially shaved and side-lock, symbol of childhood. The probable basis for this group is to be found in a traditional scene painted on tomb walls depicting servants being brought into the presence of the lord of the estate. The punishment of unruly workmen was considered so much a part of the daily routine that it was assumed that it would continue in the afterlife. The substitution of the child for the adult malefactor and the animals for supervisors may suggest a story for children in which these roles were played by unusual characters.

78 A cat waits on a mouse

Ramesside period, *c.* 1305–1080 BC

In this composition a traditional scene showing an attendant and person of distinction has been transformed by the assignment of these roles to two animals. A cat, standing erect, waits on a seated mouse. In one hand the cat holds a linen cloth and in the other a dressed fowl and fan. The mouse, dressed in an elaborate kilt, has a drinking bowl in one hand and a fragrant flower in the other. The scene parodied is the standard tomb representation of the deceased at a banquet being waited on by naked servant girls; in the reversed world the natural enemy of the mouse becomes the willing attendant.

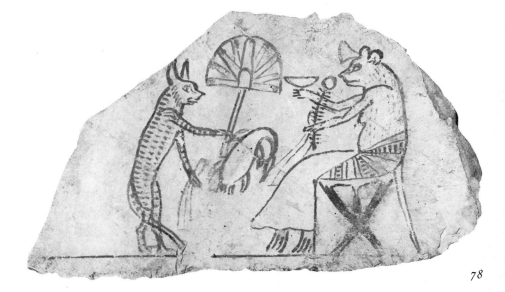

78

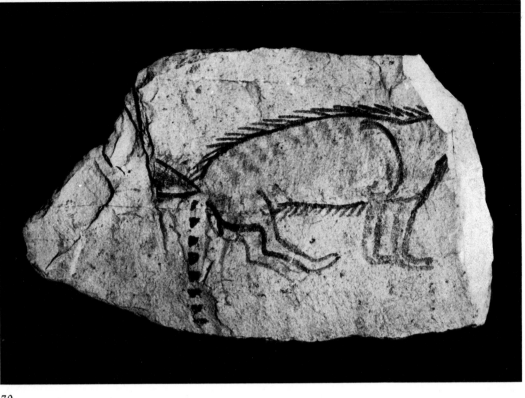

79

79 ?Hyaena defecating
Ramesside period, c. 1305–1080 BC

On this small fragment from Deir el Medina the artist may have intended to suggest the idea of cowardice through the use of a visual device. It is possible that this is only a part of a larger composition in which one animal, perhaps a hyaena, was shown confronted by another, and therefore defecating in fright. Alternatively, to judge from the shape of the stone chip, only the head of the creature may have been lost, in which case the complete drawing may merely have been a humorous sketch of an animal relieving itself.

80 A donkey in a boat
Ramesside period, c. 1305–1080 BC

An image such as this of a donkey in a boat may have had some satirical purpose. Boats were an important means of transport, it almost goes without saying, in the real life of the Nile as well as in the afterlife. In religious and funerary art they are usually meant to convey the deceased, the king or various gods, particularly the sun-god, across the waters of the underworld. That an animal such as a donkey should be substituted for the more normal occupants implies some sort of joking

reference on the part of the artist, perhaps of a sacrilegious nature. The lazy animal with his foreleg bent to provide a resting place for his muzzle has been characterized with care, however casual the drawing seems. But there is none of the finished quality of the animals of the humorous papyri. The whole composition gives the impression of a private joke, to be enjoyed by a few close friends of the artist.

81 Two boats
Ramesside period, c. 1305–1080 BC

This crude and seemingly comical sketch from Deir el Medina, in red and black ink, may possibly be a design for a piece of funerary jewelry such as a pectoral. It depicts two boats, the upper of the two bearing a sun disk with scarab, emblem of the sun-god Re, the lower carrying two baboons, who traditionally greet the morning sun. The smaller vessel has papyrus blossoms at prow and stern, the larger a rudimentary indication of a steering oar, or perhaps a streamer tied to the stern post. The compressed rectangle of water on which the lower boat rests and the bead pattern enclosing the design seem to confirm the idea that this is a study perhaps for a pectoral.

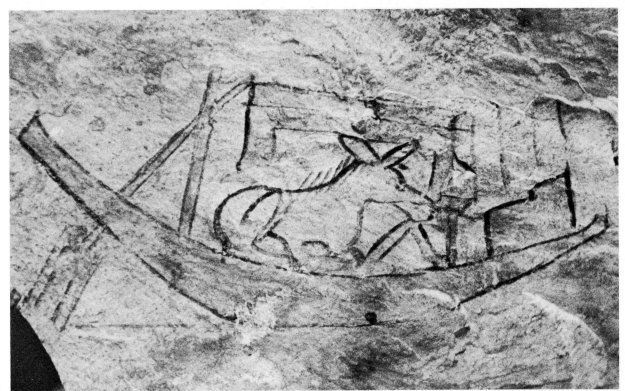

80

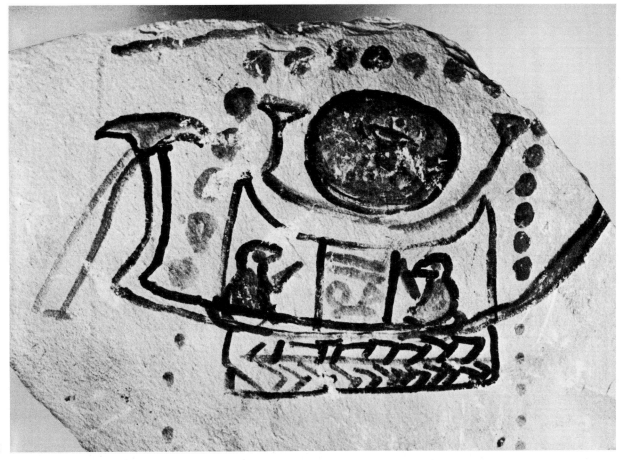

81

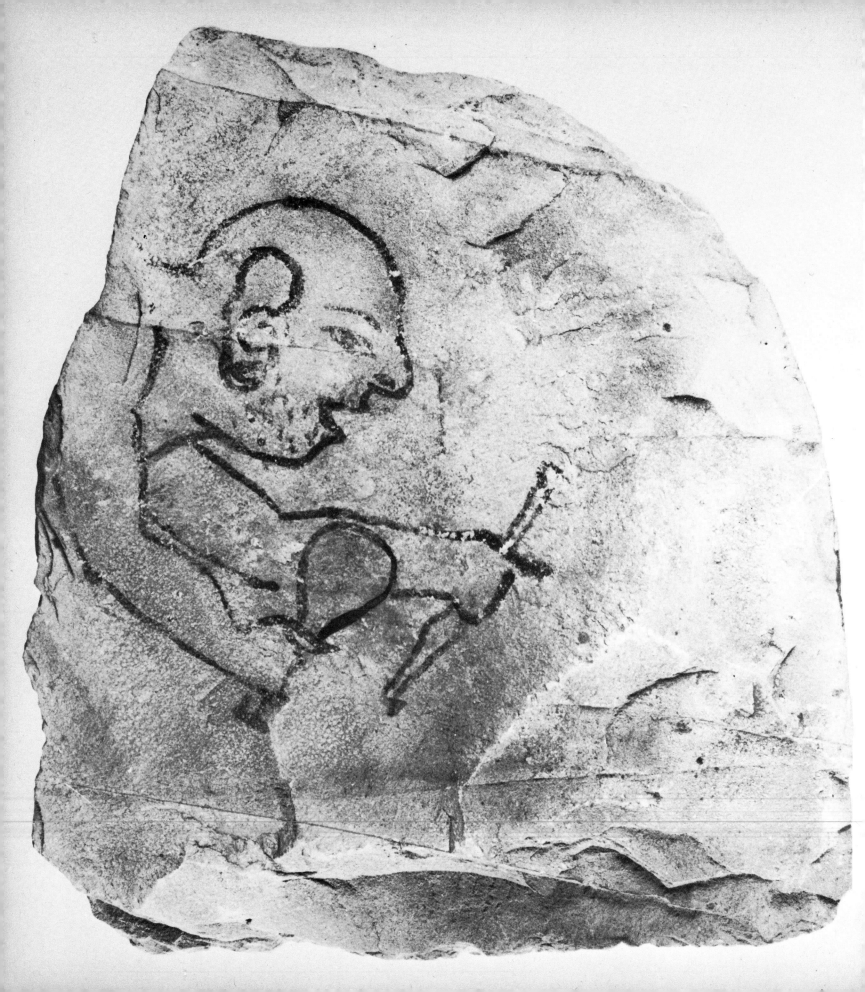

82 *Unshaven stone-mason*

Ramesside period, *c.* 1305–1080 BC

Pity the poor stone-mason thus caricatured by an anonymous draughtsman. This is probably one of the most clear-cut examples of humour to have come down to us. The skilled artist who worked with pen or brush must have looked down on the labourer who toiled with chisel and mallet. The round head, bulbous nose and open mouth create a perfect image of simple-mindedness.

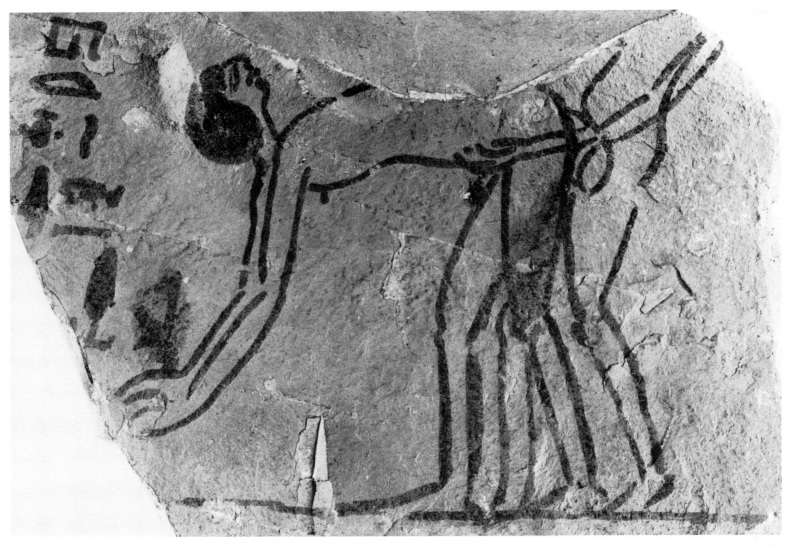

83

83 *Erotic scene*

Ramesside period, *c.* 1305–1080 BC

This simple erotic drawing is rather difficult to interpret without the help of the missing portion above. The figure on the right is clearly male, and is engaged in sexual intercourse with a bending figure who could also be male but is more probably a woman. The shape of the legs and torso as well as the prominent nipple support the latter interpretation. Unfortunately the text is short and incomplete, and therefore of no help. In the Turin 'erotic papyrus', however, there is an exact parallel for this scene in which the two participants are, without doubt, male and female.

84 Erotic scene

Ramesside period, *c.* 1305–1080 BC

This drawing is described in the catalogue of the Egyptian Museum, West Berlin, as depicting *Zwei Ringer*, 'Two wrestlers'. A close examination of the subject suggests that this identification might well be emended. It appears to represent a man, on the left, and a younger woman who fondles him while they embrace. On either side of the pair are spectators who seem to encourage their erotic play. The subject is known from the Turin 'erotic papyrus', which includes a number of vignettes of couples of the same type.

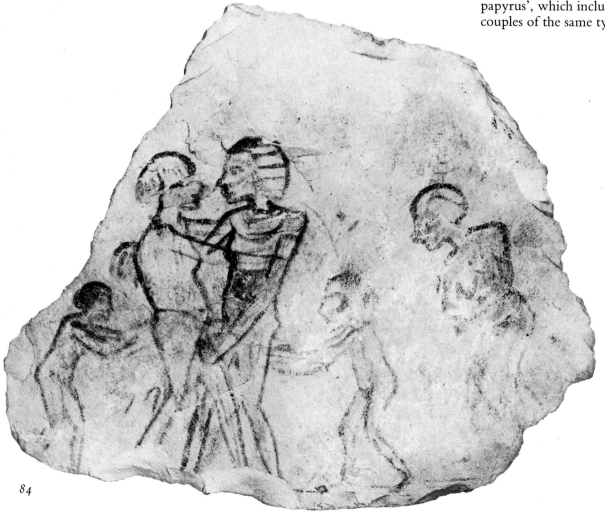

84

85 Erotic scene

Ramesside period, *c.* 1305–1080 BC

In this erotic drawing a man and a young woman are making love in a rather contorted posture. She has her legs over his shoulders and, due to the fragmentary condition of the stone chip, it is impossible to understand how her torso is

supported. That this drawing was casual in intent or experimental in nature is suggested by the lines of the woman's leg which cross the lines of the neck. The rather curious physiognomy of the man can be paralleled in the Turin 'erotic papyrus'. The quality of this intimate scene is enhanced by the gesture of the woman's hands caressing the chin of her lover.

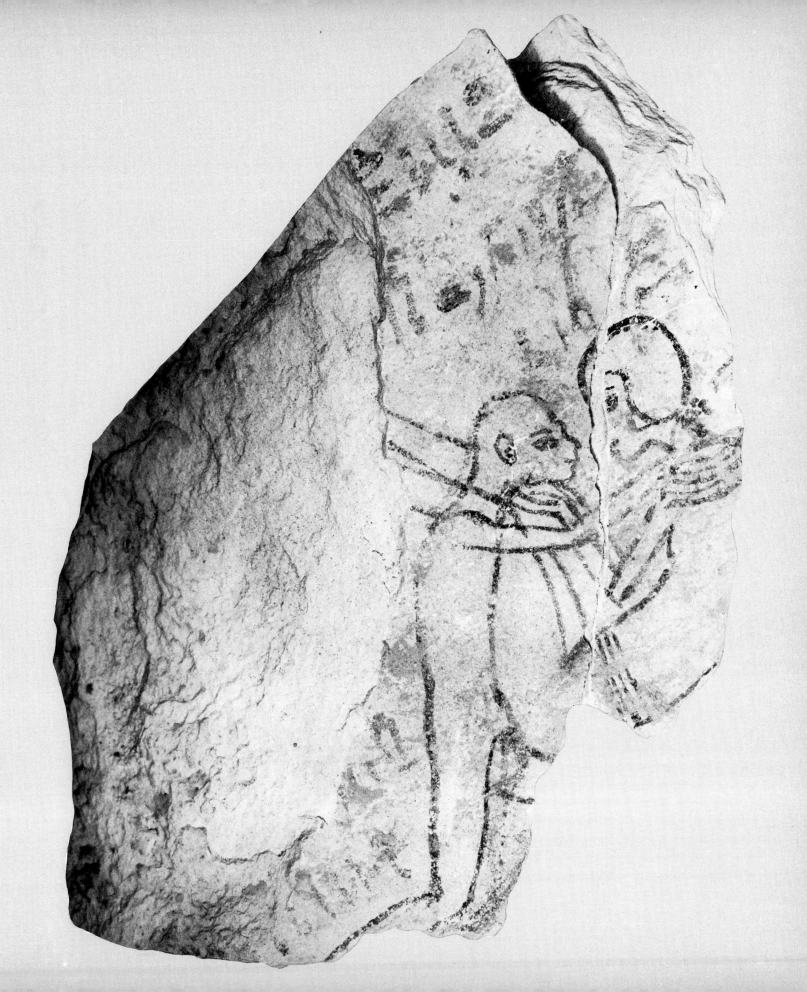

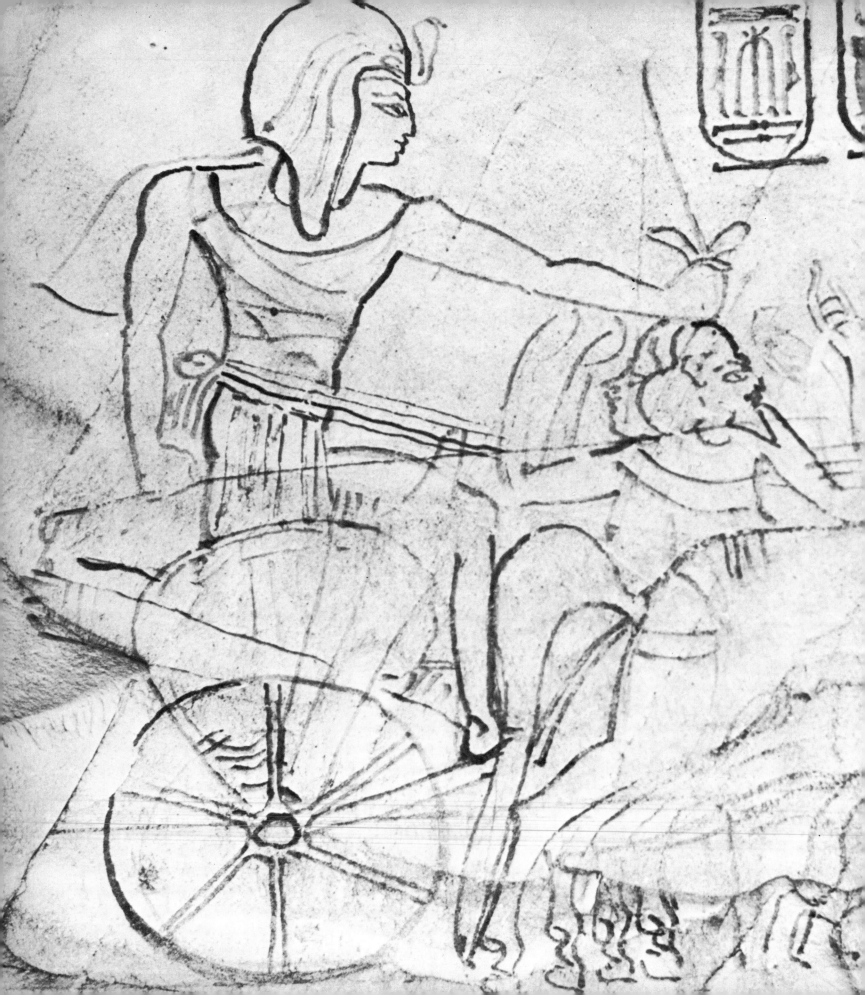

Hunting and combat

86 Ramesses IV in his chariot

Dynasty XX, time of Ramesses IV, c. 1162–1156 BC

On an ostrakon from the Valley of the Kings Ramesses IV is shown victorious in battle. He rides in a chariot pulled by two horses and holds his defeated Asiatic foe in his left hand, clutching also a war bow. As often in such scenes the groom is left out and by a heroic convention the reins are depicted tied around the waist of the king. The monarch is muscular and youthful, shown commandingly stepping forward with his left foot on to the central bar of the chariot. He is accompanied by a lion who chases a fleeing Asiatic, the intention being to suggest the power and might of the king by analogy. The details of the chariot trappings, including bow-case and quiver, and firm blocking out of the horses down to the details of their hooves, indicate the work of a master artist. Perhaps the composition was a study for a major wall relief.

87 Two combatants armed with staves

Ramesside period, *c.* 1305–1080 BC

This composition depicts two men in attitudes reminiscent of fencers. The position of their feet and upraised hands indicates an understanding on the part of the artist of the problems of balance and poise. By examining the many battle reliefs of the Ramesside period one can quickly see that the trained artist was capable of delineating with ease the varied postures of the warrior. This example probably illustrates war games rather than actual warfare. Such studies were no doubt used in the

working out of the complex compositions which formed a part of temple decoration, like the relief shown in the following plate.

88 Combat before the king

Dynasty xx, time of Ramesses III, *c.* 1193–1162 BC, with re-used blocks from Dynasty xix, time of Ramesses II, *c.* 1290–1224 BC

Scenes of unarmed combat are well known, particularly from the Middle Kingdom tombs at

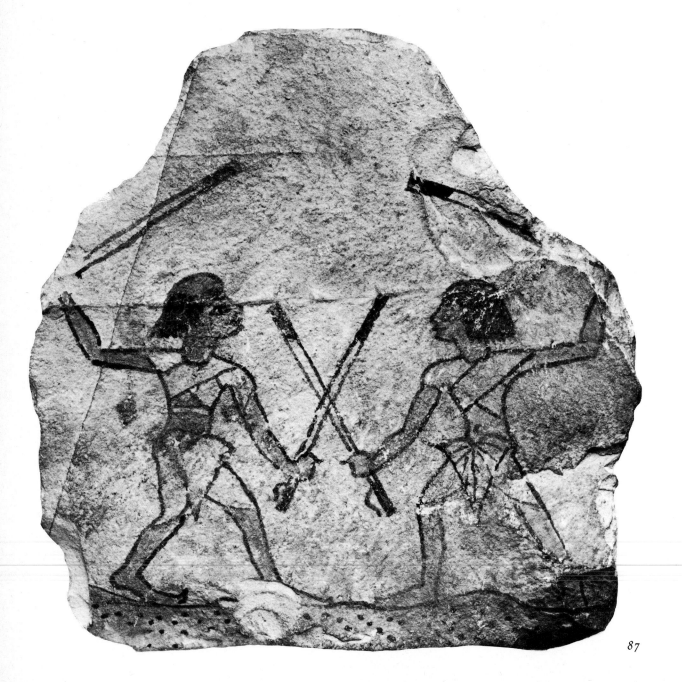

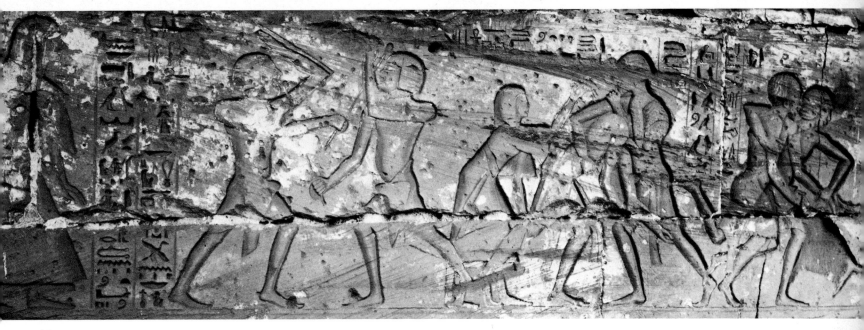

Beni Hasan, but a special ceremonial 'game'
involving combatants has been identified for the
New Kingdom which was carried out before the
king to mark a festival. It is appropriate therefore
that this tableau of combatants and wrestlers
should be located beneath the audience window in
the temple of Medinet Habu where Ramesses III
made his ritual appearances. The unusual subject
offered the artist a wide range of gestures and
combinations of figures which doubtless required
the use of preparatory sketches such as in *plates 87*
and *89*.

89 Two wrestlers
Ramesside period, *c.* 1150 BC

The two Nubian soldiers depicted on this ostrakon
from the Valley of the Kings seem to be taking
part in 'games' similar to those shown in the
preceding plate. The accompanying text reads,
'See, I'll make you take a fall helpless, in the
presence of the Pharaoh, may he live, be
prosperous and healthy' (Wilson 1931). It can be
seen that the figures here were first sketched in
loosely and the lines then corrected in the finished
drawing. The attitude in which the two grasp each
other's necks has been suggested as a starting hold,
at the beginning of the ritual bout.

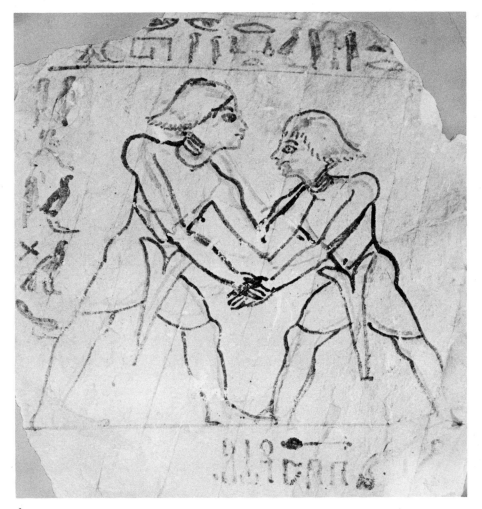

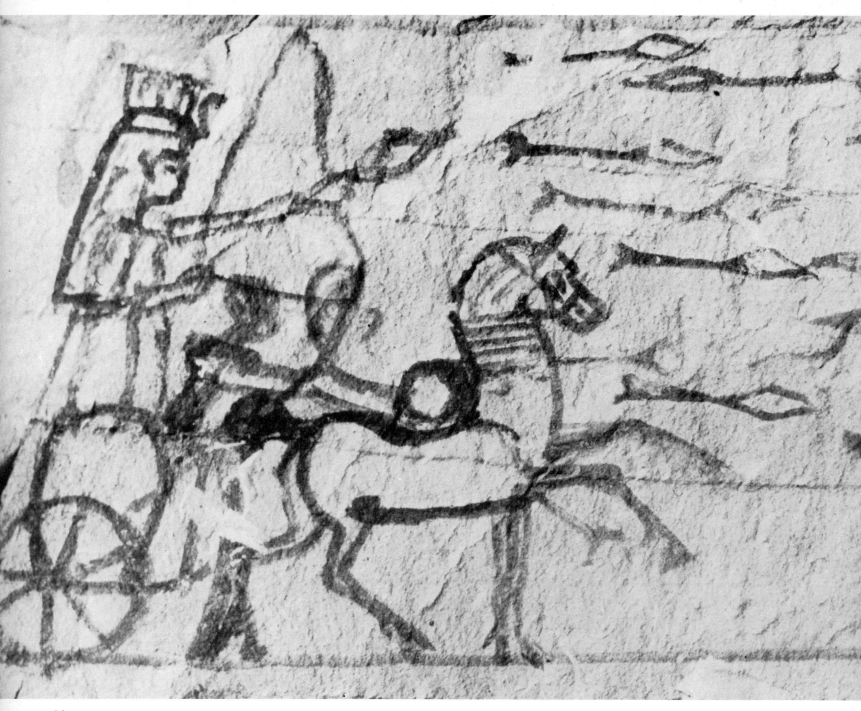

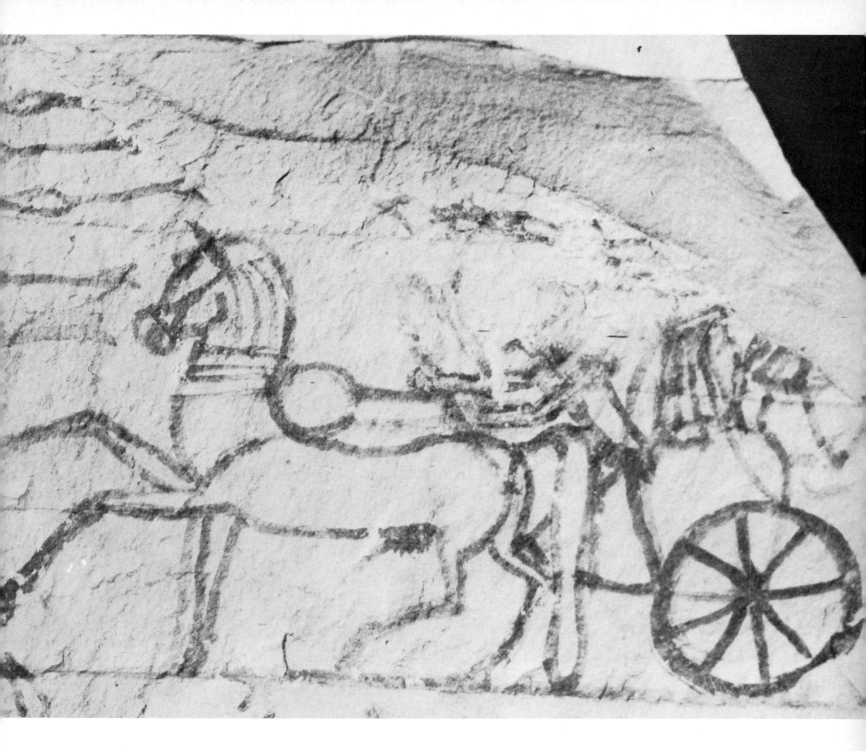

90 A queen in combat

Ramesside period, *c.* 1305–1080 BC

This unusual sketch from the Valley of the Kings depicts a queen or perhaps a goddess riding into battle in a chariot against a male opponent. She and her adversary are driven by smaller charioteers, according to the laws of aspective. She wields a large bow and has let loose a hail of arrows which are being answered in kind. The normal mural depictions of chariot warfare show the king victorious in battle, crushing the enemy by his skill and strength. The crudity of this rare scene, and curious details such as the horses with five legs, suggest that it may be a parody of the standard iconography, or more likely an illustration to a parable or legend now lost to us.

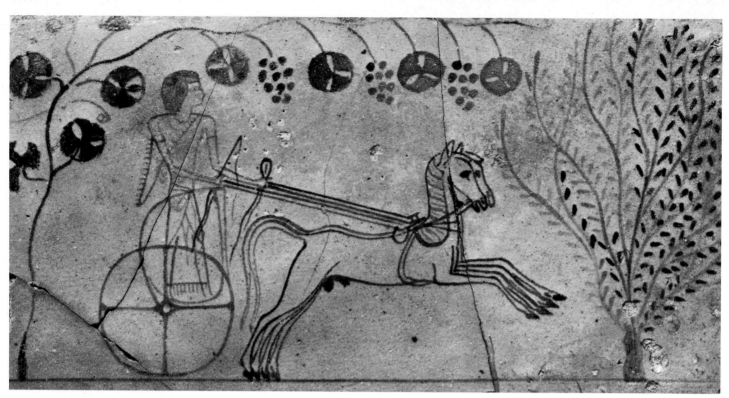

91

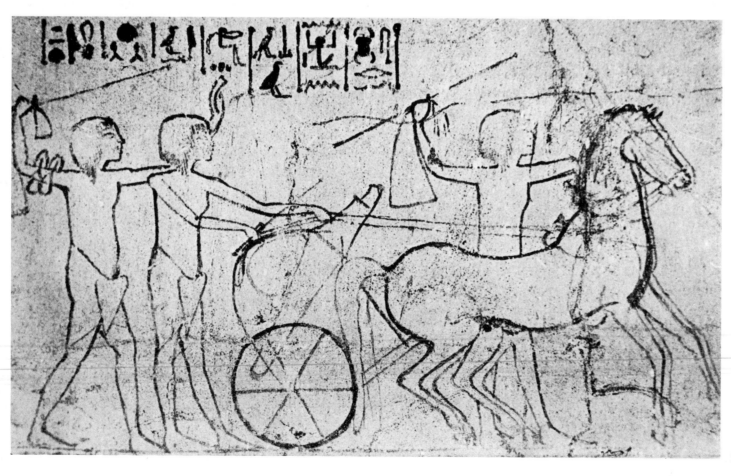

92

91 Decorative tile

Dynasty XVIII, c. 1554/51–1305 BC

A single figure drives a chariot pulled by two sprightly horses on this bright-blue tile of faience. The figures of animals, driver, grape vine and tree are all drawn with simplicity and clarity. The details of reins, whip and fringed garment are nevertheless presented completely, only the chariot pole being omitted, as it is from other examples of the same subject. This is a finished composition, skilfully arranged and beautifully balanced, giving evidence of a careful preparation which must have included preliminary sketches on which the finished design would have been based.

92 Two grooms and a charioteer

Dynasty XVIII, time of Akhenaten,
c. 1365–1349/47 BC

A familiar scene from the age of Akhenaten is the waiting chariot. Numerous wall reliefs of the subject have been found, so it is especially fortunate to have this example, in situ in the tomb of Mahu at Tell el Amarna, preserved at the drawing stage. Two grooms with arms upraised in praise of the honours bestowed on Mahu stand beside the chariot, while a charioteer pulls on the reins to restrain his horses, excited at the noise. This is a superb example of line drawing from the period; the very best abilities of Akhenaten's artists are displayed in the forceful handling of the horses, the geometric design of the light vehicle and the subtle variations in stance of the three men.

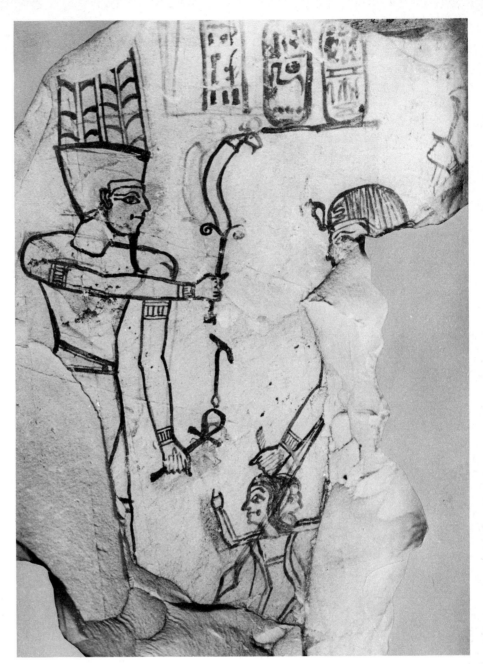

93

93 Ramesses IX offers prisoners to Amun

Dynasty XX, time of Ramesses IX, c. 1137–1119 BC

This sadly fragmented drawing from the Valley of the Kings depicts Ramesses IX in the traditional act of offering conquered enemy soldiers to the god Amun, described as 'King of the Gods'. Only the head of the king with royal uraeus is preserved, besides the clenched hand grasping the top-knots of the defeated and a lance held in the upraised left hand. Amun is shown in the standard manner with the long beard and double plumes which are his distinctive symbol. The god holds out to the king a scimitar-like weapon, popular during the Ramesside period, and two signs, the *ankh* and the *was*, giving the king 'life', 'dominion' and 'power' in battle. Traces of a first sketch are clearly visible suggesting that the conception was changed greatly in the finished version. The position of Amun's arms has been altered as well as that of the objects he holds. By comparison with many other drawings this sketch is rather crude, but it does exemplify one of the standard subjects which an artist would have to practise, master and commit to memory.

94 *A lion bites the head of a bound Nubian*

Ramesside period, *c.* 1305–1080 BC

This drawing from Deir el Medina can be included under the general heading of 'Hunting and combat' because it is essentially a symbolic representation of the king conquering the enemy.

As in *plate 86* the might and power of the king are exemplified in lion form. The drawing as a whole is of high quality. Alert and energetic, the lion is shown beginning to devour a bound Nubian or Southern foe, who kneels in what can be interpreted as a gesture of submission. As a graphic symbol of the abilities of the conquering ruler one can hardly imagine a better image.

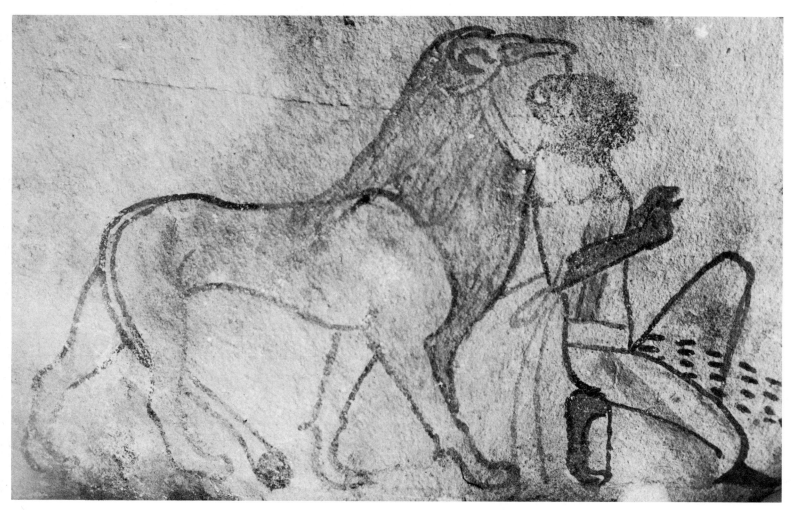

94

95 *A lion devours his prey*

Ramesside period, *c.* 1305–1080 BC

This sketch from Deir el Medina is at first somewhat difficult to interpret, but the subject becomes clearer after a brief examination. A lion is caught in the act of attacking a number of horned

91 Decorative tile

Dynasty XVIII, c. 1554/51–1305 BC

A single figure drives a chariot pulled by two
sprightly horses on this bright-blue tile of faience.
The figures of animals, driver, grape vine and tree
are all drawn with simplicity and clarity. The
details of reins, whip and fringed garment are
nevertheless presented completely, only the chariot
pole being omitted, as it is from other examples of
the same subject. This is a finished composition,
skilfully arranged and beautifully balanced, giving
evidence of a careful preparation which must have
included preliminary sketches on which the
finished design would have been based.

92 Two grooms and a charioteer

Dynasty XVIII, time of Akhenaten,
c. 1365–1349/47 BC

A familiar scene from the age of Akhenaten is the
waiting chariot. Numerous wall reliefs of the
subject have been found, so it is especially
fortunate to have this example, in situ in the tomb
of Mahu at Tell el Amarna, preserved at the
drawing stage. Two grooms with arms upraised in
praise of the honours bestowed on Mahu stand
beside the chariot, while a charioteer pulls on the
reins to restrain his horses, excited at the noise.
This is a superb example of line drawing from the
period; the very best abilities of Akhenaten's artists
are displayed in the forceful handling of the horses,
the geometric design of the light vehicle and the
subtle variations in stance of the three men.

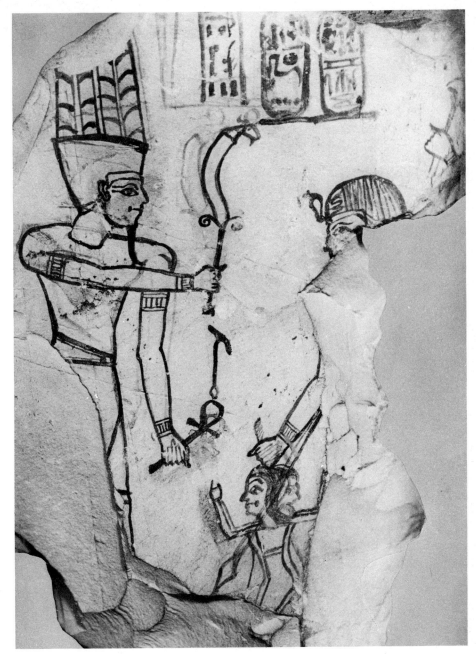

93

93 Ramesses IX offers prisoners to Amun

Dynasty XX, time of Ramesses IX, c. 1137–1119 BC

This sadly fragmented drawing from the Valley of
the Kings depicts Ramesses IX in the traditional act
of offering conquered enemy soldiers to the god
Amun, described as 'King of the Gods'. Only the
head of the king with royal uraeus is preserved,
besides the clenched hand grasping the top-knots
of the defeated and a lance held in the upraised left
hand. Amun is shown in the standard manner with
the long beard and double plumes which are his
distinctive symbol. The god holds out to the king
a scimitar-like weapon, popular during the
Ramesside period, and two signs, the *ankh* and the
was, giving the king 'life', 'dominion' and 'power'
in battle. Traces of a first sketch are clearly visible
suggesting that the conception was changed
greatly in the finished version. The position of
Amun's arms has been altered as well as that of the
objects he holds. By comparison with many other
drawings this sketch is rather crude, but it does
exemplify one of the standard subjects which an
artist would have to practise, master and commit
to memory.

94 A lion bites the head of a bound Nubian

Ramesside period, *c.* 1305–1080 BC

This drawing from Deir el Medina can be included under the general heading of 'Hunting and combat' because it is essentially a symbolic representation of the king conquering the enemy.

As in *plate 86* the might and power of the king are exemplified in lion form. The drawing as a whole is of high quality. Alert and energetic, the lion is shown beginning to devour a bound Nubian or Southern foe, who kneels in what can be interpreted as a gesture of submission. As a graphic symbol of the abilities of the conquering ruler one can hardly imagine a better image.

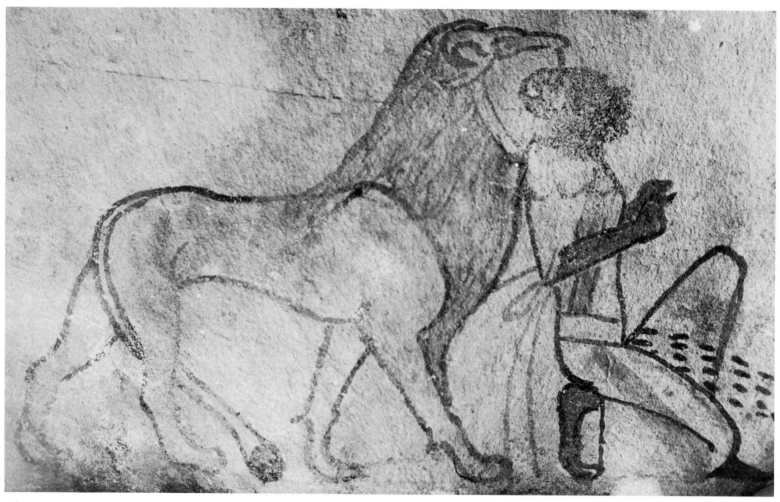

94

95 A lion devours his prey
Ramesside period, *c.* 1305–1080 BC

This sketch from Deir el Medina is at first somewhat difficult to interpret, but the subject becomes clearer after a brief examination. A lion is caught in the act of attacking a number of horned

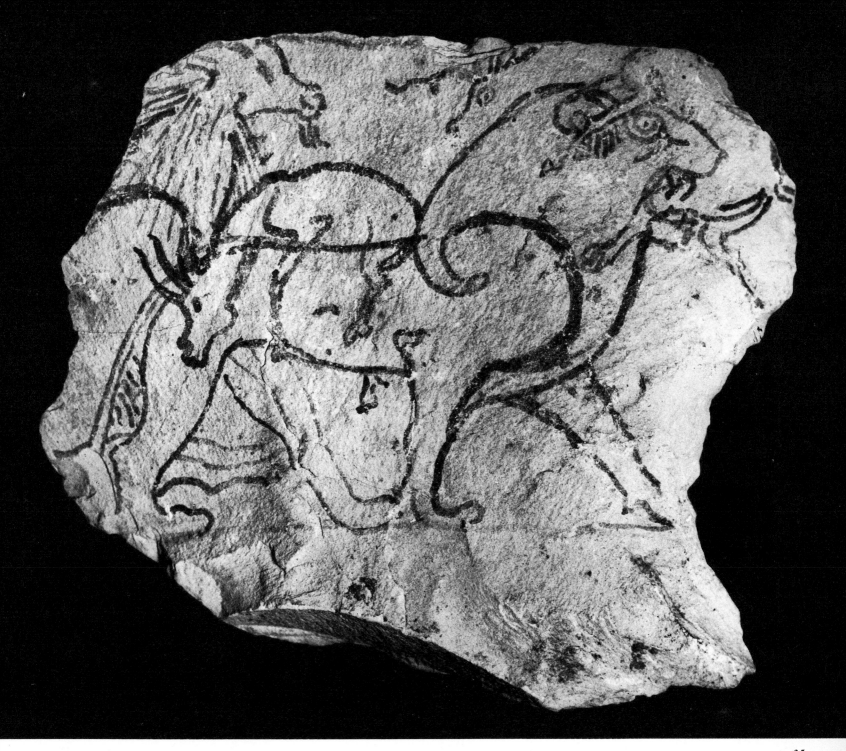

animals: he has one by a hind leg in his mouth; a second he has already tossed over his head on to his back; a third is possibly indicated on the ground behind his rear legs. This action is confused by the two other details of the horned animals which have been included, one in the upper-left-hand corner and a second indicated by an eye, a snout

and a horn over the lion's head. The whole piece is a true artist's working drawing in that he has attempted a difficult subject and has used the extra space to work out some of the finer points of detail. The fierce look captured in the lion's face and the limp, lifeless quality of the creature on his back have been handled with great sensitivity.

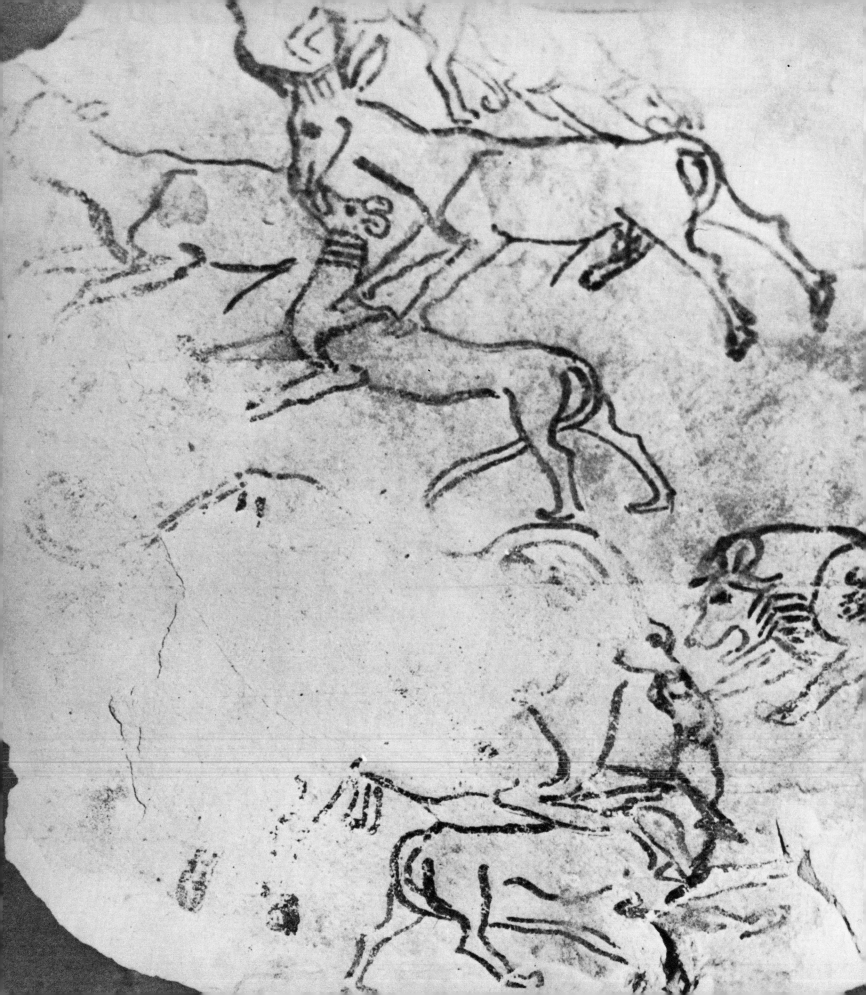

96 *Dogs, horned animals and a lion*
Ramesside period, *c.* 1305–1080 BC

Egyptian draughtsmen were at their best
when they attempted, out of long experience
and observation, to capture a complex scene
such as this in a few strokes. A single animal
was relatively easy to depict, for models
were ever present. It was only when the
combinations of animals became complicated
that it was necessary to do a number of trials
to perfect the total impression. Here, on an
ostrakon from Deir el Medina, we have a
preparatory drawing for the 'hunt in the
desert' scene often shown on tomb walls, in
which the deceased is accompanied by his
hunting dogs of an energetic and fearless
breed, trained to capture and perhaps even
make the kill. One of the hallmarks of the
'hunt in the desert' scene is the artist's
disregard for the standard register device. In
depicting the rough terrain of the desert and
foothills it was probably thought advisable to
eliminate the restrictions imposed by the
horizontal divisions customary on tomb
walls. As a result the animal groupings come
closer to suggesting a 'real' landscape than at
other times in Egyptian art.

97 *An antelope attacked by a dog*
Ramesside period, *c.* 1305–1080 BC

Scenes of hunting in the desert and uplands,
which are so often depicted on the walls of
private tombs, contain some of the most
arresting animal images to have come down
to us. This antelope on an ostrakon from
Western Thebes with legs raised at a gallop
could well have been a preparatory drawing
for one such tomb decoration. The hunting
dog attacking at the throat supports the idea
that this was a sketch for a hunt scene. The
grace and beauty of the antelope in full flight
have been caught with a few deft strokes of a
master's brush.

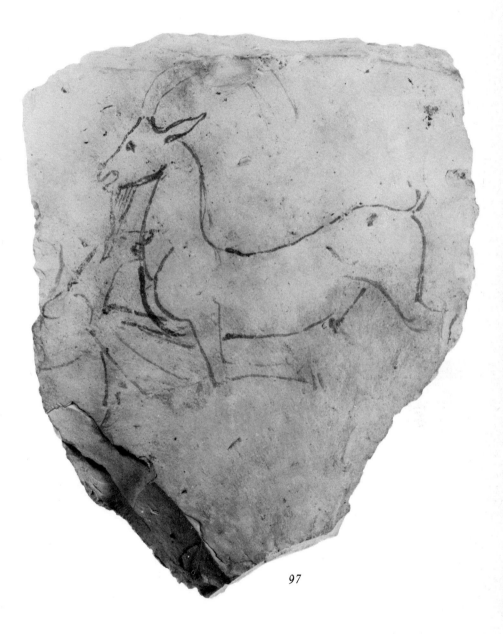

97

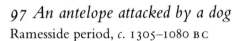

98 Three dogs attack a hyaena
Ramesside period, *c.* 1305–1080 BC

Of all the scenes designed for the wall of the tomb that depict animals, the 'hunt in the desert' gave the artist the broadest range for invention. Within the restrictions of this type could be included all manner of activity which was a part of the hunt, especially the master pursuing wild beasts with his javelin, bow and arrow and with the aid of trained hunting dogs. In depicting this aspect of the hunt the artist had to imagine the animals in unusual poses. In this drawing from Deir el Medina the three dogs are each rendered in a different attitude; for example, the one that nips at the hyaena's tail has turned its head in a characteristic way which could only have been familiar to a draughtsman who had watched the animal's habits carefully. The total effect of the composition is one of great animation.

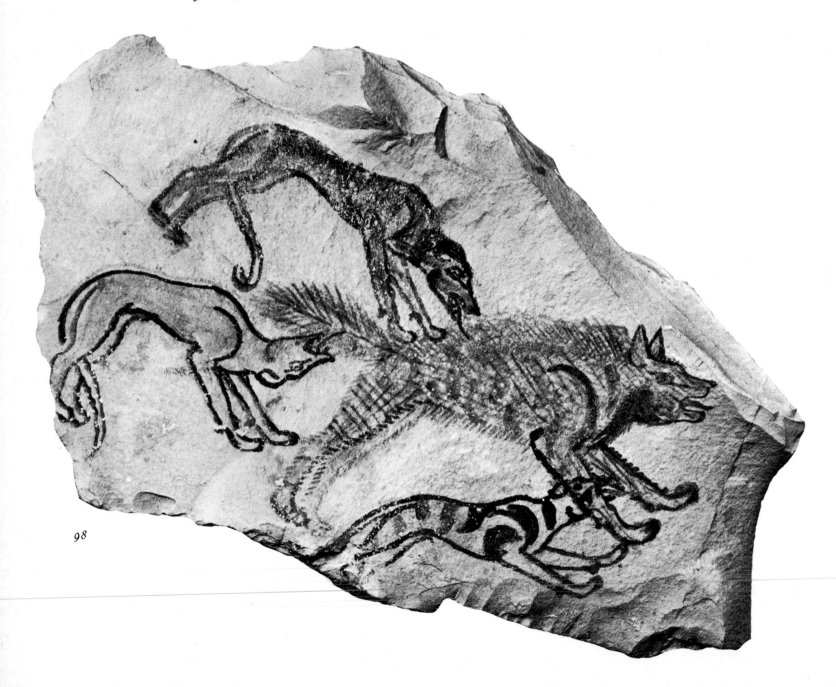

98

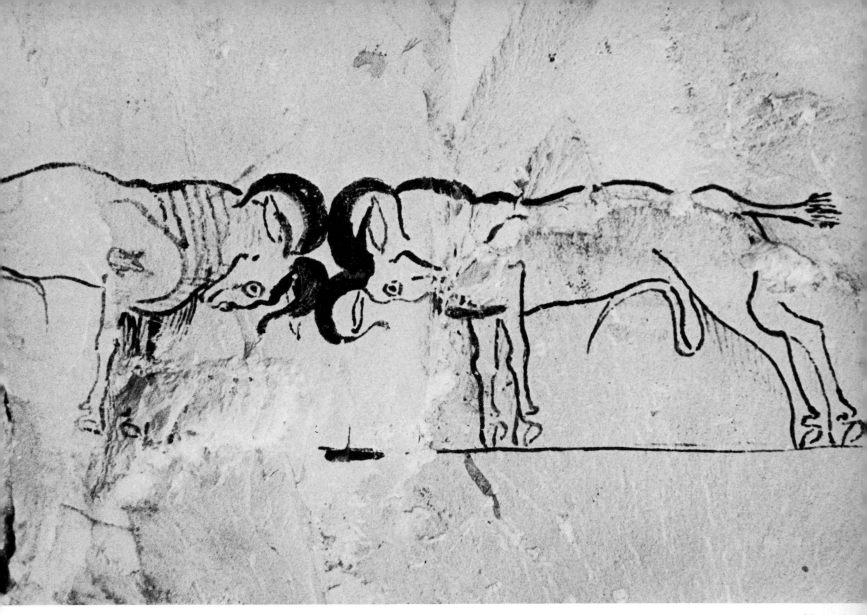

99 Two moufflon locked in combat

Ramesside period, c. 1305–1080 BC

The Egyptian artist was very often at his best in
the description of spirited scenes of animal life such
as in this drawing. We have examples of this
perception, a natural outgrowth of a close
association with nature, from the Predynastic
period onwards. Two moufflon crash horns in a
combat which seems to be too intense to be
playful. The draughtsman has captured the stance
on hoof-tip, the angle of lowered head and the
tensed muscle of neck, all in such a way as to
convey the energy and ferocity of the conflict.
This drawing from the Valley of the Kings is the
reverse side of the ostrakon shown in *plate 48*.

Animal life

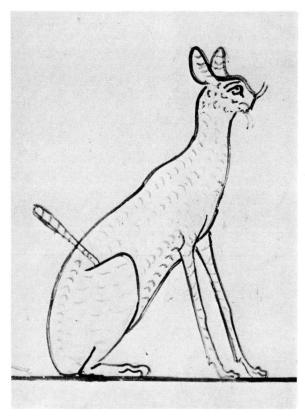

100 Seated cat

Dynasty XVIII, time of Tuthmosis III,
c. 1490–1439/36 BC

In the burial chamber of the tomb of Tuthmosis III
in the Valley of the Kings, the wall-painting was
done as if it were the text and illustrations of a
papyrus scroll. As a result, all human and animal
figures were rendered in a sparse schematic style
(cf. *plates 41–2*). The Egyptian domestic cat shown
here was a thin rangy creature anyway, but the
drawing style has somewhat over-emphasized the
thinness of the forelegs, the length of the neck, and
the smallness of the head in relation to the rest of
the body.

101 Three trial drawings

Ramesside period, c. 1305–1080 BC

Often, as in this case, the same ostrakon will bear
completely unrelated subjects. This limestone
block was apparently used as a practice piece by a
sculptor, for the surface has been cut back around
the figures; but the drawn areas have not been
touched by the chisel. On the right is an Egyptian
vulture, readily recognizable as one of the standard
hieroglyphs. The large bird in the centre has some
of the characteristics of the crane. The small dog
above seems the least assured drawing of the three.

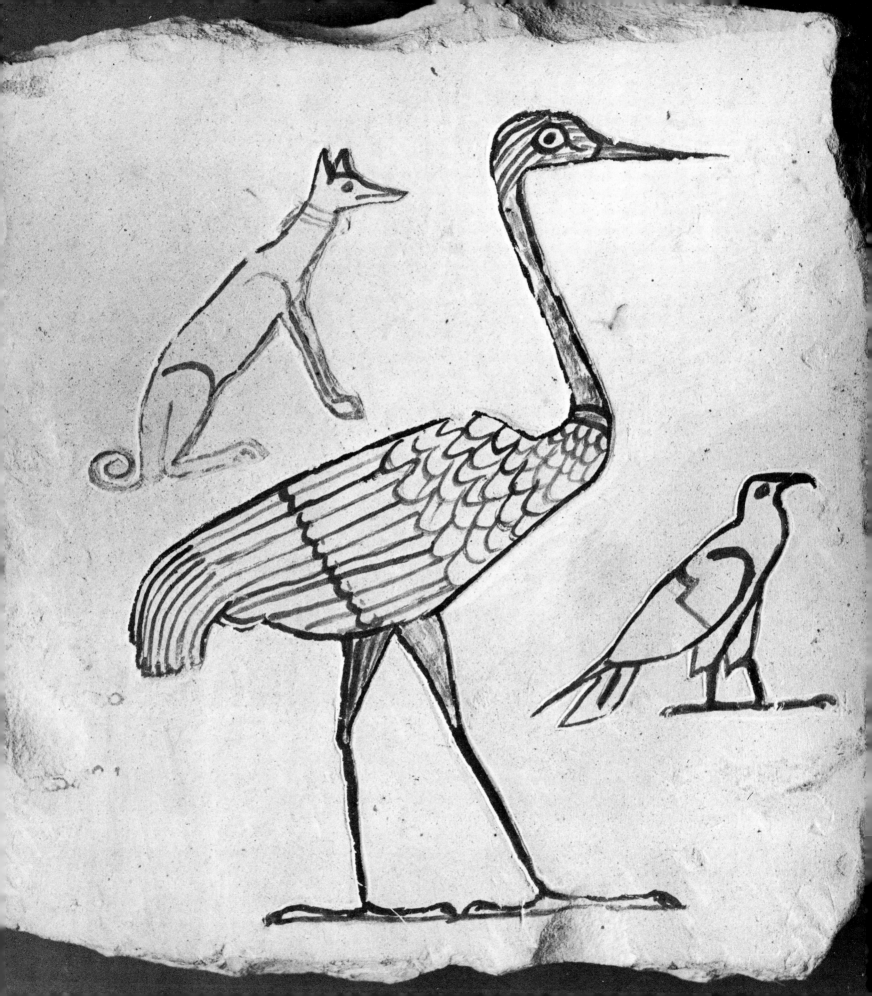

102 *Lion's head and four ducklings*

Ramesside period, *c.* 1305–1080 BC

Many working drawings show motifs which have been repeated a number of times as the artist learns how to master them. In this example the main subject is a lion's head, which is drawn with a sureness of touch suggesting a level of skill beyond that of the beginner. In addition there are four sketches of ducklings of varying degrees of proficiency. The duckling was a hieroglyphic character used in words such as 'nestling'. To capture the proper proportion of head and neck to body and legs meant some adjustment on the part of the scribe-artist from the drawing of mature birds. Here, then, is a typical exercise in which a draughtsman worked out the correct way to portray a commonly used motif.

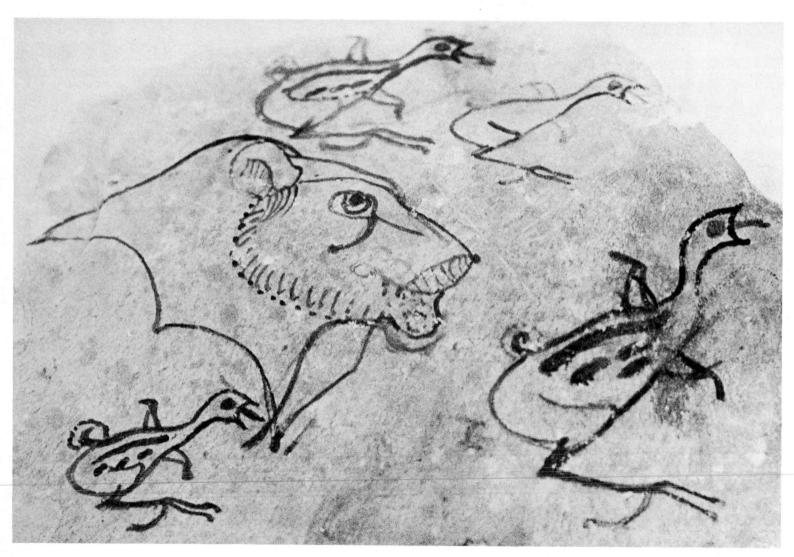

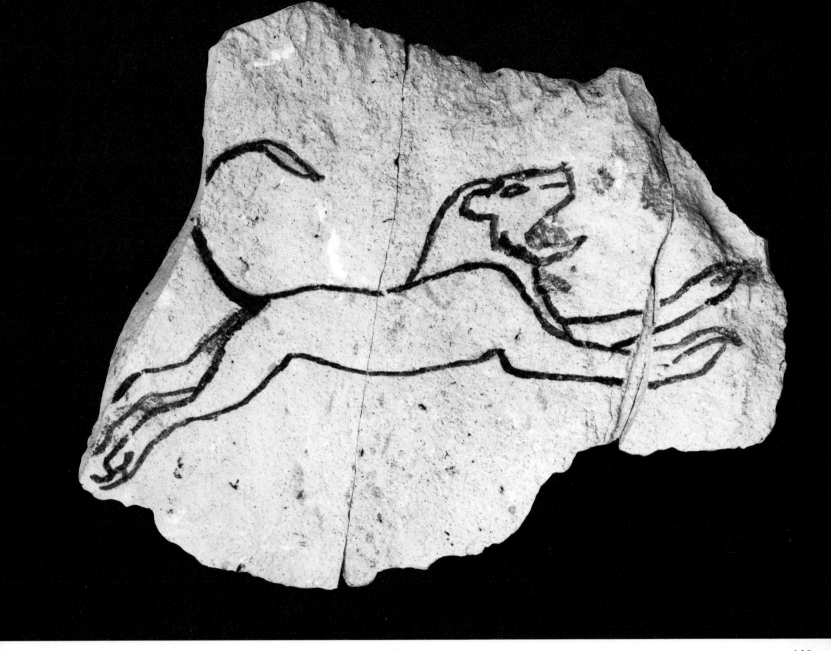

103 A leaping lion

Dynasty XXVI, *c.* 664–525 BC

Although this small image from Deir el Bahri seems very much in the nature of a quick sketch from life, it is more probably a design study for part of a large composition. The lion hunt is well known from a number of paintings and reliefs, particularly the hunting scene of Ramesses III at Medinet Habu, where one of the animals compares closely with this drawing. Such a spirited animal as this might alternatively have formed part of a tomb decoration in which the deceased was depicted during the chase. Whatever use it would have been put to, this drawing captures the litheness of the big cat, even if details such as the junction of neck and shoulders lack conviction.

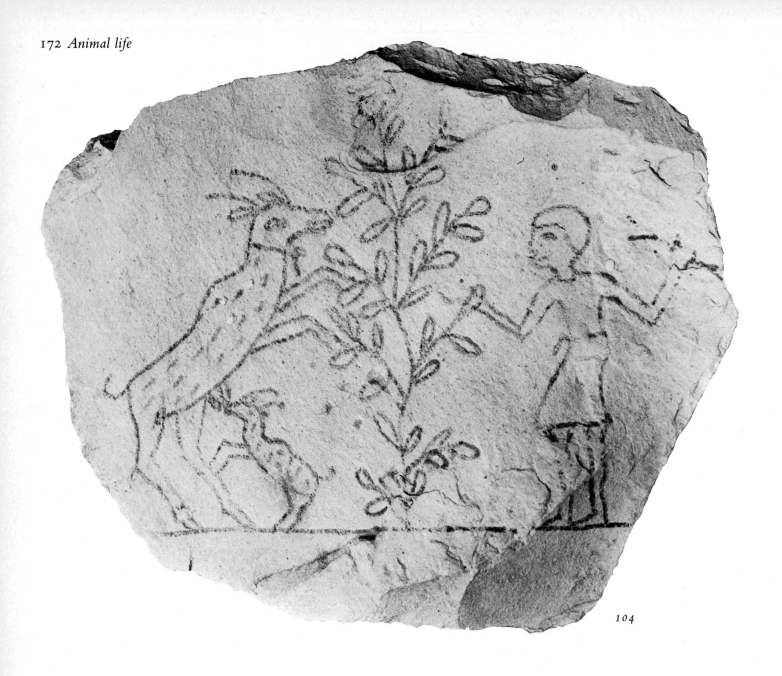

104

104 A youth and goats

Ramesside period, *c.* 1305–1080 BC

This sketch has a charming naivete. On the right, a simply drawn figure of a youth stands with one hand extended, perhaps plucking a leaf from the tree in the centre; the other hand is held in a menacing posture as though to drive away the goat that feeds from the same tree. Below, a young kid, curiously showing horns, sucks from its mother. The artist has left a record which is direct and immediate of something seen rather than a standard tableau carefully formulated. Drawings such as this indicate that the ancient Egyptian artist was moved to set down, with ink or paint, the activities around him as well as perform his primary function in the service of king or god.

105 Monkey climbing a dum-palm
Ramesside period, c. 1305–1080 B C

Of all the animals recorded by the Egyptians, either wild or domesticated, monkeys gave the artist the greatest rein for expression. They are shown at rest and in a wide variety of situations. In this example the monkey is depicted as if distracted while climbing a diminutive palm. The hatching used to suggest the texture of fur and the surface of the tree is a simple but effective device. The long limbs of the animal convey the energy and ease of movement so characteristic of the species. Monkeys are often illustrated in tomb paintings of the New Kingdom and are occasionally shown as domesticated pets. According to some, the monkey here is a trained animal taught to climb and gather fruit. The girdle tie hanging at the back of its waist may support this contention.

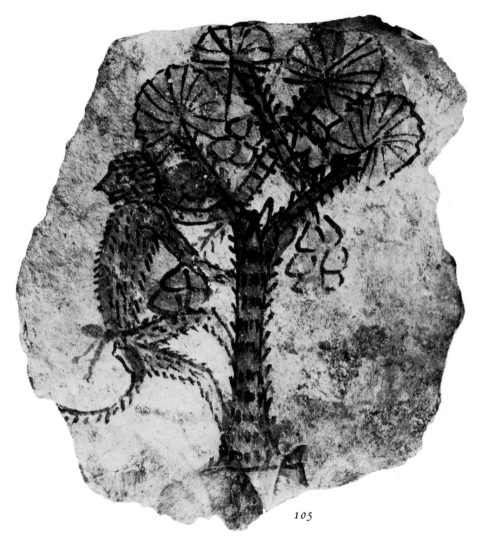

105

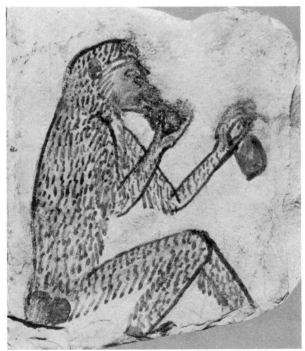

106

106 A monkey eating
Ramesside period, c. 1305–1080 B C

By contrast with the preceding example the monkey shown on this ostrakon from Deir el Medina is less animated. He eats a dum-nut with one hand, while in the other he holds another nut on a stalk. The general proportions of the primate have been well observed, as have the prominent brow and rather spindly legs. Again hatching has been used effectively to suggest monkey fur.

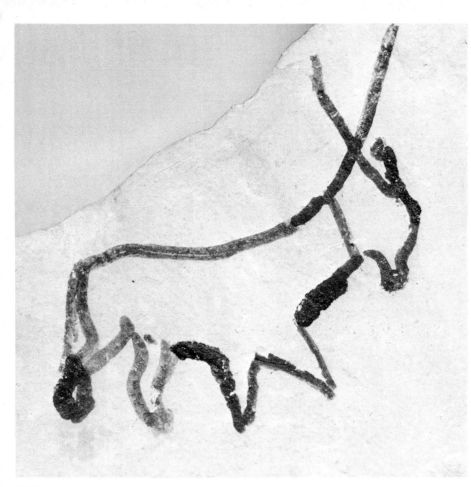

107 A horned animal

Dynasty XVIII, *c.* 1554/51–1305 BC

Unlike the usual carefully observed animal portraits of the Egyptian artist, this doodle on an ostrakon from the tomb of Senenmut at Deir el Bahri is so vague as to make the identification of the particular type impossible. Is it goat, cow or bull? The image suggests the work of a child or untrained artist, or possibly a beginner who has made his first essay at animal drawing. The blotched line would support this idea.

107

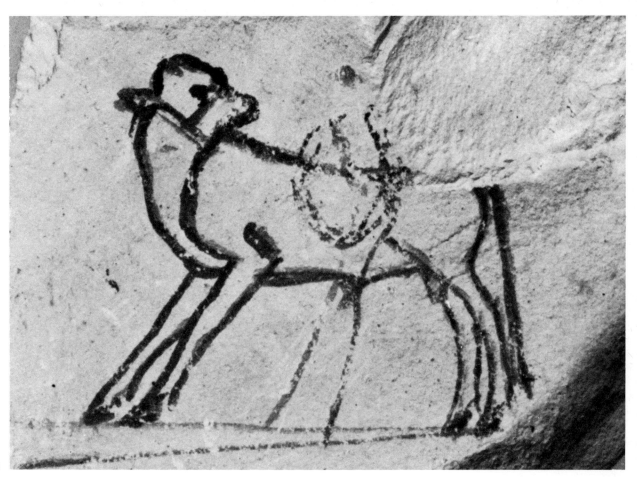

109

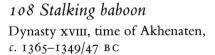

108 Stalking baboon

Dynasty XVIII, time of Akhenaten,
c. 1365–1349/47 BC

For brevity of line there are few drawings in the history of art that can compare with this simple depiction of a baboon from Tell el Amarna. Charged with energy, this drawing conveys the characteristic gait of the animal with the minimum number of brush strokes possible. Be it rapid impression or *aide mémoire* the artist has captured the type in a master sketch.

109 Calf

Dynasty XXVI (?),
c. 664–525 BC

Of all the representations of animal life in Egyptian tombs scenes of cattle-raising and herding are the most popular. In an attempt to suggest the continuation of animal life in the hereafter and, thereby, the sustenance provided for the spirit, the birth of new calves and the care given to them is often represented. The problem which the artist of this piece from Deir el Bahri tried to solve was the posture of the young animal in the act of looking back, not a rare representation at all, but one requiring a slight adjustment from the standard animal profile and consequently some study.

110 Hippopotamus

Predynastic period, before c. 3000 BC

The hippopotamus was the largest and probably one of the most terrifying animals of ancient Egypt. In the Old Kingdom it is often shown as the subject of a hunt in the papyrus marshes with harpoons. From Middle Kingdom tombs have come a large number of faience sculptures depicting the hippopotamus in blue glaze with aquatic plants decorating the body. This drawing from Wadi Barqa shows an artist's attempt to capture the massive bulk of the creature. The number of correction lines in this drawing suggests that the form was not easy to record and the spirit of the animal not easy to convey.

111 *A horse rubbing its foreleg*

From a tomb of Dynasty XXVI, c. 664–525 BC, but perhaps earlier in date

This charming drawing from Western Thebes might be better identified as depicting a colt rather than a mature horse if the proportions of the legs are accurate. The horse as a useful animal for transport did not become common until the New Kingdom, but from that period on representations abound. Although the subject of the horse (or colt), with lowered head, which rubs or bites its foreleg, is not often seen, a comparison can be made between this example and an Amarna relief in the Schimmel collection (*plate 112*), where the animal bites its foreleg in much the same

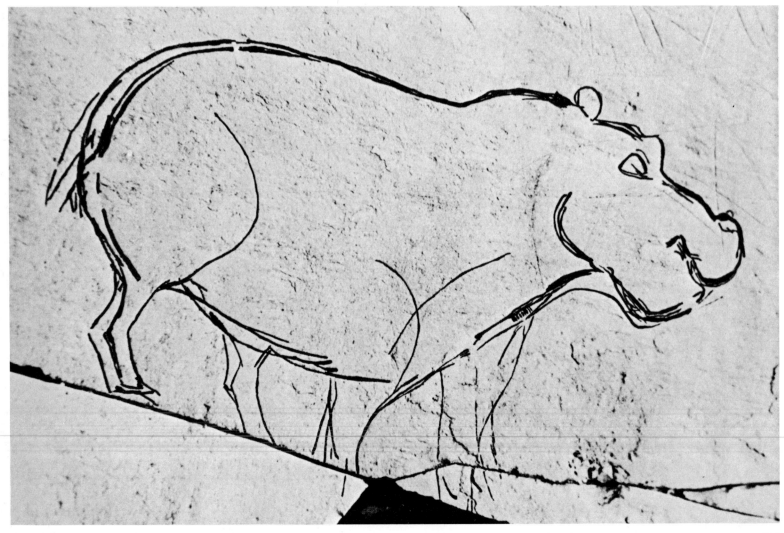

manner. Here the artist has managed to conjure up
an image of the animal in a few broad strokes of
his brush. Of all the two-dimensional depictions of
horses from ancient Egypt this deceptively simple
drawing must stand among the most skilful.

112 Relief of a horse
Dynasty XVIII, time of Akhenaten,
c. 1365–1349/47 BC

The horse carved in relief on this limestone slab
from Tell el Amarna makes an interesting
comparison with the sketch in the previous plate.
Both animals seem to rub or bite their forelegs, but
here the harness, with breastband, girth, saddle,
headstall and part of the reins indicate that this
horse pulls a chariot. The neck and legs of a second
horse can be made out in the background.

113 *She-ass and her young*
Ramesside period, *c.* 1305–1080 BC

In tomb decorations illustrating the daily round of the estate and the fields every stage of animal life is included, from procreation and the nurturing of the young to the exploitation of mature beasts as work animals. This simple sketch would have been used as the basis for a finished design in such a context. One of the main characteristics of the species, the large ears, has been exaggerated probably to make identification clearer.

114 *Head of a horse*
Dynasty XVIII, time of Horemheb, *c.* 1332–1305 BC

Of the many representations of horses known from the New Kingdom, this ochre drawing, in situ in the tomb of Horemheb at Saqqara, must stand as one of the finest. The grace of the head and neck, the careful attention to details such as the dressing of the mane and the drawing of eyes, nostrils and mouth give us a vivid picture of the animal. Such an image of a spirited charger seems especially suitable for the tomb prepared for a general who was eventually to succeed to the throne of Egypt.

113

114

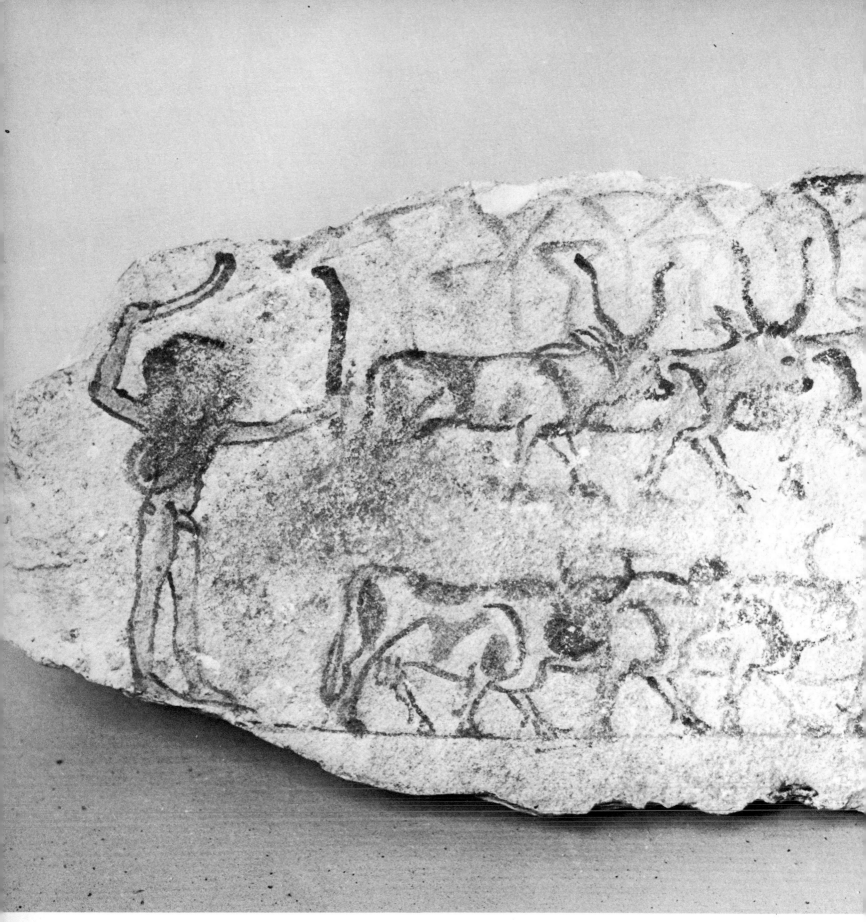

115 Two boys driving cattle
Ramesside period, *c.* 1305–1080 BC

In two registers dappled cattle are driven before a field of papyrus by two male children. In many respects this scene is similar to those painted on tomb walls which depict cattle being inspected by the deceased owner. The major difference is the age of the herdsmen, who are normally adults but here are boys, as is made clear by the lack of clothing and the hair arranged in side-locks. Each youth carries one or two sticks, probably used to prod the cattle. The youth who brings up the rear is also equipped with a roll of some sort which may be a reed mat for protection against the elements – herdsmen are often shown carrying them. The smallness of the cattle in relation to the boys may well be deliberate, an example of a device commonly employed to suggest a large number of animals.

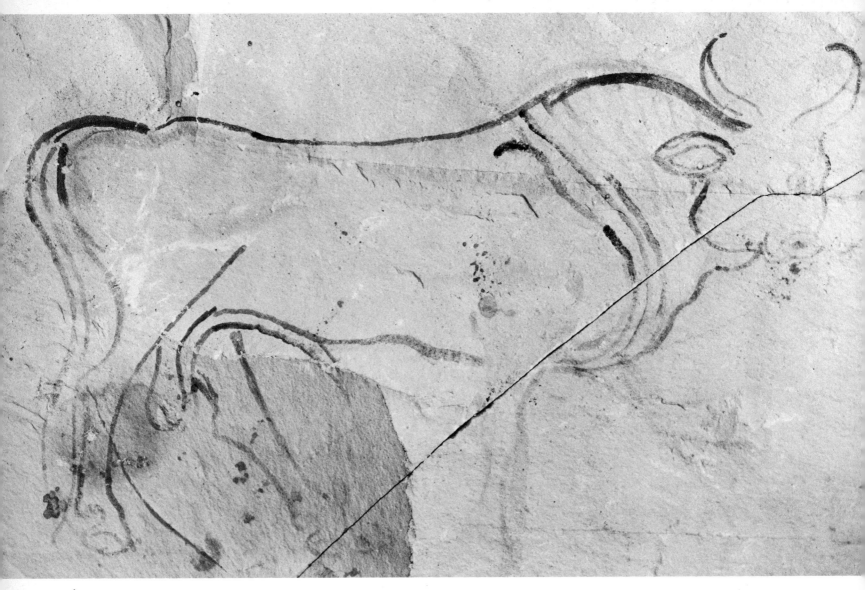

116

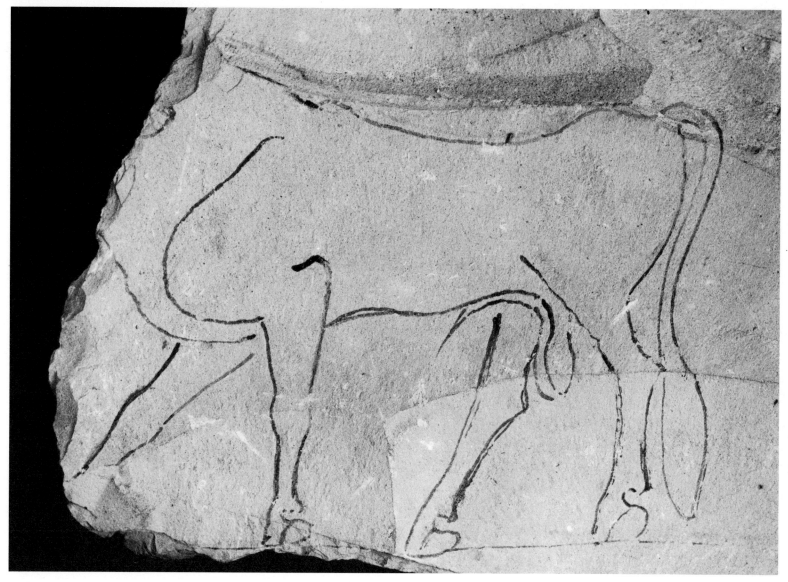

116, 117 Two bulls

Ramesside period, *c.* 1305–1080 BC

Bulls were symbols of virility and strength in
ancient Egypt as in many other civilizations.
Kings were invariably described as 'the mighty
bull' to suggest their great power. It was therefore
important that artists familiarize themselves with
the form of this animal. The sketches shown here
on ostraka from the Valley of the Kings are two
such attempts to portray bulls in the medium of
drawing. Broad strokes, here and there a little
hesitant, nevertheless convey the essential heaviness
and strength of the animal.

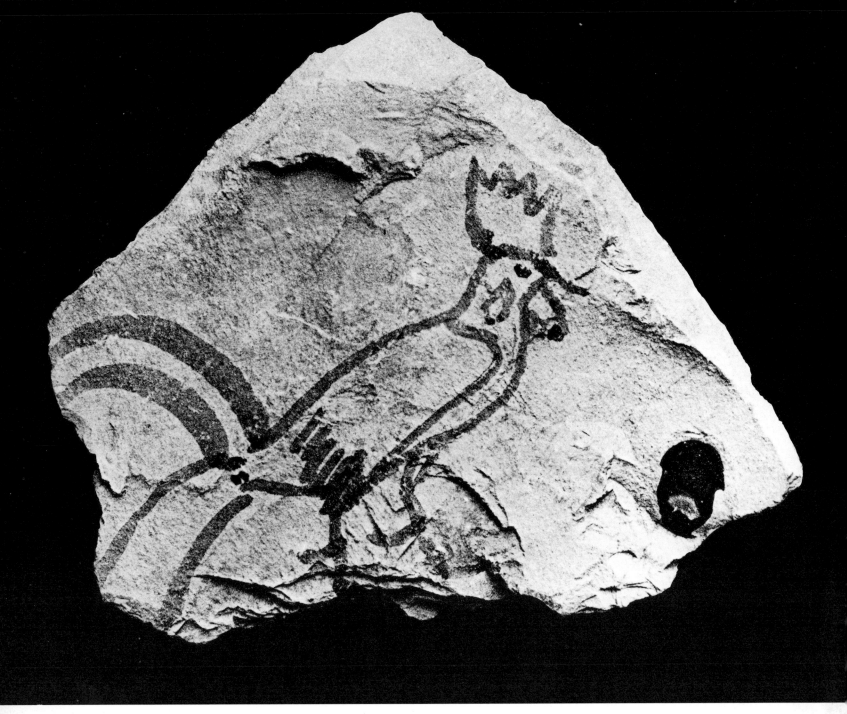

118 Rooster

Ramesside period, *c.* 1305–1080 BC

In this fluid line drawing the spirit of a perky rooster has been caught simply and directly. The barnyard fowl was a late importation into Egypt and was not as commonly drawn and painted in Egyptian art as wild birds or geese and ducks, but when the draughtsman turned his attention to this subject he showed his usual facility with the brush. From its comb to its graceful tail feathers this is a rooster through and through.

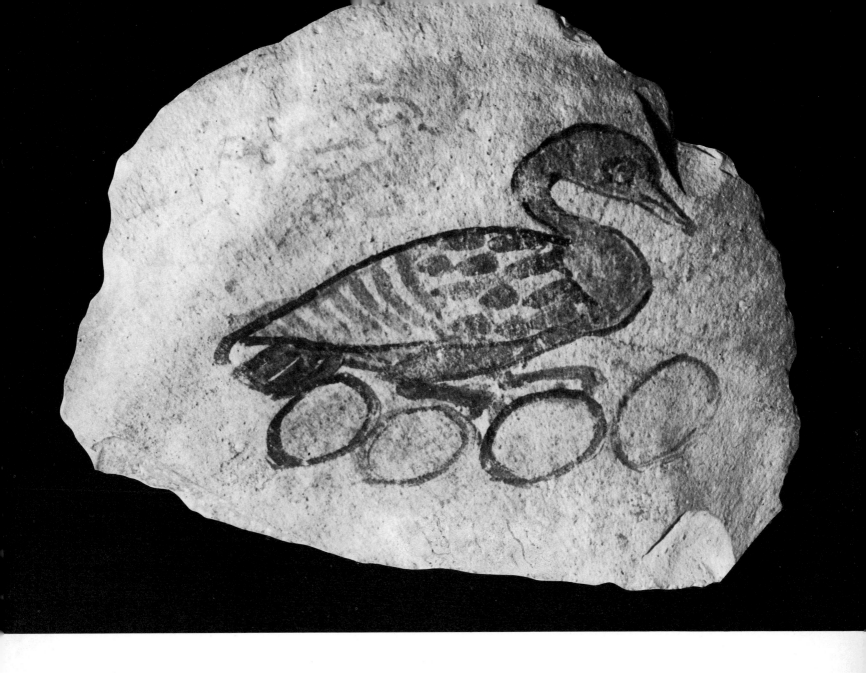

119 A goose on her nest

Ramesside period, c. 1305–1080 BC

One often encounters representations on tomb walls of geese or ducks together with a nest of eggs. In this simple drawing we can probably recognize a preliminary study for such a composition. The figure of the goose has been sketched with a fine line, the feathers with broader strokes. The mother bird rests rather uncomfortably on four large eggs, outlined summarily. In the upper-left-hand corner can be made out two very faint drawings of goslings, perhaps not intended as a part of the composition, but rather a scribal reminder of the hoped-for offspring of the protected nest.

120 Birds caught in a net
Dynasty v, *c.* 2450–2290 BC

In a scene also shown in *colour plate XI*, birds
are depicted caught in a clap-net on a wall of
the tomb of Neferherptah. A great multitude
of pigeons are sketched in what seems at first
to be a wide variety of poses. A close
inspection shows that almost all the birds are
in fact based on two stock patterns, one a
pose to the left, the other to the right. The
bodies are basically the same, it is only in the
differing placement of wings that the artist
has created a feeling of variety. A simple
device has thus been used to arrive at a
superficial sense of complexity. Although
superbly drawn, each bird alone gives the
impression of being taken directly from an
ancient 'copy book'.

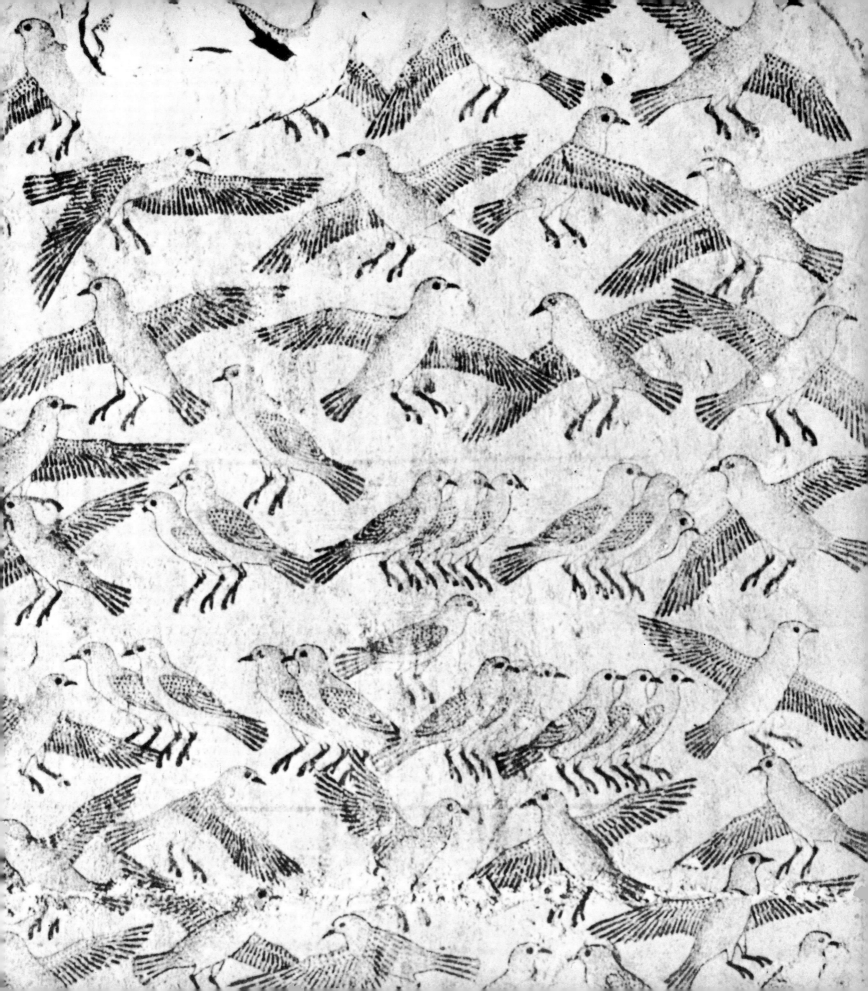

121 *Fragmentary sketch of a cat*

Ramesside period, *c.* 1305–1080 BC

The cat appears in Egyptian art of all periods, in painting and in sculpture. Bronze cats of the Late Period are among the most popular objects known from ancient Egypt, and for the good reason that the cat was the sacred animal of the goddess Bast of Bubastis. Bast was often depicted as cat-headed and Herodotus tells us that the mummified bodies of the dead animals were piously buried at her cult centre. This small sketch suggests a trial attempt to capture the characteristic grace of the animal. In building up his repertoire of forms the Egyptian artist had to practise and commit to memory the standard appearance and proportions of a wide variety of types.

122 *Fish (Synodontis?)*

Ramesside period, *c.* 1305–1080 BC

This sketch on an ostrakon from Deir el Medina represents a member of the catfish family. In its brevity and vigour it is reminiscent of a Japanese brush drawing. Numerous representations of fish exist from every period of Egyptian history. The industry and sport of fishing is illustrated in tomb decoration from the Old Kingdom onwards. The various species of fish common to the Nile were so well differentiated by the ancient artist that they can often be easily identified by their characteristic shapes. And fish were important as a decorative element and as hieroglyphic characters too. Given their significance, therefore, it is not surprising that draughtsmen devoted time to their study.

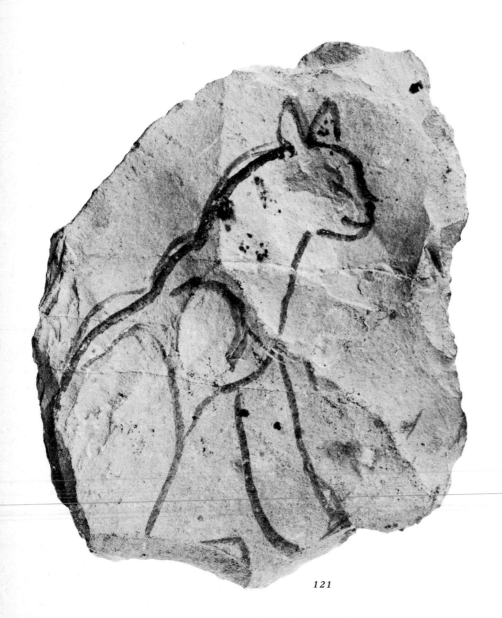

121

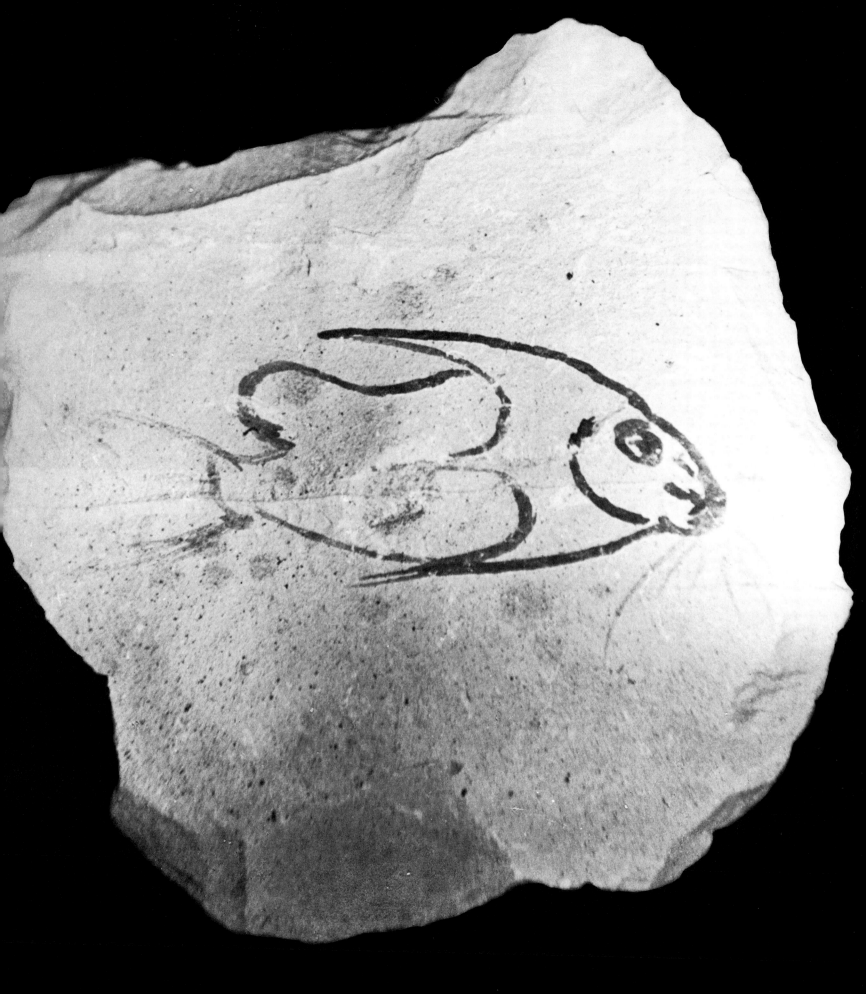

123 Fish (Tilapia Nilotica)

Ramesside period, c. 1305–1080 BC

This drawing from Deir el Medina is a much more refined study of a fish than the previous example. The dorsal fin is indicated in all its spininess, the two small ventral fins are less prominent but are included as characteristic of the species. In the rendering of fish-scales a number of conventions were employed, the two most common being the use of cross-hatching, as in this example, and a standardized series of arcs which more closely approximated the texture of the surface. One puzzling feature of this sketch is the object drawn in dark ink on the back of the fish. Perhaps it is a hook or worm on a line or other trapping device; in any case it seems purposefully designed and not the result of a chance mark.

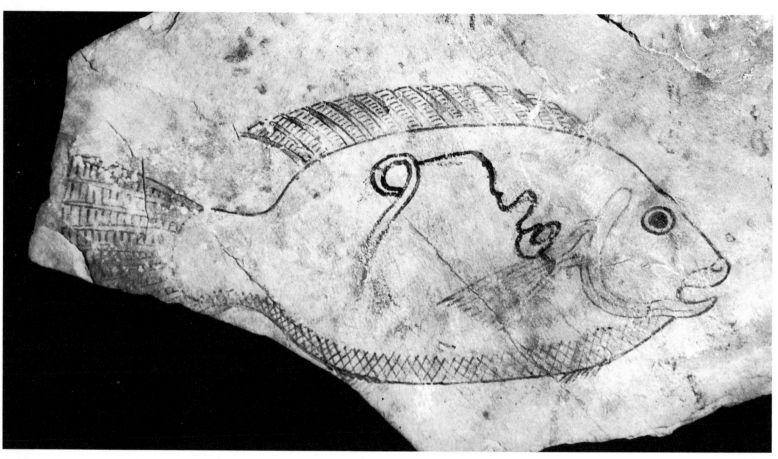

123

124 Faience bowl with fish and lotus

Dynasty XVIII–XIX, c. 1554/51–1196 BC

An apt comparison with the careful drawing of *Tilapia Nilotica* illustrated in *plate 123* is this simplified rendering of the same species for use as a decorative device. The basic features of the fish are correct but they have been slightly modified: the dorsal fin, for instance, has assumed a more geometric shape as have the scales. The lotus blossom and bud have been added to fill the field as part of the decorative pattern. This illustration is a good example of the use of a well-known image to embellish a household item. From the Predynastic period onwards it was customary to decorate pottery with linear designs. Egyptian faience, although technically not pottery, was a glazed ware which lent itself to colourful decorative effects. The major part of the faience preserved is glazed blue or green, but it was possible to produce it in other colours, including yellow, white, brown and black. The decorative elements are usually linear and fluid, resembling the ink drawings on limestone or papyrus.

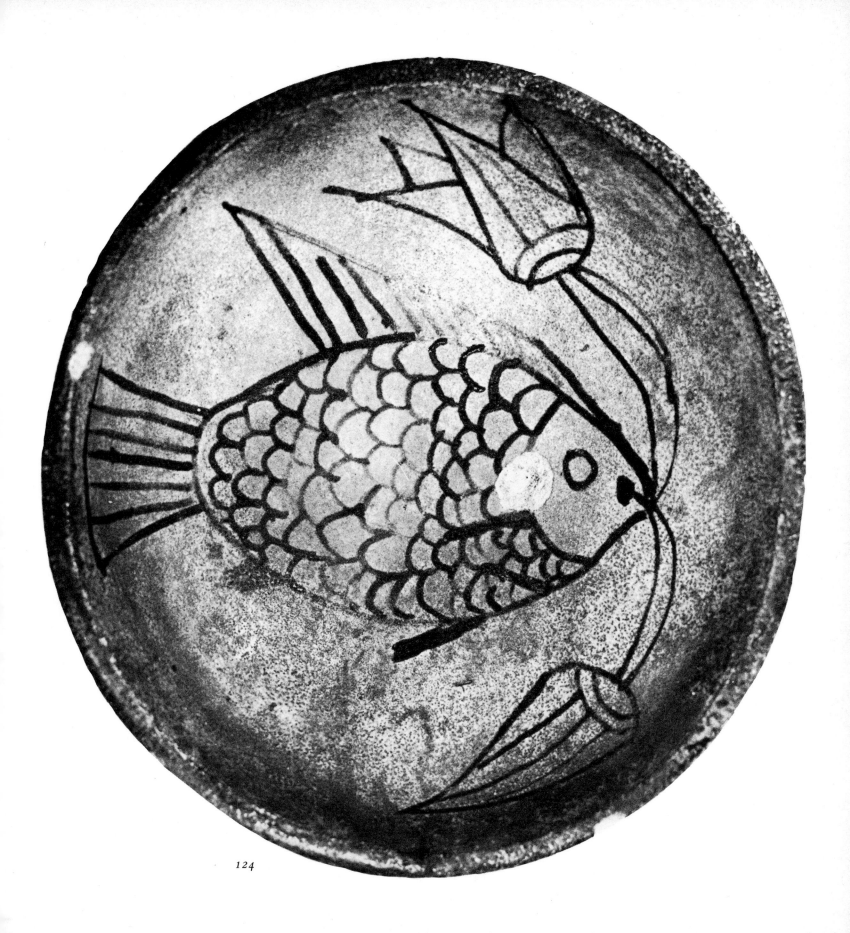

124

Architecture

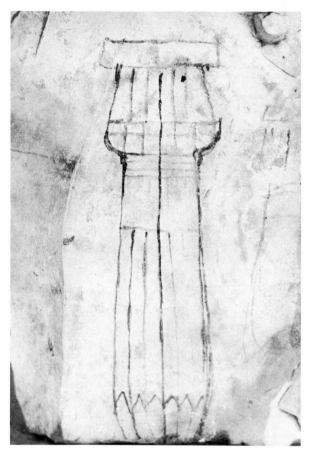

125

125 Drawing of a column
Ramesside period, *c.* 1305–1080 BC

This drawing from Deir el Medina of a papyrus-bundle column is of a proportion current in the architectural usage of Dynasty XIX. It is drawn on a central axial line and may be either a demonstration of how a column should be rendered in painting or relief, or a sketch for actual building construction. In either case it illustrates the type of column that suggests a group of papyrus rushes tied into a bundle. Such columns are characterized by a sharp compression at the foot (which normally rests on a column base, not shown in this drawing) and a distinct tapering of the shaft below the capital, which was carved or painted to represent papyrus umbels in bud. That such a drawing was made demonstrates the practice necessary for the understanding of architectural shape and proportion.

126 Computations for an arch or vault
Dynasty III, *c.* 2635–2570 BC

In aesthetic significance this small sketch found in the Zoser Complex at Saqqara does not stand comparison with the other drawings in this book; but it is important in a different way. It has lent itself to study by many scholars interested in the methods of ancient architects, for it shows the working out of the curve of an arch or vault (Clarke and Engelbach 1930, pp. 52–4). The measurements are given in cubits, palms and digits, and to understand the curve being plotted we have to assume that these are to be read as from a horizontal base line on vertical lines which are spaced at even intervals. By taking this interval as a cubit it is possible to re-plot the drawing with some accuracy. There must have been many of such working sketches; no doubt any shape that was difficult to describe had to be laid out in this manner. Once used the drawings would have had no value and would have been thrown away. Many may exist today not yet identified for what they are. If this drawing does date from the time of Zoser it is one of the oldest examples of the mathematical planning of architectural structures known.

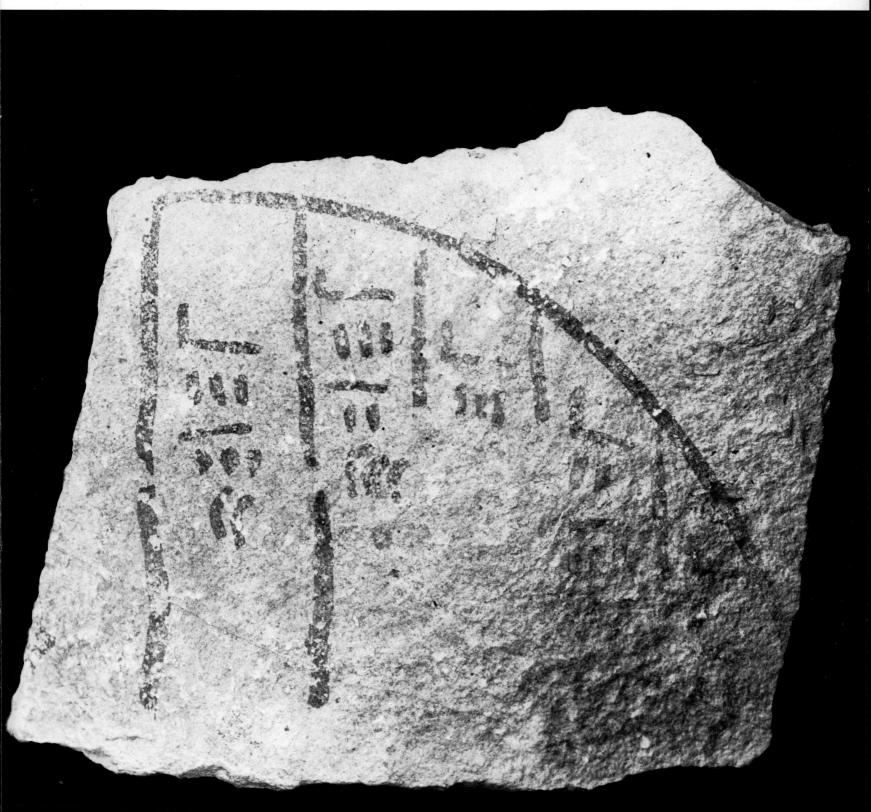

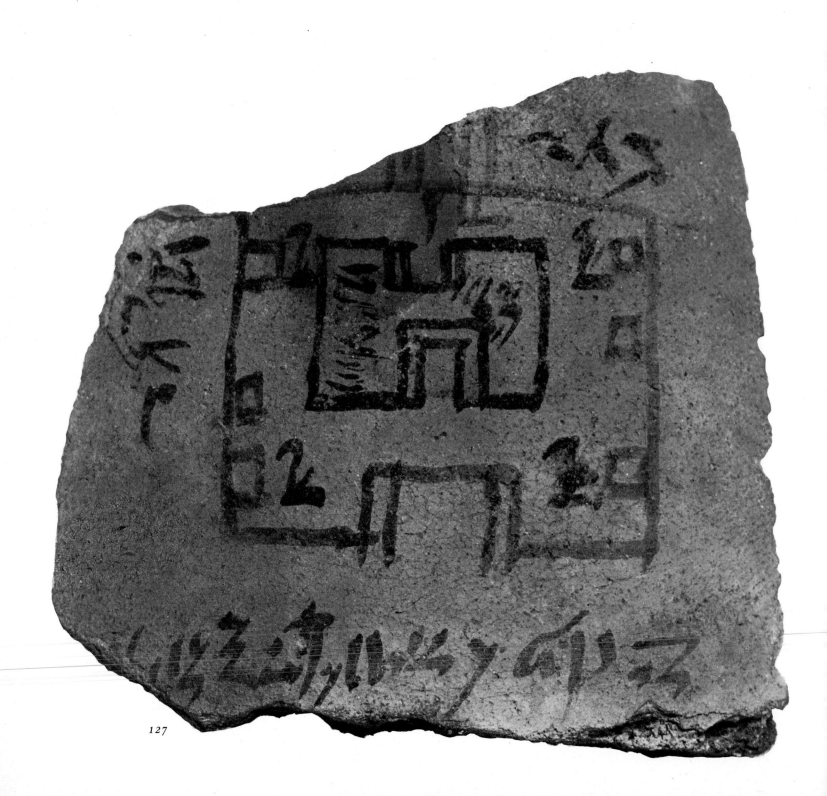

127

128

127 Plan of a shrine
Ramesside period, *c.* 1305–1080 BC

128 Elevation of a shrine
?Dynasties XVIII–XX, *c.* 1554/51–1080 BC

(*Left*) This rough sketch on a fragment of pottery from Deir el Bahri, giving measurements for the size of a wall and the building it encircles, is probably a working drawing used in construction. It was not necessary to make the plan exactly to scale for the notes of dimensions would suffice. The doors or gates are shown in elevation, the standard method of representation. A hieratic text gives information concerning the orientation of the drawing but this is unfortunately not completely preserved ('Whoever is in front of it, its west rests on his . . .' The end of the text would have indicated 'right' or 'left'). This plan can be considered typical of a number of cursory delineations for building projects. When detailed drawings exactly to scale were made, they were probably on papyrus and not many have come down to us. One exception is an elevation of the front and one side of a wooden shrine purchased at Gurab (*above*) which is in the collection of University College, London. On a squared-off grid every detail, including the lashing ropes which secure the roof and the base, is indicated.

129 Plan of the tomb of Ramesses IV
Dynasty xx, time of Ramesses IV, *c.* 1162–1156 BC

130 Plan of the tomb of Ramesses IX
Dynasty xx, time of Ramesses IX, *c.* 1137–1119 BC

Two well-known plans of Ramesside tombs exist, one on a papyrus fragment now in the Egyptian Museum, Turin (*plate 129*), the other on an ostrakon from the Valley of the Kings, now in the Egyptian Museum, Cairo (*plate 130*). The Turin plan has been the subject of much study because measurements are given in hieratic writing (Carter and Gardiner 1917). It is so accurate that it can be shown to have been a projected treatment of the tomb of Ramesses IV. One of the most interesting features of the plan is the inclusion, in the burial chamber (near the centre of the plate), of the shrines which would have covered the royal sarcophagus. It was not until the opening of the tomb of Tutankhamun that four shrines were found in place which agreed with this drawing. It is difficult to determine what stage in the cutting of the tomb this plan was made for. It could have been an initial conception, but also possibly a working drawing for the use of those who superintended the labourers on the tomb.

The Cairo drawing lacks much of the detail included in the Turin example, but is sufficiently complete to suggest that it too may have been an actual working plan for the use of overseers on the site. When compared with a modern drawing of the layout of the tomb this three-colour rendering agrees in almost every detail. The tomb was entered by a double stairway on either side of a descending ramp and the first section of the corridor has four chambers opening off it. The second section has a shallow niche on each side, while the third opens into an antechamber before a larger room with four engaged pillars. The last room or sarcophagus chamber is in reality smaller than the pillared room which precedes it, but this is the only major variation from the ancient drawing. That this plan represents the tomb of Ramesses IX there can be little doubt. The features depicted are not duplicated in any other actual tomb in the same order or layout.

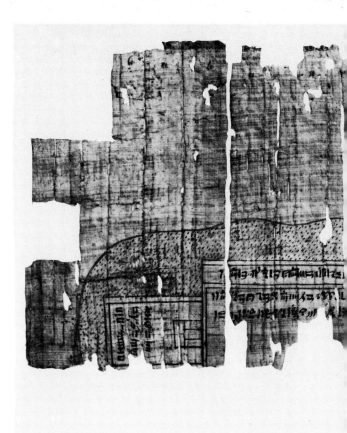

129

130

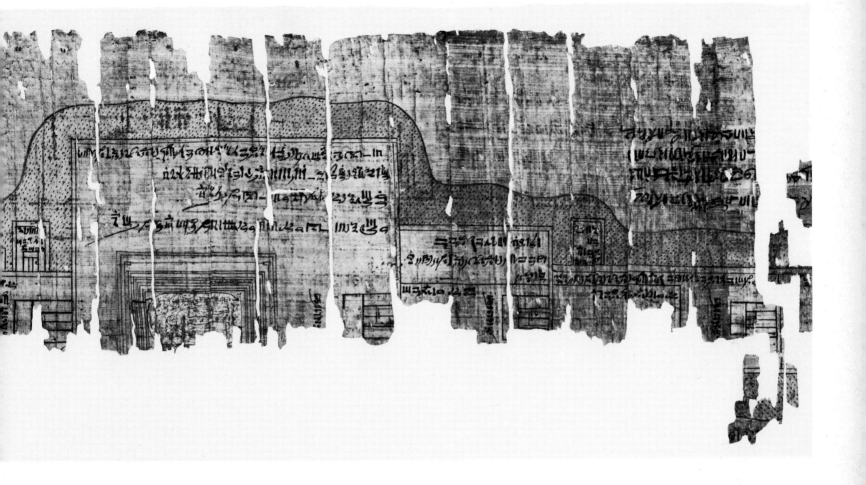

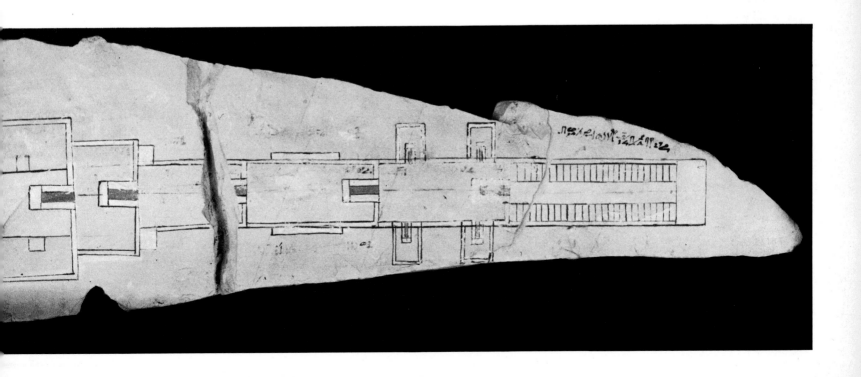

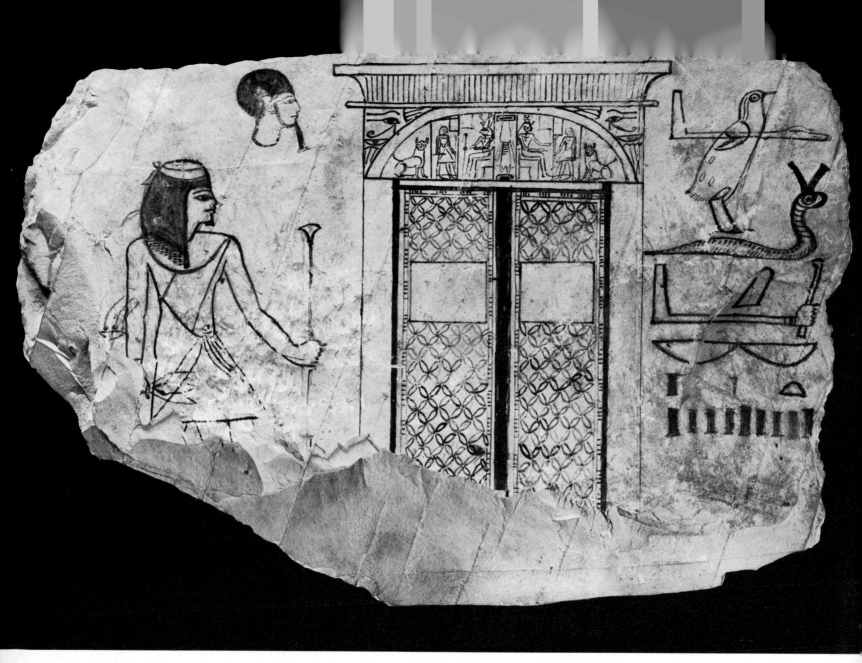

131, 132
Architectural study
with inscription

Ramesside period,
c. 1305–1080 BC

This interesting group of studies occupies both the front and back of a limestone fragment. On the front (*plate 131*) the principal subject is the rendering of a shrine with doors, an official who may be a part of that composition, a separate head of the god Ptah and a section of a text reading 'curbing the Nine Bows' (i.e. the foes of Egypt). Since the standing figure is repeated on the reverse and the text seems to bear no relationship to the other subjects, these various figures may be taken to be unrelated studies. The façade of the shrine is delineated in great detail from the cavetto cornice and the decorated arch over the door to the panels of the double-door itself. Over the door are depicted a god on the left and a goddess on the

right who face outwards from a central column. Before each is a worshipper and a cat with a frontal face. In the two corners above the arch the amuletic Eye of Horus is used as a space filler. Such careful depictions of architecture are not common and suggest that this may have been a drawing for the guidance of painters or decorators who were charged with the completion of such a structure. The official who approaches the shrine is shown standing holding a papyrus stalk in one hand and a lettuce in the other and wearing the bandolier of a priest which suggests that he is offering to the gods in the shrine. The reverse (*plate 132*) shows the officiant with an incomplete prayer to Amun-re asking for a goodly lifetime.

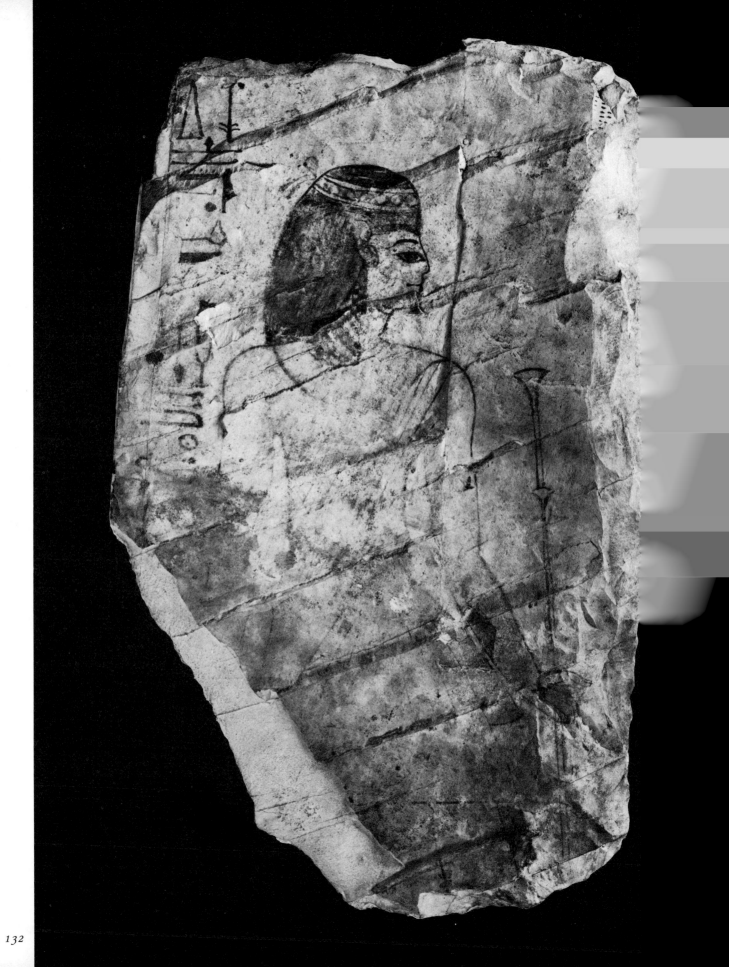

Glossary

ABYDOS — Ancient centre of the cult of Osiris and place of pilgrimage in Upper Egypt.

AMUN — Great god of Thebes and a national deity in his identification with Re as Amun-re, represented as a human being with crown surmounted by two tall feathers or with ram's head.

ankh — Hieroglyphic sign for the word 'life'. Thought to represent a sandal strap which, by utilizing similar sounds, was employed for 'life'.

ANUBIS — God of the necropolis and patron of embalmers. Depicted as a jackal or jackal-headed human being.

ATON — Sun-god represented by the visible disk of the sun. Akhenaten worshipped Aton as the creator god.

ATUM — Ancient sun-god of Heliopolis, depicted as a human being with royal attributes.

Ba — That part of a person's vital force which is close to the modern concept 'soul'. Represented as a human-headed bird.

BAST — Goddess of Bubastis in the Nile Delta, depicted as a woman with a cat's head.

BLUE CROWN — The so-called war crown of the pharaoh, depicted as blue, but possibly made of leather with small armour plates.

BOOK OF THE DEAD — New Kingdom religious text. Collection of prayers, spells and amuletic material for the use of the spirit in the afterlife.

CARTOUCHE — Originally a circular symbol for the universe, later elongated to accommodate the name of the pharaoh.

DEIR EL BAHRI — Site on the west bank at Thebes, notable for the mortuary temple of Queen Hatshepsut, the decoration of which includes the record of her expedition to Punt.

DEIR EL MEDINA — Part of the Theban necropolis, with burials of the Ramesside period, but also a workmen's village of the same time in the same area. Here were housed the artisans who laboured on the royal tombs.

DEMOTIC — The 'popular script', late cursive form of hieroglyphic writing. Used from the seventh century BC onwards.

djed — Amulet and hieroglyph in the form of a stylized pillar symbolizing 'stability' and 'uprightness' and interpreted as the backbone of Osiris.

FAIENCE — Glazed silicious ware made by firing ground quartz and natural soda. Faience could range in colour from black to white but was generally blue or green. It could be mould-made or modelled.

GEB — Personification of the earth represented as a male figure.

HATHOR — Goddess of many functions but important as a mother image. Hathor could be represented as a cow, cow-headed woman, woman with cow ears and horned headdress. Her name means 'House of Horus'.

HIERATIC — Cursive form of hieroglyphic writing, used from early Dynastic times for all but ceremonial inscriptions, which required the complete characters.

HIEROGLYPHICS — 'Sacred carving', writing form developed from the beginning of Dynastic history which combined phonetic elements and ideographs expressed in picture-signs.

HORUS — Falcon-god, god of the sky, protector of and identified with the living king and also son of Osiris, a complex series of attributions.

HORUS-NAME — One of the several names given the king and the most commonly known for early Dynastic kings.

ISIS — Wife of Osiris, mother of Horus, hence, divine mother, also protector of the dead. Usually depicted as human with a throne (part of her name in hieroglyphic) on her head.

MA'AT — Goddess (or personification) of justice, truth, right and order. Her symbol was the ostrich feather.

MEMPHIS — Capital of Egypt in the Old Kingdom located at the apex of the Nile Delta (south of modern Cairo).

NUT — Goddess of the sky, wife of Geb (the earth), represented as a naked female with hands and feet on earth supporting her arched body – the vault of heaven.

OSIRIS — God of the dead and the underworld, but also associated with vegetation. Represented as a mummified human being.

OSTRAKA — Broken pieces of pottery, but in Egyptology taken also to include flat chips or flakes of limestone.

PAPYRUS — Flat, paper-like writing surface made from the water-plant *Cyperus papyrus*. A scroll of the same material.

PTAH — God of Memphis and of creation. Represented as a mummified human being.

PUNT — Land on the east coast of Africa, source of ebony, ivory, incense-bearing trees and exotic animals.

RE — Ancient sun-god of Heliopolis, represented as falcon-headed.

RE-HARAKHTY — God with the characteristics of Re and Horus, the sun on the horizon.

RED CROWN — The crown of Lower Egypt, worn in combination with the White Crown to symbolize the unification of the two lands but also singly by deities of the North.

SAQQARA — The necropolis of Memphis, south of Giza and southwest of modern Cairo, one of the principal cemeteries of the Old Kingdom.

SEKHMET — Goddess of Memphis, wife of Ptah, depicted as a lion-headed human being and connected with the wrathful aspect of Re.

SHU — God of the Void, represented as a man with uplifted arms in the act of separating the sky from the earth.

SOTHIS — The dog-star Sirius.

TELL EL AMARNA — Site in Middle Egypt of the city (Akhetaten) founded by Akhenaten for the worship of the Aton.

THEBES — Great city of Upper Egypt, capital in the New Kingdom and the site of the temples of Karnak and Luxor.

THOTH — God of Hermopolis, god of writing, scribe of the gods. Depicted as an ibis-headed human being, but both the ibis and the baboon were sacred to him.

URAEUS — Cobra with spread hood, personification of a protective deity and symbol of royalty.

VALLEY OF THE KINGS — Secluded area of the Theban necropolis, cut off from the plain by a range of hills and chosen by rulers of Dynasty XVIII as the place of royal burial (in contrast with the Old Kingdom custom of pyramid burial). The practice was continued by kings of Dynasties XIX and XX.

VALLEY OF THE QUEENS — Area in the Theban necropolis to the south of the Valley of the Kings, reserved for burial of queens and princes.

was — Sceptre with hooked head and forked point. Hieroglyph for 'dominion' or 'power'.

WHITE CROWN — The crown of Upper Egypt. Worn in combination with the Red Crown of Lower Egypt by the king to symbolize the unity of the two lands.

Bibliography

GENERAL

BADAWY, ALEXANDER. *Ancient Egyptian Architectural Design: A Study of the Harmonic System*, Berkeley 1965.

CAPART, JEAN. *Documents pour servir à l'étude de l'art égyptien*, 2 vols., Paris 1927, 1931.

CARTER, HOWARD and ALAN H. GARDINER. 'The Tomb of Ramesses IV and the Turin Plan of a Royal Tomb', *Journal of Egyptian Archaeology*, IV (1917), pp. 130–58.

CLARKE, SOMERS and R. ENGELBACH. *Ancient Egyptian Masonry: The Building Craft*, Oxford 1930.

COONEY, JOHN D. 'Reliefs from the Tomb of Nes-peka-shuti', no. 35, plates 56–9, *Five Years of Collecting Egyptian Art, 1951–1956*, The Brooklyn Museum, Brooklyn, N.Y., 1956.

DAVIES, NINA M. DE GARIS. *Ancient Egyptian Paintings*, edited by Alan H. Gardiner, 3 vols., Chicago 1936.

DAVIES, NORMAN DE GARIS. 'The Work of the Titus Memorial Fund', *The Egyptian Expedition 1916–1919*, Supplement to the Bulletin of the Metropolitan Museum of Art (July 1920), pp. 24–33.

——*The Tomb of the Vizier Ramose*, Mond Excavations at Thebes, I, London 1941.

——*The Tomb of Rekh-mi-Re at Thebes*, The Metropolitan Museum of Art, Egyptian Expedition, XI, 2 vols., New York 1943.

ENGELBACH, R. (ed.). *Introduction to Egyptian Archaeology, with special reference to the Egyptian Museum, Cairo*, 2nd edn, Cairo 1961.

GARDINER, SIR ALAN. *Egyptian Grammar*, 2nd edn, fully revised, London 1950.

HAYES, WILLIAM C. *The Scepter of Egypt*, 2 vols., New York 1953, 1959.

IVERSEN, ERIK. 'The Canonical Tradition', in *The Legacy of Egypt*, edited by J. R. Harris, 2nd edn, Oxford 1971, pp. 55–82.

IVERSEN, ERIK, in collaboration with YOSHIZAKI SHIBATA. *Canon and Proportion in Egyptian Art*, 2nd edn, Warminster 1975.

KAISER, WERNER (Introduction by). *Ägyptisches Museum Berlin*, Berlin 1967.

LHOTE, ANDRÉ. *Les Chefs-d'oeuvre de la peinture égyptienne* (Arts du Monde), Preface by Jacques Vandier, Paris 1954.

MEKHITARIAN, A. *Egyptian Painting*, translated by Stuart Gilbert, Geneva 1954.

OMLIN, JOS. A. *Der Papyrus 55001 und seine Satirisch-erotischen Zeichnungen und Inschriften*, Catalogo del Museo Egizio di Torino, Serie Prima – Monumenti e Testi, III, Turin 1971.

PARKER, R. A. 'Ancient Egyptian Astronomy', in *Philosophical Transactions of the Royal Society of London*, 276 (1974), pp. 51–65.

PIANKOFF, ALEXANDRE. *The Tomb of Ramesses VI*, Bollingen Series, XL, Egyptian Religious Texts and Representations, I, edited by N. Rambova, 2 vols., New York 1954.

SCHÄFER, HEINRICH. *Principles of Egyptian Art*, edited by Emma Brunner-Traut and translated by John Baines, Oxford 1974.

SMITH, WILLIAM STEVENSON. *Egyptian Sculpture in the Old Kingdom*, 2nd edn, Boston and Oxford 1949.

——*The Art and Architecture of Ancient Egypt*, The Pelican History of Art, Harmondsworth 1958.

TERRACE, EDWARD L. B. *Egyptian Paintings of the Middle Kingdom*, New York 1967.

VON BECKERATH, J. *Abriss der Geschichte des Alten Ägypten*, Munich 1971.

WILSON, JOHN, A. 'Ceremonial Games of the New Kingdom', *Journal of Egyptian Archaeology*, XVII (1931), pp. 211–20.

WINLOCK, H. E. *The Egyptian Expedition, 1925–27*, Bulletin of the Metropolitan Museum of Art, New York, section II, February 1928.

WOLF, WALTHER. *Die kunst Ägyptens, Gestalt und Geschichte*, Stuttgart 1957.

DRAWINGS

ANTHES, RUDOLF. 'Studienzeichnungen altägyptischer Maler', *Pantheon*, XXIV (September 1939), pp. 300–5.

BAUD, M. *Les Dessins ébauchés de la nécropole thébaine (au temps du Nouvel Empire)* (Mémoires publiés par les membres de l'Institut français d'archéologie orientale, LXIII), Cairo 1935.

BRUNNER-TRAUT, E. *Die altägyptischen Scherbenbilder (Bildostraka) der deutschen Museen und Sammlungen*, Wiesbaden 1956.

——'Bildostraka und Buchmalerei', in *Das alte Ägypten*, vol. 15 of Propyläen Kunst-Geschichte, Berlin 1975.

——Egyptian Artists' Sketches. Figured Ostraka from the Gayer-Anderson Collection in the Fitzwilliam Museum, Cambridge (forthcoming).

DARESSY, G. *Ostraca (Catalogue général du Musée du Caire, I)*, Cairo 1901.

DAVIES, NORMAN DE GARIS. 'An Architect's Plan from Thebes', *Journal of Egyptian Archaeology*, IV (1917), pp. 194–9.

——'Egyptian Drawings on Limestone Flakes', *Journal of Egyptian Archaeology*, IV (1917), pp. 234–40.

IVERSEN, ERIK. 'A Canonical Master-drawing in the British Museum', *Journal of Egyptian Archaeology*, XLVI (1960), pp. 71–9.

KISCHEWITZ, HANNELORE. *Le Dessin au pays des pharaons*, translated by Jean-Pierre Bercot, Paris 1972.

PETERSON, BENGT E. J. *Zeichnungen aus einer Totenstadt*, Bulletin of the Museum of Mediterranean and Near Eastern Antiquities, Medelhavsmuseet, no. 7–8, Stockholm 1973.

PIEPER, M. 'Die ägyptische Buchmalerei, vergleichen mit der griechischen und frühmittelalterlichen', *Jahrbuch des deutschen Archäologischen Instituts*, XLVIII (1933), pp. 40–54.

SCHÄFER, HEINRICH. 'Ägyptische Zeichnungen auf Scherben', *Jahrbuch der Königlich preuszischen Kunstsammlungen*, XXXVII (1916), pp. 23–51.

VANDIER-D'ABBADIE, J. *Catalogue des ostraca figurés de Deir el Médineh* (Institut français d'archéologie orientale: Documents de Fouilles, II), 4 vols., Cairo 1937–46.

WERBROUCK, M. 'Ostraca à figures', *Bulletin des Musées royaux d'art et d'histoire* (Brussels), 3rd series, IV, 5 (1932), pp. 106–9.

——'Ostraca à figures', *Bulletin des Musées royaux d'art et d'histoire* (Brussels), 3rd series, VI, 6 (1934), pp. 138–40.

——'Ostraca à figures', *Bulletin des Musées royaux d'art et d'histoire* (Brussels), 3rd series, XI, 2 (1939), pp. 41–5.

——'Ostraca à figures', *Bulletin des Musées royaux d'art et d'histoire* (Brussels), 4th series, XXV (1953), pp. 93–111.

MATERIALS

LUCAS, A. *Ancient Egyptian Materials and Industries*, 4th edn, revised by J. R. Harris, London 1962.

List of illustrations

The authors and publishers are grateful to the many museums, institutions and individuals mentioned below who have granted permission to reproduce and helped in the identification of the drawings illustrated in this book. Photographs have been supplied by the owners of the drawings unless otherwise acknowledged. Measurements are given first in centimetres, then in inches, height before width. For ostraka sizes are of total surface area. Accession numbers are given after museums, where known.

ABBREVIATIONS

CCG Catalogue général des antiquités du Musée du Caire
IFAO Institut Français d'Archéologie Orientale, Cairo
JdE Journal d'Entrée of the Egyptian Museum, Cairo

ILLUSTRATIONS IN THE TEXT

COLOUR PLATES

Fitzwilliam Museum, Cambridge. EGA 3858.1943

XI Birds caught in a net. Dyn. V, *c.* 2450–2290 BC. Ink on limestone wall. Tomb of Neferherptah, Saqqara. *Photo John G. Ross*

XII Dog of the Pointer type. Ramesside, *c.* 1305–1080 BC. Ink on limestone, 17 × 24 (6¾ × 9½). From Western Thebes. Egyptian Museum, Cairo. *JdE* 36408. *Photo John G. Ross*

XIII A cat herds geese. Ramesside, *c.* 1305–1080 BC. Ink on limestone, 10.5 × 12.8 (4⅛ × 5). From Deir el Medina. Egyptian Museum, Cairo. *JdE* 65429. *Photo John G. Ross*

XIV Fish and lotus buds. Dyn. XVIII, *c.* 1554/51–1305 BC. Faience bowl, diam. 17 (6¾). Egyptian Museum, Cairo. *JdE* 63672. *Photo John G. Ross*

XV Lute player. Dyn. XX, *c.* 1305–1196 BC. Faience bowl, diam. 12 (4¾). Rijksmuseum van Oudheden, Leiden. AD 14.

XVI Study for ceiling decoration. Ramesside, *c.* 1305–1080 BC. Ink on limestone, 16 × 9 (6¼ × 3½). From Valley of the Kings. Egyptian Museum, Cairo. *JdE* 36407. *Photo John G. Ross*

MONOCHROME PLATES

1 Male head in profile. Ramesside, *c.* 1305–1080 BC. Ink on limestone, 28 × 27 (11 × 10⅝). From nr tomb 6, Valley of the Kings. Egyptian Museum, Cairo. *CCG* 25162. *Photo John G. Ross*

2 Portrait of Senenmut. Dyn. XVIII, Hatshepsut, *c.* 1490–1470/68 BC. Ink on limestone wall. Tomb of Senenmut (no. 71), Deir el Bahri. *Photo John G. Ross*

3 Head of Senenmut. Dyn. XVIII, Hatshepsut, *c.* 1490–1470/68 BC. Ink on limestone, h. of head 9.3 (3⅝). From tomb of Senenmut (no. 71), Deir el Bahri. Metropolitan Museum of Art, New York. 36.3.252. *Photo John G. Ross*

4 Two profiles of Senenmut. Dyn. XVIII, Hatshepsut, *c.* 1490–1470/68 BC. Ink on limestone, w. 17 (6¾). From Thebes. Metropolitan Museum of Art, New York, Anonymous Gift, 1931. 31.4.2

5 Egyptian courtiers. Dyn. XVIII, Akhenaten, *c.* 1365–1349/47 BC. Unfinished wall carving. Tomb of Ramose (no. 50), Thebes. *Photo John G. Ross*

6 Foreign emissaries. Dyn. XVIII, Akhenaten, *c.* 1365–1349/47 BC. Unfinished wall carving. Tomb of Ramose (no. 50), Thebes. *Photo John G. Ross*

7 Seated man. Ramesside, *c.* 1305–1080 BC. Red ink on limestone, 16.8 × 10.8 (6⅝ × 4¼). From Deir el Medina. IFAO.3963

8 Two Nubians and a ?lynx. Ramesside, *c.* 1305–1080 BC. Ink on limestone, 44 × 22 (17¾ × 8⅝). From nr tomb 9, Valley of the Kings. Egyptian Museum, Cairo. *CCG* 25133. *Photo John G. Ross*

9 Two boys burnishing jar. Ramesside, *c.* 1305–1080 BC. Ink on limestone, 9.5 × 11 (3¾ × 4⅜). From Deir el Medina. Ägyptisches Museum der Staatlichen Museen Preussischer Kulturbesitz, Berlin. 21444

10 Figure of a man. Ramesside, *c.* 1305–1080 BC. Ink on limestone, 18 × 18 (7⅛ × 7⅛). From Saqqara. Egyptian Museum, Cairo. 39139. *Photo John G. Ross*

11 Woman on horseback. Ramesside, *c.* 1305–1080 BC. Black and red ink on limestone, 7.5 × 11.3 (3 × 4½). ?From Deir el Medina area. Fitzwilliam Museum, Cambridge. EGA.4290.1943 = Brunner-Traut (forthcoming), no. 5

12 A princess at table. Dyn. XVIII, Akhenaten, *c.* 1365–1349/47 BC. Drawn and partly carved, ink on limestone, h. 23.5 (9¼). From Tell el Amarna, North Palace. Egyptian Museum, Cairo. *JdE* 48035

13 Woman nursing a child. Ramesside, *c.* 1305–1080 BC. Ink on limestone, 10 × 6 (4 × 6⅜). From Deir el Medina. IFAO.3787

14 Woman nursing a child. Ramesside, *c.* 1305–1080 BC. Ink on limestone, 16.5 × 19.1 (6½ × 7½). From Deir el Medina. British Museum, London. 8506

15 Torso of a woman. Ramesside, *c.* 1305–1080 BC. Ink on limestone, 24 × 16.5 (9½ × 6½). From Valley of the Queens. Egyptian Museum, Turin. 5689

16 Full-length portrait of Isis. Ptolemaic or Roman, after 332 BC. Ink on linen, 24 × 10 (9½ × 6¾). Musée Historique des Tissus, Lyon. *Photo Giraudon.* 55 276 LA

17–20 Here-ubekhet enters the Fields of the Blessed. Dyn. XXI, *c.* 1000 BC or later. Papyrus 133A, h. 23.8 (9⅜), total w. 198 (78). From Deir el Bahri. Egyptian Museum, Cairo. 14–7/35–6

21 Courtesan at her toilet. Dyn. XX, *c.* 1196–1080 BC. Ink on papyrus, 15.7 × 10.2 (6¼ × 4). Egyptian Museum, Turin. 2031

22 Here-ubekhet before the gods. Dyn. XXI, *c.* 1000 BC or later. Papyrus 133B, h. 23.5 (9¼), total w. 191 (75⅜). From Deir el Bahri. Egyptian Museum, Cairo. *Photo John G. Ross*

23 Mourning women. Dyn. XVIII, *c.* 1554/51–1305 BC. Papyrus of Ani, black, blue and red ink, h. of figures 8.0 (3⅛). Provenance unknown. British Museum, London. 10470 sheet 6. *Photo John G. Ross*

24–5 Details from Papyrus of Anhai. Dyn. XX, *c.* 1196–1080 BC. Ink and colour on papyrus, h. 24.0 (9½). Provenance unknown. British Museum, London. 10472. *Photos John G. Ross*

26 Head of Akhenaten. Dyn. XVIII, Akhenaten, *c.* 1365–1349/47 BC. Partly carved limestone relief, 23 × 31 (9 × 12⅛). From Tell el Amarna. Egyptian Museum, Cairo. *JdE* 59294. *Photo Roger Wood Studio*

27 Head of Akhenaten. Dyn. XVIII, Akhenaten, *c.* 1365–1349/47 BC. Drawn and partly carved limestone relief. From Tell el Amarna. Egyptian Museum, Cairo. *JdE* 64957. *Photo John G. Ross*

28 King Den smites an enemy. Dyn. I, *c.* 2900 BC. Incised ivory label, 4.5 × 5.4 (1¾ × 2⅛). From Abydos. British Museum, London. 55586

29 A pharaoh slays a lion. Dyn. XIX, *c.* 1305–1196 BC. Ink on limestone, h. 14.0 (5½). From Valley of the Kings. Metropolitan Museum of Art, New York, Carnarvon Collection 1926, gift of E. S. Harkness. 26.7.1452

30 Head of Akhenaten and fist. Dyn. XVIII, Akhenaten, *c.* 1365–1349/47 BC. Ink on limestone, 11.6 × 13.8 (4⅝ × 5¼). The Brooklyn Museum, New York. 36.876

31 Head of king with Blue Crown. Ramesside, *c.* 1305–1080 BC. Black and red ink on limestone, h. 18.4 (7¼). Provenance unknown. Walters Art Gallery, Baltimore. 32.1. *Photo John G. Ross*

32 Master drawing. Dyn. XVIII, Tuthmosis III, *c.* 1490–1439/36 BC. Ink and gesso on board, 36.4 × 53.7 (14⅜ × 20¾). From a tomb at Thebes. British Museum, London. 5601

33–4 Two royal heads. Dyn. XIX, *c.* 1305–1196 BC. Ink on limestone, h. 32.0 (12⅝). From Western Thebes. Soprintendenza alle Antichità d'Etruria, Firenze. 7618

35 Standing queen. Ramesside, *c.* 1305–1080 BC. Ink on limestone, 28 × 17 (11 × 6¾). From nr tomb 9, Valley of the Kings. Egyptian Museum, Cairo. *CCG* 25044. *Photo John G. Ross*

36 King's head and two figures. Ramesside, *c.* 1305–1080 BC. Ink on limestone, 26 × 22 (10¼ × 8⅝). Provenance unknown. Metropolitan Museum of Art, New York. 14.6.191. *Photo John G. Ross*

37 A king with a Blue Crown. Ramesside, *c.* 1305–1080 BC. Ink on limestone, 23 × 14 (9 × 5½). From Western Thebes. Egyptian Museum, Cairo. *JdE* 47605. *Photo John G. Ross*

38 Figure of a king. Ramesside, *c.* 1305–1080 BC. Red ink on limestone, 47 × 41 (18½ × 16⅛). From nr tomb 9, Valley of the Kings. Egyptian Museum, Cairo. *CCG* 25002. *Photo John G. Ross*

39–40 Seti I and Atum. Dyn. XIX, Seti I, *c.* 1303–1290 BC. Ink on limestone wall. Tomb of Seti I, Valley of the Kings. *Photos John G. Ross*

41–2 Tuthmosis III in the underworld. Dyn. XVIII, Tuthmosis III, *c.* 1490–1439/36 BC. Ink on limestone wall. Tomb of Tuthmosis III (no. 34), Valley of the Kings. *Photos John G. Ross*

43 Ramesses III conducts a review. Dyn. XX, Ramesses III, *c.* 1196–1162 BC. Carved wall relief. Temple of Ramesses III, Medinet Habu. *Photo courtesy the Oriental Institute, University of Chicago*

44 Ramesses IX receives suppliants. Dyn. XX, Ramesses IX, *c.* 1137–1119 BC. Ink on limestone, 46.0 × 74.8 (18⅛ × 29½). From Thebes. British Museum, London. 5620

45 The Queen of Punt. Dyn. XVIII, Hatshepsut, *c.* 1490–1470/68 BC. Painted wall relief, h. 36.0 (14⅛). From temple of Hatshepsut, Deir el Bahri. Egyptian Museum, Cairo. 12–11/16–5

46 The Queen of Punt. Ramesside, *c.* 1305–1080 BC. Ink on limestone, 14 × 8 (5½ × 3⅛). From Deir el Medina. Ägyptisches Museum der Staatlichen Museen Preussischer Kulturbesitz, Berlin. 21442

47 Two Hathor heads. Dyn. XVIII, *c.* 1554/51–1305 BC. Blue faience bowl, diam. 16.5 (6½). Egyptian Museum, Turin. 3368

48 Two Nile gods. Ramesside, *c.* 1305–1080 BC. Ink on limestone, 21 × 21.5 (8¼ × 8½). From nr tomb 9, Valley of the Kings. Egyptian Museum, Cairo. *CCG* 25062. *Photo John G. Ross*

49 Man in adoration. Ramesside, *c.* 1305–1080 BC. Black ink on limestone, prelim. drawing in red, 45 × 35 (17¾ × 14¾). From nr tomb 9, Valley of the Kings. Egyptian Museum, Cairo. *CCG* 25029. *Photo John G. Ross*

50 Kneeling Isis. Ramesside, *c.* 1305–1080 BC. Ink on limestone, 24.5 × 21 (9⅝ × 8⅝). From nr tomb 9, Valley of the Kings. Egyptian Museum, Cairo. *CCG* 25065. *Photo John G. Ross*

51 Four sketches. Ramesside, *c.* 1305–1080 BC. Red ink on limestone, 26 × 22 (10¼ × 8⅝). From Valley of the Kings. Egyptian Museum, Cairo. *CCG* 25176. *Photo John G. Ross*

52 Oryx, goddess and scarab. Ramesside, *c.* 1305–1080 BC. Ink on limestone, 12 × 9 (4¾ × 7½). From nr tomb 37, Valley of the Kings. Egyptian Museum, Cairo. *CCG* 25179. *Photo John G. Ross*

53 The cow of Hathor. Ramesside, *c.* 1305–1080 BC. Ink on limestone, 30 × 37 (11⅞ × 14½). From nr tomb 9, Valley of the Kings. Egyptian Museum, Cairo. *CCG* 25092. *Photo John G. Ross*

54 Horus-name of Ramesses IV. Ramesside, Ramesses IV, *c.* 1162–1156 BC. Ink on limestone, 26 × 48 (10¼ × 19). From Valley of the Kings. Egyptian Museum, Cairo. *CCG* 25194. *Photo John G. Ross*

55 Book of the Dead vignette. Dyn. XXI, *c.* 1080–946 BC. Ink on papyrus, 48.0 × 88.5 (18⅞ × 34¾). From Deir el Bahri. British Museum, London. 10554 sheet 87

56 Re-Harakhty and Thoth. Ramesside, *c.* 1305–1080 BC. Ink on papyrus, 48 × 31 (18⅞ × 12⅛). Provenance unknown. British Museum, London. 10554 sheet 52

57 Osiris enthroned. Dyn. XVIII, Horemheb, *c.* 1332–1305 BC. Ink on limestone wall. Tomb of Horemheb (no. 57), Valley of the Kings. *Photo Bollingen Foundation*

58–9 Barque of the Night Sun. Dyn. XVIII, Horemheb, *c.* 1332–1305 BC. Unfinished wall relief and preliminary drawing. Tomb of Horemheb (no. 57), Valley of the Kings. *Photos Harry Burton, courtesy Metropolitan Museum of Art, New York*

60–2 Details of astronomical ceiling. Dyn. XVIII, Hatshepsut, *c.* 1490–1470/68 BC. Ink on limestone ceiling. Tomb of Senenmut (no. 71), Deir el Bahri. *Photos John G. Ross*

63 Seated harpist. Dyn. XXVI, *c.* 664–525 BC. Ink on limestone, 15 × 11 (5⅞ × 4⅜). From Deir el Bahri. Metropolitan Museum of Art, New York, Museum Excavations, 1922–3. 23.3.31

64 Harpist's hands. Ramesside, *c.* 1305–1080 BC. Ink on limestone, 23 × 23 (9 × 9). From nr tomb 9, Valley of the Kings. Egyptian Museum, Cairo. *CCG* 25038. *Photo John G. Ross*

65 Hunchback. Ramesside, *c.* 1305–1080 BC. Ink on limestone, 19 × 10 (7½ × 4). From nr tomb 9, Valley of the Kings. Egyptian Museum, Cairo. *CCG* 25040. *Photo John G. Ross*

66 Harpist. Ramesside, *c.* 1305–1080 BC. Black and red ink on limestone, 12 × 8 (4¾ × 3⅛). From Deir el Medina. Egyptian Museum, Cairo. *JdE* 69409. *Photo John G. Ross*

67 Dancers and a harpist. Dyn. XVIII, Hatshepsut, *c.* 1490–1470/68 BC. Carved quartzite. From Karnak. Luxor Museum. *Photo John G. Ross*

68 Acrobatic dancer. Ramesside, *c.* 1305–1080 BC. Black and red ink on limestone, 7.4 × 10.3 (3 × 4). From Deir el Medina. IFAO. 3779

69 Stick-figures. Ramesside, *c.* 1305–1080 BC. Black design on red pottery, w. 13 (5⅛). From Deir el Medina. IFAO.3190

70 Stick-figures and a monkey. Ramesside, *c.* 1305–1080 BC. Red and black ink on limestone, 24 × 17 (9½ × 6¾). From nr tomb 9, Valley of the Kings. Egyptian Museum, Cairo. *CCG* 25138. *Photo Harry Burton, courtesy Metropolitan Museum of Art, New York*

71 Animal dancer and musicians. Ramesside, *c.* 1305–1080 BC. Black and red ink on limestone, 11.2 × 14 (4⅜ × 5½). From Deir el Medina. IFAO. 4010

72 Monkey and boy. Dyn. XX, *c.* 1196–1080 BC. Black, grey and red ink on limestone, 14 × 9.6 (5½ × 3¾). From Deir el Medina. Louvre, Paris. E.25.309

73 Two animals. Ramesside, *c.* 1305–1080 BC. Ink on limestone, 10.2 × 8.5 (4 × 3⅜). From Deir el Medina. Louvre, Paris. E.14.368

74–6 Animal procession. Ramesside, *c.* 1305–1080 BC. Ink and colour on papyrus, h. 15.5 (6⅛). Provenance unknown. British Museum, London. EA 10016 sheet 1

77 Two animals chastise youth. Dyn XX, *c.* 1196–1080 BC. Red and black ink on limestone, 7.8 × 12.6 (3 × 5). Exact provenance unknown. Oriental Institute, University of Chicago. 13951. *Photo John G. Ross*

78 Cat waits on a mouse. Ramesside, *c.* 1305–1080 BC. Ink on limestone, 8.9 × 17.3 (3½ × 6¾). From Thebes. The Brooklyn Museum, New York. 37.51 E

79 Hyaena defecating. Ramesside, *c.* 1305–1080 BC. Black ink on limestone, 4.9 × 7.9 (1⅞ × 3⅛). From Deir el Medina. IFAO. 3778

80 Donkey in a boat. Ramesside, *c.* 1305–1080 BC. Ink on limestone, 24 × 14.5 (9½ × 5¾). Provenance unknown. Metropolitan Museum of Art, New York. *Photo John G. Ross*

81 Two boats. Ramesside, *c.* 1305–1080 BC. Red and black ink on limestone, 22 × 45 (8⅝ × 17½). From Deir el Medina. Egyptian Museum, Cairo. *CCG* 25182. *Photo John G. Ross*

82 Stone-mason. Ramesside, *c.* 1305–1080 BC. Red and black ink on limestone, 14.5 × 13.2 (5¾ × 5¼). ?From Deir el Medina area. Fitzwilliam Museum, Cambridge. EGA.4324.1943 = Brunner-Traut (forthcoming), no. 14

83 Erotic scene. Ramesside, *c.* 1305–1080 BC. Ink on limestone, 13.5 × 17.8 (5¼ × 7). Provenance unknown. British Museum, London. 50714

84 Erotic scene. Ramesside, *c.* 1305–1080 BC. Ink on limestone, 12 × 14.3 (4¾ × 5⅝). Provenance unknown. Ägyptisches Museum der Staatlichen Museen Preussischer Kulturbesitz, Berlin. 23676

85 Erotic scene. Ramesside, *c.* 1305–1080 BC. Ink on limestone, 12 × 9 (4¾ × 3½). Provenance unknown. Egyptian Museum, Cairo. 11198 in Special Register. *Photo John G. Ross*

86 Ramesses IV in his chariot. Dyn. XX, Ramesses IV, *c.* 1162–1156 BC. Black ink on limestone, 32 × 41.5 (12⅝ × 16⅜). From nr tomb 9, Valley of the Kings. Egyptian Museum, Cairo. CCG 25124. *Photo John G. Ross*

87 Combatants with staves. Ramesside, *c.* 1305–1080 BC. Ink on limestone, 14 × 9.1 (5½ × 3⅝). From Deir el Medina. Louvre, Paris. E.25.309. *Photo John G. Ross*

88 Combat before the king. Dyn. XX, Ramesses III, *c.* 1193–1162 BC, with re-used blocks of Dyn. XIX, Ramesses II, *c.* 1290–1224 BC. Wall relief. Temple of Ramesses III, Medinet Habu. *Photo John G. Ross*

89 Two wrestlers. Ramesside, *c.* 1150 BC. Black and red ink on limestone, 30 × 23 (11⅞ × 9⅛). From nr tomb 9, Valley of the Kings. Egyptian Museum, Cairo. CCG 25132. *Photo John G. Ross*

90 A queen in combat. Ramesside, *c.* 1305–1080 BC. Red with traces of black ink on limestone, 25 × 38 (9⅞ × 15). From nr tomb 9, Valley of the Kings. Egyptian Museum, Cairo. CCG 25125. *Photo John G. Ross*

91 Decorative tile. Dyn. XVIII, *c.* 1554/51–1305 BC. Black drawing on blue faience, 8.3 × 15.6 (3¼ × 6⅛). Provenance unknown. Metropolitan Museum of Art, New York, gift of J. Pierpont Morgan, 1917. 17.194.2297

92 Two grooms and a charioteer. Dyn. XVIII, Akhenaten, *c.* 1365–1349/47 BC. Ink on limestone wall. Tomb of Mahu, Tell el Amarna. *Photo E. L. B. Terrace*

93 Ramesses IX before Amun. Dyn. XX, Ramesses IX, *c.* 1137–1119 BC. Black ink on limestone, 29.5 × 21 (11⅝ × 8¼). From nr tomb 6, Valley of the Kings. Egyptian Museum, Cairo. CCG 25121. *Photo John G. Ross*

94 A lion bites head of a Nubian. Ramesside, *c.* 1305–1080 BC. Black and red ink on limestone, 5 × 11 (2 × 4¾). From Deir el Medina. Egyptian Museum, Cairo. JdE 63802. *Photo John G. Ross*

95 A lion devours his prey. Ramesside, *c.* 1305–1080 BC. Black ink on limestone, 11 × 13 (4⅜ × 5⅛). From Deir el Medina. IFAO. 3851

96 Dogs, horned animals and a lion. Ramesside, *c.* 1305–1080 BC. Red overlaid by black ink on limestone, 11.5 × 13 (4½ × 5⅛). From Deir el Medina. Egyptian Museum, Cairo. (IFAO 3005.) *Photo John G. Ross*

97 Antelope attacked by a dog. Ramesside, *c.* 1305–1080 BC. Ink on limestone, 23 × 18.5 (9 × 7¼). From Sheikh Abd el-Qurna, Thebes. Ashmolean Museum, Oxford. 1945.14

98 Three dogs attack a hyaena. Ramesside, *c.* 1305–1080 BC. Black outline with red and black wash on limestone, 9 × 15.6 (3½ × 6⅛). From Deir el Medina. Louvre, Paris. E.14.366

99 Two moufflon in combat. Ramesside, *c.* 1305–1080 BC. Ink on limestone, 21 × 21.5 (8¼ × 8½). From nr tomb 9, Valley of the Kings. Egyptian Museum, Cairo. CCG 25062. *Photo John G. Ross*

100 Seated cat. Dyn. XVIII, Tuthmosis III, *c.* 1490–1439/36 BC. Ink on limestone wall. Tomb of Tuthmosis III (no. 34), Valley of the Kings. *Photo John G. Ross*

101 Three trial drawings. Ramesside, *c.* 1305–1080 BC. Drawn and partly carved limestone, 18 × 18 (7⅛ × 7⅛). From Valley of the Kings. Egyptian Museum, Cairo. JdE 46732. *Photo John G. Ross*

102 Lion's head and ducklings. Ramesside, *c.* 1305–1080 BC. Ink on limestone, 11.9 × 16.3 (4¾ × 6⅜). Provenance unknown. British Museum, London. 26706. *Photo John G. Ross*

103 A leaping lion. Dyn. XXVI, *c.* 664–525 BC. Ink on limestone, 16 × 12.8 (6¼ × 5). From Deir el Bahri. Metropolitan Museum of Art, New York, Museum Excavations, 1922–3. 23.2.28

104 A youth and goats. Ramesside, *c.* 1305–1080 BC. Ink on limestone, w. 11.7 (5⅝). From el Gilf el Kabir. Egyptian Museum, Cairo. JdE 69408. *Photo John G. Ross*

105 A monkey climbing a tree. Ramesside, *c.* 1305–1080 BC. Black outline with red and grey paint on limestone, 10.8 × 10 (4¼ × 4). ?From Deir el Medina area. Fitzwilliam Museum, Cambridge. EGA.4292.1943 = Brunner-Traut (forthcoming), no. 22

106 A monkey eating. Ramesside, *c.* 1305–1080 BC. Black ink and red paint on limestone, 8 × 6.5 (3⅛ × 2½). From Deir el Medina. Egyptian Museum, Cairo. JdE 63717. *Photo John G. Ross*

107 A horned animal. Dyn. XVIII, *c.* 1554/51–1305 BC. Ink on limestone, 9 × 13.5 (3½ × 5¼). From tomb of Senenmut (no. 71), Deir el Bahri. The Brooklyn Museum, New York. 58.28.3

108 Stalking baboon. Dyn. XVIII, Akhenaten, *c.* 1365–1349/47 BC. Ink on limestone, 7.5 × 16 (3 × 6¼). From Tell el Amarna. University College, London. 1585

109 Calf. Dyn. XXVI(?), *c.* 664–525 BC. Ink on limestone, 11 × 9 (4⅜ × 3½). From Deir el Bahri. Metropolitan Museum of Art, New York, Museum Excavations, 1922–3. 23.3.27

110 Hippopotamus. Predynastic, before *c.* 3000 BC. Rock engraving. Site 45, Wadi Barqa. After H. A. Winkler, *Rock Drawings of Southern Upper Egypt*, vol. II, London 1938

111 A horse rubbing its leg. Dyn. XXVI, *c.* 664–525 BC, or possibly earlier. Ink on limestone, w. 21.5 (8½). From tomb 312, Western Thebes. Metropolitan Museum of Art, New York. 23.3.33. *Photo John G. Ross*

112 Relief of a horse. Dyn. XVIII, Akhenaten, *c.* 1365–1349/47 BC. Carved limestone relief, 23.2 × 52.5 (9⅛ × 20¾). From Tell el Amarna. Collection Mr and Mrs Norbert Schimmel, New York

113 She-ass and her young. Ramesside, *c.* 1305–1080 BC. Ink on limestone. From Thebes. Egyptian Museum, Cairo. *Photo courtesy the Oriental Institute, University of Chicago*

114 Head of a horse. Dyn. XVIII, Horemheb, *c.* 1332–1305 BC. Ochre drawing on wall. Tomb of Horemheb, Saqqara. *Photo John G. Ross, by courtesy of The Egypt Exploration Society*

115 Two boys driving cattle. Ramesside, *c.* 1305–1080 BC. Black outline with red and black paint, 4.5 × 11 (1¾ × 4⅜). From Deir el Medina. Egyptian Museum, Cairo. JdE 63794. *Photo John G. Ross*

116 Bull. Ramesside, *c.* 1305–1080 BC. Ink on limestone, 19 × 29 (7½ × 11½). From nr tomb 9, Valley of the Kings. Egyptian Museum, Cairo. CCG 25080. *Photo John G. Ross*

117 Bull. Ramesside, *c.* 1305–1080 BC. Ink on limestone, 17 × 26 (6¾ × 10¼). From nr tomb 6, Valley of the Kings. Egyptian Museum, Cairo. CCG 25078. *Photo John G. Ross*

118 Rooster. Ramesside period, *c.* 1305–1080 BC. Ink on limestone, 15.3 × 18.8 (6 × 7⅜). From Valley of the Kings. British Museum, London. 68539

119 A goose on her nest. Ramesside, *c.* 1305–1080 BC. Ink on limestone, 6.4 × 8.3 (2½ × 3¼). Provenance unknown. British Museum, London. 56706. *Photo John G. Ross*

120 Birds caught in a net. Dyn. V,
 c. 2450–2290 BC. Ink on limestone
 wall. Tomb of Neferherptah, Saqqara.
 Photo John G. Ross

121 Cat. Ramesside, c. 1305–1080 BC. Red
 ink on limestone, 13 × 10.5 (5⅛ × 4⅛).
 ?From Deir el Medina area. Fitzwilliam
 Museum, Cambridge. EGA.3859.1943
 = Brunner-Traut (forthcoming), no. 25

122 Fish (*Synodontis?*). Ramesside, c.
 1305–1080 BC. Ink on limestone, 9 × 10
 (3½ × 4). From Valley of the Kings.
 Egyptian Museum, Cairo. *JdE* 66158.
 Photo John G. Ross

123 Fish (*Tilapia Nilotica*). Ramesside,
 c. 1305–1080 BC. Black and red ink on
 limestone, 21 × 27 (8¼ × 10⅝). From Deir
 el Medina. IFAO. 3658

124 Fish and lotus decoration. Dyn.
 XVIII–XIX, c. 1554/51–1196 BC. Painted
 and glazed faience. Egyptian Museum,
 Turin

125 Papyrus-bundle column. Ramesside,
 c. 1305–1080 BC. Ink on limestone,
 21 × 16.5 (8¼ × 6½). From Deir el
 Medina. Louvre, Paris. E.14315.
 Photo John G. Ross

126 Computations for arch or vault. Dyn. III,
 c. 2635–2570 BC. Ink on limestone,
 15 × 16 (5⅞ × 6¼). From Saqqara.
 Egyptian Museum, Cairo. *CCG* 50036.
 Photo John G. Ross

127 Plan of a shrine. Ramesside period, c.
 1305–1080 BC. Painted pottery, 9.8 × 9.5
 (3⅞ × 3¾). From Deir el Bahri. British
 Museum, London. 41228

128 Elevation of a shrine. ?Dyns. XVIII–XX,
 c. 1554/51–1080 BC. Ink on papyrus, front
 view h. 89 (35), side view h. 50 (19¾).

Purchased at Gurab. University
 College, London. 27934 i and ii

129 Tomb plan of Ramesses IV. Dyn. XX,
 Ramesses IV, c. 1162–1156 BC. Ink on
 papyrus, 31.1 × 104.8 (12½ × 41¼).
 Egyptian Museum, Turin. 1885

130 Tomb plan of Ramesses IX. Dyn. XX,
 Ramesses IX, c. 1137–1119 BC. Ink and
 colour on limestone, 14 × 83.5
 (5½ × 32⅞). From nr tomb 9, Valley of
 the Kings. Egyptian Museum, Cairo.
 CCG 25184. *Photo John G. Ross*

131–2 Architectural study. Ramesside, c.
 1305–1080 BC. Ink on limestone, 27 × 42
 (10⅝ × 16½). ?From Deir el Medina area.
 Fitzwilliam Museum, Cambridge.
 EGA.4298.1943 = Brunner-Traut
 (forthcoming), no. 1

Index

Italic numerals refer to the numbered plates; **bold**-face numerals indicate illustrations
(by page number) in the introductory text.